Photography in Brazil
1840–1900

Photography in Brazil
1840–1900

Gilberto Ferrez

Translated by Stella de Sá Rego

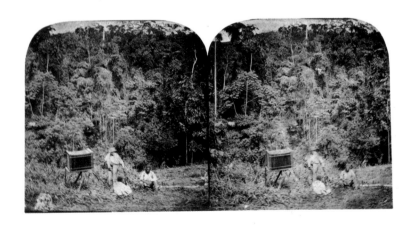

University of New Mexico Press *Albuquerque*

Library of Congress Cataloging-in-Publication Data

Ferrez, Gilberto.
 [Fotografia no Brasil, 1840–1900. English]
 Photography in Brazil, 1840–1900 / Gilberto Ferrez ;
 translated by Stella de Sá Rego. — 1st U.S. ed.
 p. cm.
 Translation of: A fotografia no Brasil.
 Includes bibliographical references.
 ISBN 0-8263-1211-X
 1. Photography—Brazil—History—19th century.
 I. Title.
 TR41.F4313 1990
 770′.981′09034—dc20
 90-11903
 CIP

Photograph on page iii: Anonymous albumen 7.5 × 15 cm GF
Stereoscopic photograph taken around 1875. Majestic,
unexpected, and extremely rare, made in the middle of
the forest, it has an incalculable value: that of document-
ing for posterity the type of camera then used.

Contents

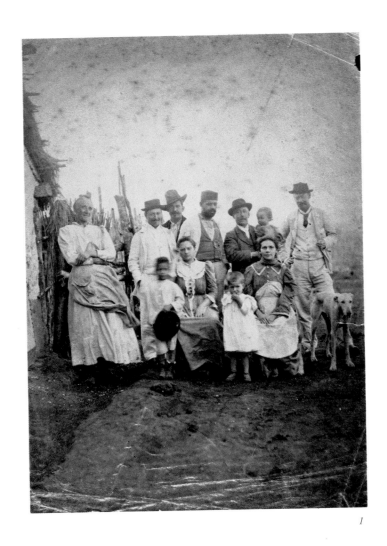

1. Henrique Morize albumen 21.8 × 16 cm GF
Photograph made on the Goiás plateau in 1893, when the
Comissão Exploradora do Planalto Central do Brasil de-
marcated the site of the future capital of the country, the
present location of Brasília. Standing at left and seated at
right are, respectively, the aunt and wife of Dr. Morize,
founder of the Observatório Nacional.

Preface to the English Edition

I had the pleasure of meeting Gilberto Ferrez in the summer of 1987, while in Brazil acquiring materials for the University of New Mexico General Library under a grant from the Burlington Northern Foundation. During that trip, I became aware of the dedicated and informed efforts being made in that country to preserve the cultural patrimony expressed in historical photographs. No one has contributed more to this undertaking than Gilberto Ferrez. For more than forty years, he has preserved original photographic documents, researched their history, and disseminated the fruits of his labors in publications whose quality is as impressive as their number. Of all his books on Brazilian photography, *A Fotografia no Brasil, 1840–1900* is the most comprehensive, covering fourteen states and the work of all the most noteworthy photographers working there in that period. For this reason, I felt that a translation into English would be of real interest to scholars and students, both of the history of photography and of the history of Brazil. Lovers of fine photography will also find here ample material for their enjoyment. The beauty of the Brazilian landscape and the skill of the photographers resulted in some arresting images.

Published in Brazil in 1985, *A Fotografia no Brasil, 1840–1900* remains the fundamental reference on nineteenth-century Brazilian photography. It is my hope that this English translation will bring it before a larger audience, whose access to the subject has heretofore been limited by the dearth of material on Latin American photography and art available in our language.

I must thank Gilberto Ferrez for his careful review of this manuscript and for his enduring patience. I would also like to express my gratitude to H. L. Hoffenberg for his help in realizing this project, and to my husband, Enylton de Sá Rego, for his unfailing support and assistance. Pedro Vasquez, author of the preface and glossary, offered helpful suggestions and should also be recognized for his efforts to preserve Brazil's photographic record, as well as for his own creative works. The University of New Mexico General Library granted me time to complete this project; I am grateful for the support. Lastly, I would like to dedicate this translation to my friends Joye and Bill Lucas, and to my father Jimmie R. Major.

Stella M. de Sá Rego
Albuquerque, 1990

Preface to the 1985 Brazilian Edition

If it is impossible to have a clear picture of Brazilian photography, to speak of a Brazilian style as one speaks of a French or American style, it is because of the lack of knowledge of the history of photography in our country.

It is not by chance that the dominant schools of photography, in terms of international influence and impact, are those which have their past more perfectly mapped and preserved: the French and American. These countries have published more than any others in the field of photography and hold the two largest collections in existence—at the Bibliothèque Nationale in Paris, and the Library of Congress in Washington.

Therefore, it is a task of utmost importance to preserve, promote, and disseminate our photographic heritage, which, in terms of quality, is in no way inferior to those countries north of the Equator. We must remember that photography was introduced in Brazil six months after the official announcement of its invention, and that one of the pioneer inventors, Hercules Florence—a Frenchman living in Campinas, São Paulo—was responsible for the development of his own process at the same period that Nièpce and other of the better known precursors were carrying out their experiments.

A past we have, and an important one. What we lack is the proper recognition of the value of this past in our own country, since, oddly enough, it is much better known and appreciated outside Brazil than here in the *terras tupiniquins*.

It was to correct this distortion that the Instituto Nacional da Fotografia, of Funarte, created a collection entitled *História da Fotografia no Brasil*, and now joins the Fundação Nacional Pró-Memória in producing this book. The author, historian Gilberto Ferrez, was the first to take action against the neglect in which our photography found itself. Single-handedly, he took the initiative to preserve our photographic heritage.

Ferrez seemed predestined to photography; he is a descendent of a distinguished precursor in that field, the photographer Marc Ferrez. Gilberto Ferrez is author of the first study of the history of photography in Brazil, published in *Revista do Patrimônio Histórico*, n°. 10, in 1947, and later as an offprint by the same review, in 1953.

To appreciate the true dimension of Gilberto Ferrez's pioneering work, one should remember that, at that time, studies of this kind were few, even in Europe. Today, more than thirty years later, they are still rare in Brazil.

It should be pointed out that the present edition of this book is not a re-edition, in the conventional sense of the term, of the work by the same name published in 1947. The amount of text was considerably enlarged, while the number of photographs is five times greater. The relation between the two works is, therefore, that of a tree to the seed from which it came.

When Ferrez began his research, he had to overcome considerable difficulties. Beside having no reference work to guide his steps through the twists and turns of the history of our photography, he had to work with collections that were widely dispersed and poorly organized, if not complely disorganized. Few were the institutions that gave particular attention to photography, and rare the individual who recognized the value of photography as historical document or could intuit the specificity of its language within the broader field of visual arts. And, if this situation changed for the better in Brazil, the credit must be given, in great part, to Gilberto Ferrez. Since those early days, he has bent over backwards to gain recognition, here and abroad, for the profound originality and technical mastery of our photographers.

With quixotic persistence (he has the slenderness and determination of Cervantes's hero, but, fortunately, not the naïveté), he strove to destroy the windmills of our proverbial apathy. He was responsible for works of primary importance for the promotion of Brazilian photography, such as the exhibition and book of the same name, *Pioneer Photographers of Brazil*—organized with Weston Naef, then curator of New York's Metropolitan Museum.

In spite of all this work on behalf of photography, one must remember that, for the author, this is only one among a universe of major preoccupations; as art critic Mário Barata noted: "We can say, on behalf of everyone, that we are proud that our generation has had a Ferrez to give us detailed and patient works, of a Benedictine fervor, in the field of iconography, historical topography, the history of photography, and who has even delved into bibliophily, the history of engraving, and published much information on painting in Brazil."[1]

In truth, Ferrez's fundamental interest, that which motivates all his works, is the history of Brazil through the iconography of her cities. He acknowledges that all his efforts have been in the direction of opening the eyes of Brazilians to the beauty of their cities and the wealth of their traditions.

He was revolted by Brazilians' indifference toward their own country when he began to study the history of Rio de Janeiro. At that time, he was using iconography only as supporting material for his research. Then, an unexpected gift from his father guided his steps toward the path that he travels today, the study of Brazilian iconography. Impressed by his dedication, his father turned over to him an unsuspected treasure: hundreds of negative plates made by his grandfather, photographer Marc Ferrez. Gilberto had these printed at the time, around 1935, by a former employee of his grandfather. The negatives would become the beginning of his collection, which has grown to such a dimension today that it could come to serve as the nucleus of a future museum of Brazilian photography.

His preference is for the documentary work of landscape photographers, "those who, working outside the studios, left us views and panoramas" that replaced academic painting as a dependable reference to the evolution of the appearance of our cities. Ferrez considers this kind of photography as formal proof "that leaves no doubts"; a kind of more efficient substitute for text, allowing a more complete and rapid comprehension of a given reality "relieving us from the reading of descriptions that are sometimes long and tedious." This approach, I should point out, reduces photography to only one of its possibilities, neither more, nor less, valuable than its many others. Ferrez's personal preference for outdoor, documentary photography is the reason for the numerical predominance, in this volume, of urban and rural views over the many other photographic genres, and the determining factor in the division of the book into chapters devoted to particular states—enlarged from the original essay to include extensive material on the city of Petrópolis, and a separate chapter dedicated to the photographer Marc Ferrez.

The special attention given Petrópolis has a simple rationale: Imperial city, site of the summer residence of the Emperor (an ardent admirer of photography), Petrópolis became a natural attraction for photographers, who had in the court a guaranteed clientele. The prominence accorded Marc Ferrez comes from the original structure of the 1947 work, published under the title *A Fotografia no Brasil e um de seus mais fiéis servidores, Marc Ferrez* (*Photography in Brazil and one of its most loyal servants, Marc Ferrez*). Yet, even if motivated in the first instance by family relationship, this emphasis is justified, since Ferrez was undoubtedly one of the best landscape photographers of all times, combining technical mastery with aesthetic sensibility of impeccable delicacy.

Not all of the Brazilian states are represented here. Some are left out because they did not even exist politically during the period covered by this book, others because no trace of photographic activity relevant to the period in question has been found. Still others are missing because the historian does not have enough information to dedicate a separate chapter to those areas—reserving for himself the right to include new chapters in future editions.[2] Rio de Janeiro dominates the volume since it was the city where photography was introduced in Brazil in the first place, spreading rapidly from there throughout the rest of the country. The reader should remember that Rio was the most important city in the country at that time, with a population greater than that of other urban centers. The census of 1872 indicates, for example, that its population of 272,972 inhabitants was twice that of Bahia and Pernambuco, while São Paulo was only in its infancy, recording 31,000 residents. These densely populated areas attracted a proportional number of photographers. The *Almanak Laemmert* of 1863 already recorded the existence of thirty photographic studios in the city, at a time little more than two decades after the invention of photography.

The attribution of dates constitutes a grave problem for the serious historian, and Gilberto Ferrez tells us that after years of dealing with this difficult problem, he was able to pinpoint the dates in which the photographs were made, allowing a narrow margin of error—five years more or less. He was able to do this thanks, above all, to the existence of information referring to the construction of buildings that appear in the photographs.

As for other information given in the captions, I should point out that, wherever possible, the photographers' names are given. Lacking that information, the studio names are cited. We adopted the form of the name used by the photographers or studios themselves. For example: Augusto Riedel, in full, or only J. Gutierrez, since he preferred to sign his photos this way.

The photographic process employed, when known, follows the photographer's name. In the case of reproductions where nothing was known about the original, we used the indication *pni*—process not identified. For the photographs of Marc Ferrez, the original prints made by the photographer himself have greater contrast and a wider range of tonal gradation and delicacy than those prints made from the original negatives in the 1930s or later, commissioned by Gilberto Ferrez. This fact results, undoubtedly, from the inferior technical mastery of many laboratory technicians, together with the use of modern photographic paper, which differs in its chemical make-up from that employed in Marc Ferrez's times.

The dimensions are given in centimeters, height preceeding width. In the case of photographs printed by an unidentified process (*pni*), the size of the copy print used for this book has been placed in parentheses, making many of the measurements approximate. We also opted to abbreviate the name of the collections in which the photographs are found, giving their names in full on the first page, together with the abbreviations assigned.

To conclude, I can only hope that this book (modestly qualified by Gilberto Ferrez as "a drop in the ocean," but more truly a sea in the ocean of the history of Brazilian photography) serves to encourage more scholars to turn their attention to our photographic past, offering them an indispensable base and an aid for contemporary studies, and an ever-clearer and more complete picture of Brazilian photography.

Pedro Vasquez

Notes

1. Mário Barata, "O mérito da obra de Gilberto Ferrez." *Jornal do Comércio*, Rio de Janeiro, October 6, 1969.

2. Aware of the difficulty of undertaking a global study of the history of photograpy in a country as vast as ours, the Instituto Nacional da Fotografia has fostered cooperation with state and municipal institutions, since 1982, in carrying out this study at the state and regional level, thus allowing for the future elaboration of a more comprehensive panorama of the history of photography at the national level.

Prologue

The present revised and enlarged second edition, like the first, is not a a catalog of photographs. Rather, it has been my intention to point out the most representative figures among the country's photographic artists, placing special emphasis on the landscape photographers who, working outside the studios, left us views and panoramas.

Today, only the oldest among us remember these photographers. Yet, their works have been reproduced numerous times in books, newpapers, and magazines, both in Brazil and abroad by authors who, with few exceptions, did not bother to mention them. Even today, as in the past, lithographers, draftsmen, and painters copy the works of these photographers without anyone's taking the trouble to cite their names.

In this happy era of amateur photographers (initiated in 1888 by Eastman with his first Kodak box camera, and expanded through the continuous improvement of lenses, negatives, and papers), when photography is within the reach of everyone, it is difficult to appreciate the nature of the art—and the work of the photographer—in the period from 1840 to 1900.

From the study of all the material reproduced here, one can conclude that the evolution of photographic technique in Brazil followed closely, with only the time lapse required by a voyage, all that was happening in the world, and that Brazil had photographic artists equal to the best of those in the great centers where the course of the new invention was charted: France, England, Germany, the United States of America. Even the provinces paid careful attention to these novelties as they appeared.

The difference lies in the material that survived and has come down to us. This is our weak point, especially in regard to daguerreotype views and panoramas. What exists today, preserved in libraries, museums, and archives, both institutional and private, in those countries mentioned above, as well as in Holland, is infinitely superior to what exists in Brazil. In Europe and the U.S., complete collections of all the equipment that would have been found in photographic studios is conserved. Here in Brazil, almost nothing. To appreciate the difference, one has only to visit the collections of the Musée des Arts et Métiers and those of the Société Française de Photographie in Paris, the Musée de la Photographie de Biévre, the magnificent Kodak Museum in Harrow, the British Museum, or the Royal Photographic Society of Great Britain in Bath, the International Museum of Photography at the George Eastman House in Rochester, New York, or the Gernsheim Collection at the University of Texas, not to mention a number of private collections.

As for daguerreotype portraits and photographs, we have some good collections, such as that of Francisco Rodrigues, acquired by the Museu do Açúcar in Recife, the collections of D. Pedro, D. João, and D. Teresa de Orleans e Brangança, the albums belonging to families such as those of Joaquim Nabuco and Joaquim de Sousa Leão, those in the Biblioteca Nacional, the Museu Imperial, the Museu Histórico Nacional, and the Instituto Histórico e Geográfico Brasileiro, aside from other, smaller scale collections of individuals. This material has been best used by the historian José Wanderley Pinho, in his work *Salões e damas do Segundo Reinado.*

We are impoverished in daguerreotype views or panoramas. Let it suffice to say that in forty years of research, I have succeeded in locating only the three views reproduced in this book, thanks to D. Pedro II. In this category, the Europeans and Americans, in spite of having lost valuable collections through neglect and, especially, fire, possess extraordinary and extensive archives.

As for views and panoramas in negatives or positives on paper, we still have many precious things in the museums and libraries already mentioned and in collections maintained by organizations such as the Ministério das Relações Exteriores, the Arquivo Nacional, the Arquivo da Cidade do Rio de Janeiro, the Museu Paulista, the Museu Mariano Procópio, the Biblioteca Municipal de Petrópolis, the Archives of the Prefeitura de São Paulo, and the Iconography Section of the Divisão de Documentação Social e Estatística de São Paulo. I should also mention the archive of the old Light & Power Company, and private collections, such as those of Coleção Malta, Américo Jacobina Lacombe, Wanderley Pinho (now in the Instituto Histórico e Geográfico Brasileiro), and the author, who owns, in addition to the photographs of Marc Ferrez, his negative plates and more than thirty albums of vintage prints made by various photographers, dating from 1860 to 1940.

Much more existed. Termites, humidity, carelessness, and lack of interest and space destroyed many fine things, but what remains is precious and begs the urgent reproduction and dissemination it deserves. If not, we will soon lose more of this fabulous resource, indispensable for the accurate study of the historical and social evolution of our principal cities. These materials are already a hundred years old; there is no guarantee that they will endure so many more. Adding to the importance of these materials is the fact that, with the advent of abstract painting and the almost complete disappearance of figurative painting, the only remaining visual medium for the study of the urban scene is photography.

The study of history through photography is only beginning in some places. From this standpoint, what we have is valuable, since it helps us to understand the radical transformations that are operating in our great urban centers, primarily from 1940 on. To examine carefully one of these photographs is to see what a world of things can be learned in an instant, relieving us from the reading of descriptions that are sometimes long and tedious and that, as detailed and accurate as they might be, do not enable us to visualize a period that we never knew. There in the photographs are the architecture, vegetation, civil, military, and religious costumes, means of transportation, illumination, paving, habits and customs, and celebrations of a bygone era. In short, the photograph contains life's realities, captured in momentary segments, to the delight of the contemporary viewer. The reader will get an idea of how documentary photography can be used in historical studies by consulting the works that I published in the *Revista do Instituto Histórico e Geográfico Brasileiro*, volumes 268 and 278.

A good part of the material reproduced in this book was included in the first exhibition of Brazilian photography that, with the support of my friend Haskel Hoffenberg, was held in New York in 1976, opening on September 14. The exhibition was sponsored by the Center for Inter-American Relations, which was also responsible for the publication of a book with the same title as the show, *Pioneer Photographers of Brazil 1840–1920*. That text is the product of my collaboration with Weston J. Naef, renowned scholar of photography and then curator of the photographic archive of the Metropolitan Museum of Art.

This exhibition opened at the Museu de Arte de São Paulo in 1978 and, the following year, at the Museu Nacional de Belas-Artes do Rio de Janeiro. As we hoped, the reaction to this show, both in Brazil and abroad, demonstrated that, at last, the inestimable historical and artistic value of this material was beginning to be realized, along with the necessity for preserving it and bringing it into the national patrimony.

The hope that I may be contributing to this objective has motivated me to take up this text once more—the first version of which long ago went out of print—and to enlarge it in a number of areas. In doing so, I hope to facilitate the contact of today's readers with the most representative works and figures of the history of photography in Brazil. I would like to thank the publishers of the Brazilian edition of this book, Fundação Nacional de Arte/Fundação Nacional Pró-Memória, and the editorial team that worked on it: Pedro Vasquez, João de Souza Leite, Solange Garcia de Zuñiga, and Vera Bernardes.

As on other occasions, many people and institutions placed their collections and archives at my disposal: the Biblioteca Nacional, Instituto Histórico e Geográfico Brasileiro, Museu Histórico Nacional, Mapoteca do Itamarati, Prince D. Pedro de Orleans e Bragança, Américo Jacobina Lacombe, and the Subsecretaria do Patrimônio Histórico e Artístico Nacional. To all, I express here my most sincere thanks.

Gilberto Ferrez
Rio, January 1983

The first line of each caption indicates, in order, the name of the photographer or studio that made the photograph, the process employed, the dimensions of the original print (height by width), and the initials of the person or institution in possession of the photograph. In cases where it was not possible to reproduce the original photograph, the dimensions of the copy used are given in parentheses.

Identification:

AJL Américo Jacobina Lacombe

BN Biblioteca Nacional, Rio de Janeiro

mc modern copy print from the original
 glass-plate negative

DJOB Dom João de Orleans e Bragança (private collection)

DPHOB Dom Pedro Henrique de Orleans e Bragança

DPOB Dom Pedro de Orleans e Bragança (private collection)

FJN Fundação Joaquim Nabuco, Recife

GF Gilberto Ferrez (private collection)

I Palácio do Itamaraty, Rio de Janeiro

IHGB Instituto Histórico e Geográfico
 Brasileiro, Rio de Janeiro

MI Museu Imperial, Petrópolis

SPHAN Subsecretaria do Patrimônio Histórico e
 Artístico Nacional, Rio de Janeiro

pni process not identified

Photography in Brazil
1840–1900

Rio de Janeiro

In January 1840, the Franco-Belgian corvette *L'Orientale* called at the port of Rio de Janeiro. The school-ship, commanded by Captain Lucas, was on a voyage around the globe.

Traveling aboard was a chaplain named Louis Compte, who ventured to reveal to the world that astonishing marvel of the age: a certain mechanical apparatus that captured light and fixed the images of persons and things, just as nature had created them, in perfect miniatures. This was daguerreotypy, an early form of photography and the invention of two Frenchmen: Joseph Nicéphore Nièpce and the painter Louis-Jacques Mandé Daguerre.

It was Compte who first revealed to Brazilians the most popular invention of the last century, one that has revolutionized the world, expanding our awareness and imposing itself into every aspect of our lives. It was photography, after all, that enabled us to accompany the astronauts to the moon and to see, on the return trip, that memorable photograph of Earth, all blue and wrapped in clouds. Undeniably, the medium has traveled a great distance from its beginnings, some 150 years ago.

The first demonstrations of daguerreotypy in Brazil took place on January 17, 1840, in the best hotel in the city of Rio de Janeiro, the Hotel Pharoux, which had been inaugurated two years before in the Largo do Paço.[1] Reporting the occasion, the columnist of the *Jornal do Commercio* expressed his amazement:

> At last the daguerrotype [sic] has come to us from across the sea; and photography, until now known only in theory in Rio de Janeiro, is here in fact and the facts exceed what we have read about it in the newspapers as much as life exceeds a painting.[2] This morning, an extremely interesting photographic experiment was carried out at the hotel Pharoux, being the first time that this new marvel has appeared to the eyes of Brazilians. The experiment was conducted by the abbot Combes [sic], one of the travelers aboard the the French corvette L'Orientale, who brought with him the ingenious instrument of Daguerre. [Ingenious] because of the facility with which, by means of it, one may obtain the representation of objects whose images one wishes to preserve.

> It is necessary to have seen this thing with one's own eyes to appreciate the rapidity and the result of the operation. In less than nine minutes, the fountain of the Largo do Paço, the Praça do Peixe, the monastery of São Bento, and all the other surrounding objects were reproduced with such fidelity, precision, and detail that it was readily apparent that the thing had been made by the very hand of nature, almost without the intervention of the artist.

> It is unnecessary to exaggerate the importance of this discovery which I have mentioned to the readers [of this newspaper] before: the simple exposition of fact says more than any exaggeration.

The writer made a slight mistake with the name of the daguerreotypist, calling him Combes.[3] Thanks to the work of José Maria Fernández Saldaña and Julio F. Riobó,[4] we know today that the correct name is Louis Compte and that, before laying anchor in Rio, the ship *L'Orientale* made a stop in Bahia. However, no record has been found that the "new art" was demonstrated there.[5]

The three precious originals of Father Compte, iconographic pieces of the greatest historical value, have been carefully preserved. It was a fortunate circumstance that, at the time the the first edition of this book was in preparation, these daguerreotypes were brought to Brazil from the castle d'Eu in France. There, they had been kept by Prince Dom Pedro Gastão d'Orleans e Brangança, to whom Brazil owes the recuperation of documents of the highest value. In one of these daguerreotypes, the Paço da Cidade appears with a group of soldiers in formation before it, at what must have been the moment of arrival or departure of the Emperor Dom Pedro II.[6] This piece is of extraordinary value for the world history of photography, since historians believed that the earliest known daguerreotype view of a public event dated from 1859. It should be remembered that the daguerreotype required a rather long pose, during which the subjects had to remain absolutely motionless. Otherwise, the resulting image would be blurred. The instantaneous photograph only became possible at the end of the nineteenth century.

According to Michel Braive (one of the best and certainly the most subtle of historians of photography), until 1945 scholars believed that the first instantaneous photographs of people were taken when victorious French troops were depicted marching through Paris after their return from Italy in 1859.[7] Yet, he states:

> If, however, studies in the history of photography of other countries are consulted, it can be verified that this instantaneous photograph of 1859, spectacular as it is, was not the first. There were other documents that could be qualified as instantaneous photographs, in spirit if not in form. . . . In the book by the American scholar Taft, there is a daguerreotype of the Mexican War, made in 1846. The horsemen are blurred, but one can see that they are soldiers. In the Catalog of the Institute of Graphic Arts of Vienna, a view of a group in Joseph of Vienna Square can be found. The photograph was made by a certain Nattereh and dated 1841.[8] Although blurred and taken from a distance, it clearly manifests the photographer's desire to include people in the scene. In a study by Gilberto Ferrez on daguerreotypy in Brazil, there are also views of people, distant and vague. Still, the photographer did not eschew [shooting on] busy streets, something that was never done in the United States of America.

Braive's allusion to the United States is natural since, from the beginning of daguerreotypy, the Americans were not only the greatest enthusiasts of this invention, but also produced several of the best daguerreotypists. This, however, does not preclude the fact that in distant, less well-equipped places, extraordinary images were obtained, such as the daguerreotypes taken in Brazil in 1840. It is quite possible that these are the oldest known daguerreotype landscapes in the world. It should be emphasized that they were taken in mid-summer—January—when the luminosity of a clear day with a cloudless sky is very intense in Rio. Moreover, the daguerreotype of the Paço da Cidade, with people in the street, was made from a distance. In Braive's opinion, this certainly allowed the exposure to be made in a much shorter time than would have normally been possible in Europe.

But, returning to the other precious daguerreotypes of Father Compte, the second depicts the fountain of Master Valentim, with the façade of the old market designed by the architect of the French Mission, Grandjean de Montigny, and the towers of the Church of Candelária.[9] The third daguerreotype shows the Praia do Peixe, with boats in the foreground, and the Monastery of São Bento in the background.

The three, all in their original cases of wine-colored leather measuring about eight by six centimeters, are well preserved. In accordance with the customary practice, these daguerreotypes were not dated. However, the description given in the *Jornal do Commercio* of the places depicted corresponds to the images fixed on the plates. For this reason, certainly, they were kept so carefully preserved by Dom Pedro II and his descendents (see figures 2, 3, and 4).

A few days after the demonstrations of daguerreotypy in the Hotel Pharoux, the apparatus was demonstrated for the Emperor and Their Imperial Highnesses. All were enchanted to see, fixed on the daguerreotype plate in just nine minutes, the façade of the palace (taken from a window in the small tower) and, soon after, a view taken from the veranda.[10]

2. Louis Compte daguerreotype 7 × 9 cm DPOB
Enlarged reproduction of the first daguerreotype made in South America, in January 1840. Rio de Janeiro: the Paço da Cidade, with troops formed in front. In the background, at left, the tower of the Capela Imperial; at center, the provisionary bell tower of the Igreja da Ordem Terceira do Monte do Carmo; at right, the Hotel de France.

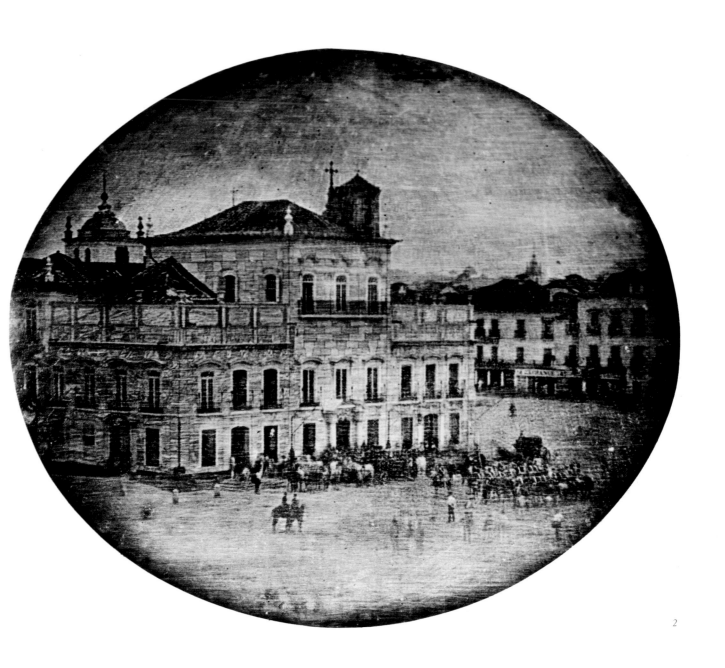

Thus, the daguerreotype was introduced to the *fluminenses* [river-dwellers], as the citizens of the city of Rio de Janeiro were known at that time. It should be noted, however, that other newspapers and periodicals did not give the slighest notice to the fact. *O Diário do Rio de Janeiro*, which at that time was just as important as the *Jornal do Commercio*, wrote nothing of the event. While there is no record in the appropriate section concerning the arrival or the departure of the ship, the newspaper did complain of the misbehavior of several sailors from the *Orientale* who caused disturbances in the streets. The very rare *Revue Française*—with its pompous epigraph: *"Littérature, Sciences, Beaux-Arts, Politiques, Commerce,"* and an engraving by the editor, C. H. Furcy, in each monthly issue—reported in its news section the Emperor's visit to the Academy of Fine Arts exhibition on December 17, 1839, as well as the arrival in Le Havre of the French naturalist Guilmain who brought with him seedlings of tea plants that he had learned to grow and process in Brazil. Yet, it did not mention a word about the first demonstration, made by a Frenchman, of a French invention in Rio de Janeiro! Even the *Revista do Instituto Histórico e Geográfico Brasileiro*, whose fourth issue was announced in the *Diário do Rio de Janeiro* on January 27, 1840, did not consider it interesting to record this historic event in its pages. Nor did the *Museu Universal* write anything on the subject. This almost absolute silence of the press about the daguerreotypes of Father Compte contrasts with the outburst of interest in the graphic arts attested by the reports and announcements published in the same period.

As for the corvette *L'Orientale,* she continued her trip to Montevideo where the demonstrations of daguerreotypy made quite an impact. The repercussions reached as far as Buenos Aires, where the ship was unable to lay anchor due to local political turmoil, aggravated by the French Navy's blockade of the port. While heading south and toward the Pacific Ocean, the *Orientale* was shipwrecked off the port of Valparaíso during a storm. Fortunately, all aboard were rescued.[11]

So, what was the daguerreotype, this seemingly magical invention that married art and science?

Mr. Arago described the process of Daguerre to the Academy of Sciences in Paris thus:

> A plate of metal (copper and silver), well-cleaned with diluted nitric acid, is exposed to the vapor of iodine. . . . Thus prepared, the plate is exposed to the action of light at the focal point of the camera obscura, and removed after eight minutes. The most experienced eye cannot distinguish anything whatever. However, on exposing the plate to the vapors of mercury heated to 60 degrees, the miniatures appear as if by magic. Extraordinary and inexplicable! The plate at the focal point of the camera obscura must be placed in an inclined position.[12]

Thanks to a gesture on the part of the French government that placed the process in the public domain, as well as to the business acumen of the inventor, daguerreotypy so captured the imagination of our forefathers that it soon spread around the world. Not only did the process arrive in Brazil just five months after its official announcement in Paris, but on November 23 of the same year, 1840, the *Jornal do Commercio* published the following announcement: *"Daguerreotypes*—This instrument, with which views and portraits of extraordinary exactitude may be made without any knowledge of draftsmanship, is available for purchase, along with a brochure of instructions for its use, at 90A Rua Ouvidor."

3. Louis Compte daguerreotype 7 × 9 cm DPOB Rio de Janeiro, 1840: the Candelária market, designed by Grandjean de Montigny, demolished in 1911. In the distance, the Mosteiro de São Bento.

4. Louis Compte daguerreotype 9 × 7 cm DPOB Rio de Janeiro, 1840: the fountain of Mestre Valentim and the façade of the market in the Largo do Paço; in the background, the towers of the Igreja da Candelária.

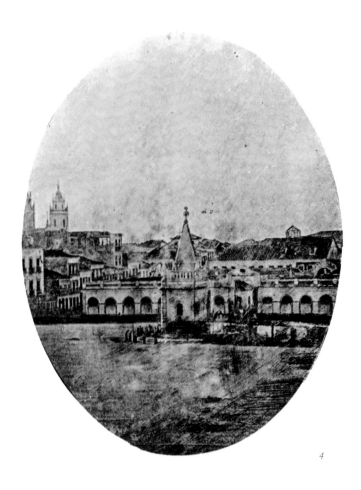

4

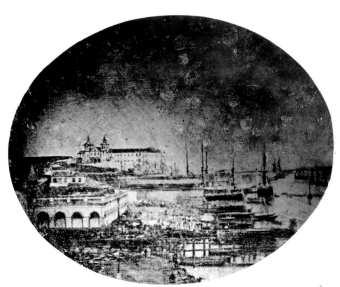

3

The Emperor himself, then only fourteen years old, was so enraptured with the invention that in March 1840—eight months after the announcement in Paris transcribed above—he acquired a camera from Felício Luzaghy for 250 *mil-réis* becoming, probably, the first Brazilian to make daguerreotypes.[13] The fact that Dom Pedro II undertook early on to familiarize himself with the camera and that he used it with relative frequency prompted Prince Adalbert of Prussia to write in his diary on September 8, 1842: "The Emperor has already made several experiments with daguerreotypy and given me his opinion that luck plays a great part in this process, with which I agree."[14] Dom Pedro's fascination with photography never left him. Of his own work, several photographs are known, the most interesting being a self-portrait on the back of which is inscribed in his unmistakable handwriting: "photograph taken by myself" (Fig. 5). Throughout his life, he collected photographs of his family, friends, and visitors to Brazil. He accumulated numerous albums, most of which are in the the collection of Empress Teresa Cristina which was given to the National Library in Rio de Janeiro.[15]

Soon professionals and amateurs of the new art began to appear in every part of Rio de Janeiro. Among the first of these was the Argentine immigrant Don Florencio Varella, who had witnessed the first demonstrations of daguerreotypy in Montevideo. Varella's evaluation of the importance of this invention and his enthusiastic account of the demonstrations were recorded in the local newspaper *El Correo* and in his letter to a resident of Buenos Aires.[16]

Another of the first devotees of the new art was Mrs. Hippolyte Lavenue, who showed several daguerreotype portraits in the 1842 Exhibition of the Imperial Academy of Fine Arts.[17] The presence of these daguerreotypes in a fine arts exhibition sponsored by an academic institution in Rio de Janeiro, only three years after the official proclamation of its invention, is impressive. It is common knowledge that in other countries photography was only admitted to such salons at a much later date. In his monumental *Histoire de la Photographie*, Raymond Lécuyer reveals that it was difficult for photography to gain entry to the official exhibitions, being considered graphic art by scientists, and a product of physics and chemistry by artists. Photography was included in the Universal Exhibition of 1855, but only as a "poor cousin," since it was classed with

"Design and Arts Applied to Industry."[18]

It was also in 1842 that Augustus Morand, of New York, arrived in Brazil. With an associate or colleague named Smith, Morand established his business in the Hotel Pharoux. There, he received clients from eight o'clock in the morning until three o'clock in the afternoon. The advertisement published in the *Jornal do Commercio* on December 23, 25, and 27, 1842 (from which this information was taken) further informs us that: "The advertisers, being of the conviction that they are able to completely satisfy those who choose to honor them [with their patronage], invite lovers of the arts and all who desire to possess a perfect portrait, a family picture, or any view whatever, to visit their studio."

Writing in the same newspaper, an awe-struck journalist informed the public that: "We have visited the studio at Hotel Pharoux several times already, under varying conditions of sun, shade, and rain, and cannot cease to wonder at the extraordinary perfection to which Mr. Morand has brought the great discovery of Daguerre."[19] The writer's admiration was justified. Augustus Morand was one of the finest practitioners of daguerreotypy in the United States of America, where he learned the process as soon as it reached New York.

5. D. Pedro II calotype 10 × 6.2 cm DPOB
Self-portrait of the Emperor, taken at São Cristóvão palace in Rio de Janeiro, c. 1855. D. Pedro was the first Brazilian to acquire and use, only months after its invention, a daguerreotype camera.

6. Anonymous daguerreotype 12.5 × 9 cm DPOB
7. Anonymous daguerreotype 12.5 × 9 cm DPOB

The Emperor D. Pedro II and the Empress D. Teresa Cristina, c. 1850.

5

6

7

Morand and Smith were also received by Dom Pedro II in the Palace of São Cristóvão. There, they made portraits of the Emperor and his family, as well as views of the palace. Prince Adalbert of Prussia was probably referring to Morand when he wrote in the text previously cited: "His Majesty Dom Pedro II also very kindly presented me with two beautiful daguerreotyped views of São Cristóvão, taken by a foreign artist about whom he had spoken to me the evening before [September 7, 1842]."

In the magnificent book by the American scholar Beaumont Newhall, *The Daguerreotype in America*, there is an interesting biographical sketch of Morand, reprinted from the *Photographic Art Journal*. The passage was written by the Reverend Daniel Parish Kidder, author of two books about his long stay in Brazil.[20] In it, he recounts another meeting of Morand with Dom Pedro II:

> It was the custom of the Emperor to visit, every Saturday morning, his Palace in the city. One of these occasions he [Morand] conceived to be an excellent opportunity for producing a fine picture of the Emperor with the body guard and splendid equipage. Having prepared his plates at an early hour, he awaited their arrival. At the usual time the guard drew near in advance of the Emperor's carriage; the instant it halted, and while the Emperor was in the act of stepping out of his carriage, Mr. M. exposed his plate, and in a second of time, procured a truly beautiful picture.
>
> The body guard composed of forty horsemen, were with but one or two exceptions all perfect, also the "Major Domo" in the act of kneeling to kiss the Emperor's hand as he stepped from the carriage. The likeness of the Emperor himself was very correct.
>
> The whole time consumed in taking, finishing, and framing the picture was less than forty minutes from when he arrived at the Palace. The Emperor doubted the fact, until his attention was called to the carriage in the plate, when he immediately assented, for it was the one presented to him by Queen Victoria, and one that he had not used for several months previous. The Emperor was in raptures with the picture and ordered that it should be hung in the Imperial Gallery, where it now remains, a testimonial of the enterprise and skill of our American artist. Mr. Morand's studio was enriched by many views taken from the most beautiful sites around Rio de Janeiro—and but for feeble health, a complete Daguerrean Panorama would have been the result of his abode within the tropics.[21]

What could have happened to these precious daguerreotypes made in 1842, in which even the young emperor and the beautiful carriage presented to him by Queen Victoria can be recognized, and which include *people and horses* in the view?

Before leaving Rio de Janeiro, Augustus Morand and Smith transferred their studio to J. D. Davis, according to an advertisement found in the *Jornal do Commercio*, dated May 3, 1843. In this same period, other Americans in Brazil were Henry Schmidt and J. Elliot.[22]

Having briefly discussed the origins of photography in Rio de Janeiro, it is appropriate, at this point, to mention Hercules Florence. A native of Nice, France, he settled in Brazil and established a family there. He died in Campinas on March 27, 1879, after having lived in Brazil for almost fifty years. Florence was a talented draftsman, and in this capacity accompanied the scientific expedition of Baron Langsdorff from Tietê to Amazonas.[23] Despite his inventiveness, he was, unfortunately, unable to bring his work with photography to fruition under the conditions that existed in Campinas at that time.

Since the publication of Boris Kossoy's study, the inclusion of Florence among the pioneers of photography has become obligatory.[24] By 1832, he had already constructed a portable camera obscura, which he used to produce both negatives and positive images, coined the word *photography*, formulated the basic principles of the process, and foresaw its possible applications. In spite of this, he did not succeed, as he candidly confessed in declarations to newspapers in São Paulo and Rio de Janeiro, in correctly or permanently fixing his photographs. Because he was really more interested in discovering a means of reproduction that would be simpler, faster, and—especially—cheaper than printing, he devoted more attention to this goal, inventing a "polygraph" that he hoped would replace lithography.

In an article published in the São Paulo newspaper *Phenix* on October 26, 1839, and transcribed in the *Jornal do Commercio* in Rio on December 29 of the same year, Florence wrote:

I have just learned that in Germany prints have been made by means of light, and that in Paris the fixation of images of great perfection is being attained. As I dealt little with photography for want of more sophisticated methods and sufficient knowledge of chemistry, I do not contest the discoveries of anyone since the same idea may occur to two people, [because] I always found uncertainty in the conclusions that I reached, [and moreover, because I believe that] everyone should receive his just dues. Yet, I am making the claim of precedence in respect to the polygraph . . . so that its inventor will be forever recognized.

Is it possible that the impact of the news of Father Compte's daguerreotypes compelled Florence to come forward? He wrote in the same newspaper on February 10, 1840:

I do not know if anyone might have concluded from this recent news that I confused polygraphy, an invention entirely my own, with photography, to whose invention I make not the slightest pretension after learning what has taken place in Europe in this regard. It is a fact that I had already made use of photography, years ago, [as an aid] for drawing; and that, in 1834, I did this in the presence of Messrs. Riedel and Lunt, who took several of my photographed works with them. And, since it was never reported to me until August of 1839 that these same or better experiments had been conducted in Europe, perhaps it would not be overly bold to say that I invented photography; nor was the name new to me when I saw it in the papers in Rio de Janeiro; but the truth is that I did not persist in my experiments, and, for this reason, I do not wish to attribute to myself a discovery to which another might be better entitled. . . .

The author shares the opinion that it would not be "overly bold" to place Florence—as Kossoy has—among the "international precursors of photography, and the first in the Americas."

A new and important field in which photography was destined to play a role was foreshadowed in an article that appeared in a Rio newspaper in 1843. In its "Miscellaneous" section, the *Diario do Rio de Janeiro* of November 22 placed this interesting note under the rubric "Improved daguerreotypes and passports:"

Prof. Bottiger, of Frankfurt, has discovered a method of making daguerreotypes in color, as simple and rapid as the ordinary process; however, it is only possible at present to reproduce three colors.

The first complete experiment made was a portrait of Baron von Humboldt, that is said to be excellent.

If the operation could be made with paper instead of metallic plates, the police might make good use of this discovery, requiring that every passport bear a daguerreotyped portrait of the holder. In China, the higher authorities sometimes send to local ones the portrait of a criminal or suspect, in order to facilitate capture.

Of Bottiger's experiment, the author of this book has never seen any reference in those works specialized in the history of photography. Yet, his suggestion, made in 1843, for the use of photographs on passports, seems to be the earliest.

From 1844 on, the number of itinerant daguerreotypists grew to the point that in the same establisment, Hotel de Itália at Praça da Constituição, there were two artists offering their services to the public. They were the Englishman Yeanne, or Jeanne, from London, and Joseph Chauvin, from Paris. Both advertised in the *Jornal do Commercio*, expounding the perfection, originality, speed, and moderate prices of their services. They made portraits of groups or individuals in fifteen seconds for prices that varied from four to eight *mil-réis*, depending upon the size of the picture. Since both worked on the same premises—and even on the same veranda—they emphasized in their advertisements that one was installed at the entrance, the other at the end of the terrace and that the public should not confuse them.[25] Also working in Rio at that time were the Germans Conrad Gerbig and Hoffman & Keller.[26] Such was the interest in daguerreotypy.

Seeing the success of the new invention and its impact on their earnings, painters were led to join the movement that was rapidly enriching so many others. The first of these about whom we have information was Francisco Napoleão Bautz, who arrived in Brazil in 1839.[27] The painter of a number of estimable canvases, he was advertising his daguerreotype studio at 146 Rua do Cano (the present Rua 7 do Setembro) as early as January 1846: "F.N. Bautz, portrait painter, has just opened a studio for the making of portraits, toned or colored, in accordance with the latest improvements of this apparatus. The facilities are of the most appropriate nature; and portraits are taken in less than a minute in any weather."[28]

The comment that portraits could be made under any weather conditions in less than one minute is interesting, since it indicates that seven years after the invention of the daguerreotype, it was already perfected to the point that pictures could be made with a very short exposure time on a cloudy day.

The same Bautz, back from Europe and installed in the same location, announced in 1850 that he "continues to make portraits, toned or colored . . . using plates from one palm in length to the size of the buttons on a shirt. Only those portraits that please [the customer] will be delivered." He also gave "lessons in making portraits by all methods."[29]

Three "offices" offering "toned or colored" portraits taken in less than a minute and lessons in "the apparatus" are listed for the first time in the *Almanak Laemmert* of 1847, under the heading "Daguerreotypes." The *Jornal do Commercio* contained the following entry on June 15, 1848:

> Colored Portraits—Photographic, awarded prizes in the United States. This incomparable establishment, the largest and oldest of the United States (which was false), where portraits are made by an entirely new and previously unknown system, is now open at 56 Rua do Ouvidor. Lovers of the fine arts are invited to visit it and to examine the beautiful collection of portraits, whose loveliness and fine finish is such that the photographer challenges the masters, wherever they might be, to present works of equal perfection. W. R. Williams, professor of photography.[30]

Guilherme Auler (writing under the pseudonym Ricardo Martim) published, in 1955, the results of his research in the Imperial Account Books. Among other important things, he revealed that the daguer-

reotypists Buvelot & Prat made two brief sojourns in Petrópolis in 1851, the first from February 25 to March 14, and the second from April 9 to 15. During these periods, they made daguerreotype views of the city.[31] Although the whereabouts of these works are unknown, we do know that Dom Pedro II was so pleased with them that in March 1851 he issued a permit giving the daguerreotypists permission to use the Imperial Coat of Arms on the façade of their offices. Buvelot & Prat were located at 36 Rua dos Latoeiros (present-day Gonçalves Dias).[32] Mello Moraes Filho called them "Beauvelot e Duprat."[33]

The *Almanak Laemmert* of 1854 contains an entry for "Buvelot's Imperial Studio," giving the address cited above, which leads us to assume that Buvelot was the sole proprietor of the business at that time. Moreover, mention of this studio had appeared, without proprietor's name, in the same almanack since 1847 and in the *Jornal do Commercio* since 1845.

Buvelot was the well-known painter Louis-Abraham Buvelot, born in Morge, Switzerland, in 1814. In the double role of painter and daguerreotypist, he went first to Bahia, arriving in Rio in 1840. Several oil paintings by this artist and a beautiful and very rare album that he made in collaboration with Louis Auguste Moreau, have remained in Brazil.[34] Buvelot married in Rio and fathered a daughter. In 1860, he went back to Switzerland, returning to Brazil in 1864. Finally, he traveled to Australia were he became that country's first great painter.[35] He died in Melbourne in 1888.

Another of the "professors" of daguerreotypy who worked in Brazil was Guilherme Telfer. Located upstairs at 126 Rua do Ouvidor, Telfer guaranteed his potential clients "an expression to the eyes so natural that no artist has yet been able to rival it."[36] He was the first to employ the word *photography* in his advertisements, doing so when he inaugurated his new studio at 34 Rua dos Ourives. On December 24, 1854, he made portraits of Their Imperial Majesties.[37]

Around 1850, the Hungarian photographers Biranyi and Kornis arrived in Rio de Janeiro. Of their work, only two very rare and valuable lithographs made after their daguerreotypes are known. The first is a view of the gas works at the Mangue landfill, taken shortly after their inauguration in 1854. The other, taken in 1856, shows the second balloon ascension in Brazil. The lithographs were made by L. Therier. The only surviving copies are in Rio de Janeiro, in the collections of the Biblioteca Nacional and the Instituto Histórico e Geográfico Brasileiro.

Carlos Kornis Totvarad—criminologist, polyglot, and artist—and Biranyi—professor from the University of Pest—were political exiles who earned their livings as daguerreotypists. Mello Moraes Filho described their studio thus:

> The daguerreotypy studio of Birany [sic] and Carlos Kornis at Rua de S. Pedro was simple, austere, and modest. In the front room, there were framed engravings, and a central table with bronze statuettes. . . . Frequented by a foreign elite, as well as by the illustrious personalities and families of the country, this establishment enjoyed a wide measure of public respect, due to the unusual competence of both artists.[38]

Beginning in December 1849, the newspapers in Rio de Janeiro wrote about a new invention: "daguerreotype on paper"; that is, photography as we understand it today. "Portraits on paper are true pictures that can be seen in any position, . . . having, moreover, the advantage of allowing an infinite number of copies to be made. These portraits are permanent . . ." and could be purchased at the studio, 233 Rua do Cano, for three *mil-réis* and up.

By saying that the pictures on paper could be seen in any position, the writer of the advertisement emphasized the principal advantage of the new process. It was the general opinion that the mirror-like surface was the greatest disadvantage of the daguerreotype, since the image could only be seen clearly when light fell upon it at a certain angle. The significance of the second advantage mentioned in the advertisement (the possibility of making multiple copies) is obvious if one remembers that the daguerreotype was a unique, positive image and, unlike a photographic negative, did not lend itself to reproduction.

The discovery of the collodion wet-plate process by the Englishman Frederick Scott Archer in 1851 was a boon to photography. This process consisted of covering a glass plate with a uniform layer of collodion. Immersion in a solution of silver nitrate sensitized the plate, which had to be exposed before the collodion dried, and developed immediately after exposure. It was a difficult and delicate procedure, especially out-of-doors, away from the studios.

The collodion wet-plate process spread rapidly and soon reached Brazil, where many people found it attractive, mainly daguerreotypists and painters. From 1853 on, Brazilian daguerreotypists began to study and apply this and other methods of photography, such as the albumen process, ambrotypy, and calotypy. The new techniques were almost always brought to Brazil by foreigners who had acquired them in their countries of origin. Around this time, Germans, French, North Americans, English, Swiss, Mexicans, and Austrians began to arrive in Brazil, where they established their photographic businesses in the principal cities of the Empire.

Most of these photographers worked exclusively with portraiture, which was—as it is today—more lucrative than view photography. However, there were several photographers, masters of the art of portraiture, who also dedicated themselves to making landscapes and cityscapes in the areas where they worked.

In "the Court," as Rio de Janeiro was then spoken of, daguerreotypists began to be called photographers around 1855 or 1856. Their number increased from three in 1847, to eleven in 1857, reaching thirty in 1864, according to the *Almanak Laemmert* for these dates. The following text deals with several of the better-known of these photographers, especially those who worked more in landscape and outdoor photography. Many became famous, and their names and works still survive.

Among these is Revert Henrique Klumb, photographer to Their Imperial Majesties and to the Imperial Academy of Fine Arts. Klumb arrived in Brazil in 1852 or 1853 and settled in Rio in 1855. In Prince Dom Pedro's rich collection of daguerreotypes, there is a magnificent example of Klumb's work: a double-sided portrait of Empress Teresa Cristina, in excellent condition. In its beautiful, original case and gilded mat with designs in low-relief, it is in perfect harmony with the taste of the period. In 1855, Klumb was already making photographic views around Rio de Janeiro and Petrópolis. The latter city so enchanted him that in 1859 he settled there permanently. Enlarging the scope of his activities, he made portraits of the distinguished personages who spent their summers in Petrópolis and organized exhibitions of his work where visitors, upon paying an entrance fee, acquired "the right to one framed copy of a portrait of themselves to be delivered within three days."[39]

Klumb made photographic views of Petrópolis and the surrounding region. A list of these views was published in a book in octavo entitled *Petrópolis e seus arrabaldes, tirados por R.H. Klumb, fotógrafo de SS.MM.II.* Some of these photographs were used to illustrate the delightful and rare little book *Viagem pitoresca a Petrópolis por *** attributed to Carlos Augusto Taunay, as well as the very rare *Doze horas em diligência, guia do viajante de Petrópolis a Juis de Fora . . . , por Rt. H. Klumb*, Rio, 1872.

The Empress was a good customer of Klumb, judging from invoices (presently located in the Imperial Archives in Petrópolis) that she paid to the studio on August 29, 1865. In the space of five months, she spent 480 *mil-réis* on portraits, views, and stereoscopic cards—a rather significant sum for the period.

In an article dated January 9, 1875, a critic writing in the Petrópolis newpaper *O Mercantil*, had this to say about Klumb and his work:

The exhibition of photographs to which we referred in an earlier issue has just opened. On a recent visit there, we could feel, after close and attentive examination, the palpable progress that has been made in the photographic art applied to landscape, especially when practiced by an artist with the initiative, talent, and perseverance of Mr. Klumb who, deservedly, is photographer to Their Imperial Majesties.

The landscapes, portraying almost all of Petrópolis's most picturesque places, are there to be seen—now directing our attention to the meanders, valleys, and mountains—now leading us to admire the beautiful skies that appear, in all their variety, on our horizon and whose mobility seems impossible to reproduce.

Some, depicting the night, are even more impressive when we realize that, until today, only one photographic artist has attempted this specialty, without great success.

Truly beautiful is picture no. 2 portraying the Imperial Palace, which seems to be touched by the pale and oblique light of the moon. . . . In the crowns of the trees and bushes that surround the palace, forms are delineated by a magnificent effect of light.

There are several other nocturnal landscapes that are very beautiful, such as those of the bank of the Piabanha River, the lower Palatinado, the Renânia cotton mill, etc. Mr. Klumb must have studied a great deal to achieve these superb results. . . .

Nevertheless, it was not easy to make a living in Petrópolis as a photographer. Klumb found it expedient to advertise that he also sold French and Portuguese wines of assorted qualities, at moderate prices.

In his book *Artistas do meu tempo*, one of the first to include information on painters and photographers, Mello Moraes Filho maintains that Klumb and a certain Afonso Rouel were fugitives from the French military service who arrived in Brazil armed with their camaras. Unknown and penniless, they became associates of the painter François Moreau, who had a studio on the corner of Rua do Rosário and Gonçalves Dias, "without having their names appear as owners of the business on the photographic mounts."[40]

8. Klumb albumen 8.7 × 5.4 cm DPOB
D. Pedro II, c. 1855.

9. Klumb albumen 9 × 5 cm DPOB
The Empress D. Teresa Cristina with children peering out from behind backdrop, c. 1866.

8

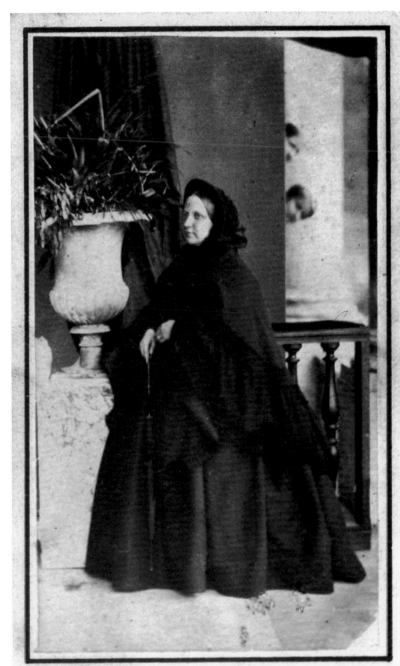

9

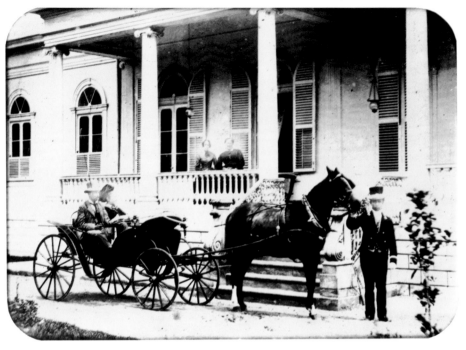

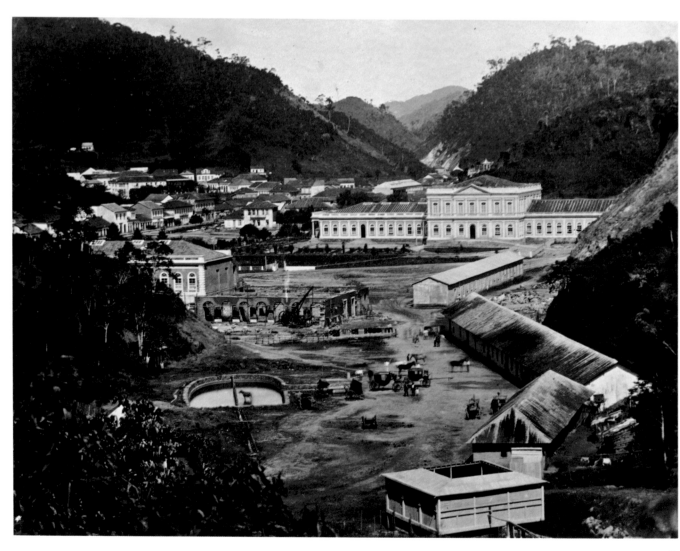

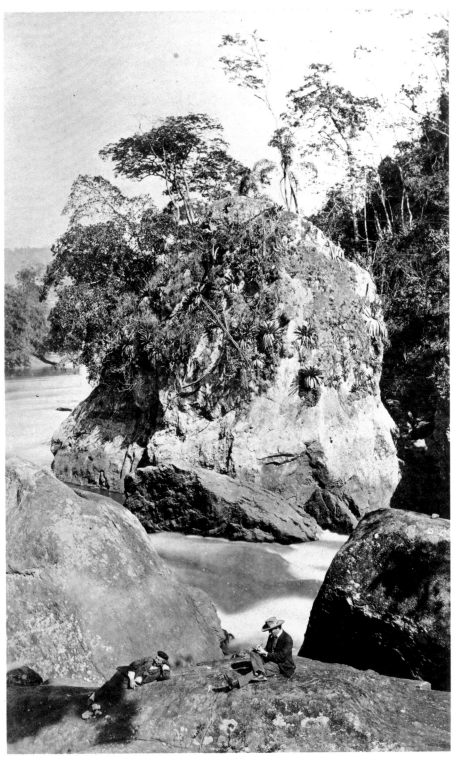

12

10. *Klumb albumen DPOB*
Princess Isabel and the Count d'Eu leaving their resi-
dence in Petrópolis, 1870. Today the house is the head-
quarters of the Cia. Imobilária de Petrópolis.

11. *Klumb albumen 16.5 × 22 cm GF*
Palćio Imperial, in Petrópolis, c. 1865. Photograph taken
from what is now Rua Pedro I. In the foreground,
coaches and stables of the palace; at left, the Casa dos Se-
manários (now the Palácio do Grão-Pará).

12. *Klumb albumen 20.3 × 12.6 cm GF*
Cascata do Inferno on the Paraibuna River, along the Es-
trada União Indústria (from Petrópolis to Juiz de Fora, in
Paraibuna), 1861. One of the people shown is probably
the photographer.

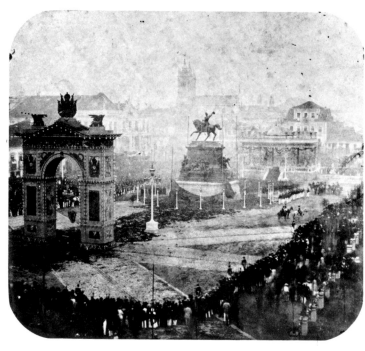

13

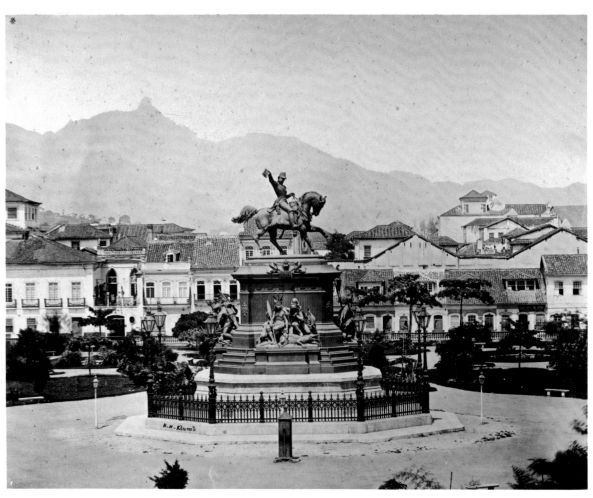

14

15

13. *Anonymous albumen 32 × 40 cm AJL*
Inauguration of the statue of D. Pedro I, work of the
French sculptor Louis Rochet, in the Largo do Rocio
(now called Praça Tiradentes), Rio de Janeiro, March 30,
1862. The ground is covered, as was the custom then,
with aromatic leaves from mango, cinnamon, and
pitangueira trees. In the distance, the towers of the
church of São Francisco de Paula.
The photograph was a tour de force since the day was
rainy and the instantaneous photograph yet unknown.

14. *Klumb albumen 22.3 × 28.3 cm GF*
Statue of D. Pedro I, in the Largo do Rocio (Praça Tira-
dentes), Rio de Janeiro. Looking from the north side, typ-
ical housing from the end of the 18th century is visible
between Rua Visconde do Rio and Rua Constituição, c.
1864.

15. *Klumb albumen 15.5 × 21 cm GF*
View of the city of Juiz de Fora in 1861.

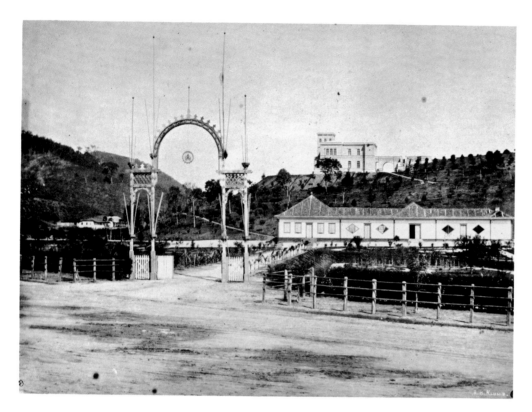

16

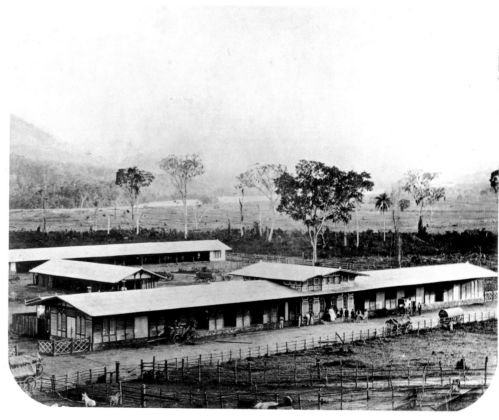

17

Guilherme Auler found references to Klumb in the Imperial Account Books.[41] He informs us that Klumb sent to the Annual Exhibition of the Imperial Academy of Fine Arts in 1860 six portraits, two views of the seawall at Ilha das Cobras and others of the waterfalls at Tijuca, and views of the farm there, the forest in the same area, and the country residence on the banks of the Paraíba River in Campos. Auler further states that Klumb lived at 44 Rua dos Latoeiros (present-day Gonçalves Dias) and that he photographed the Marquis of Paraná in his death chamber (the marquis died on September 3, 1856). That photograph became the basis for a lithograph published by the firm of L. Therrier. In 1861, two months after completing a commission to photograph the inauguration ceremonies for the União Indústria highway from Rio to Juiz de Fora, Klumb received the title "Photographer of the Imperial House." This honor carried with it the right to use the Imperial Coat of Arms in his advertising. By order of Emperor Dom Pedro II, Klumb photographed the interior of the Palace of São Cristóvão, which had been remodeled by the architect Teodoro Marx and decorated by the painter Mário Bragaldi. For his services, he received the amount of one *conto*, 300 *mil-réis*. He also taught photography to Princess Isabel, earning 400 *mil-réis* annually.

Auler goes on to tell us that Klumb went back to Europe with his wife, Hermelinda Barreto. In 1886, he sent from Paris a request to the Empress Dona Teresa Cristina "telling of misadventures and calamities, soliciting imperial intervention in order to obtain free passage, second-class, on any ship" to return to Bahia with his wife and their two daughters who had been born there. The request granted, the Brazilian minister, Barão de Arinos, informed Klumb that he should embark in October 1886.[42]

16. Klumb albumen 15.2 × 21 cm GF
Juiz de Fora. Festive arch, decorated with the imperial arms, at the entrance of the estate of Comendador Mariano Procópio Ferreira Lage (now the Museu Mariano Procópio) on the occasion of the inauguration of the Estrada União Indústria by Their Imperial Majesties on June 23, 1861.

17. Klumb albumen 22 × 28.5 cm BN
The station at Entre-Rios in 1861, on the then recently inaugurated Estrada União Indústria. At stations like this one, coaches changed horses.

Another photographer active in Rio de Janeiro in the mid-1850s was Joaquim Insley Pacheco. His portraits rivaled those of the best in this genre, anywhere. According to Mello Moraes Filho, Insley Pacheco learned daguerreotypy from the Irishman Frederick Walter (who had introduced this invention into the Brazilian State of Ceará) "in exchange for designing 'fortunes' to be used in magic shows." As soon as Pacheco had learned the technical rudiments of his new craft, he left Ceará and set off for northern Brazil. With the money that he had earned, he departed for the United States. In New York, he worked as an apprentice, first in the studio of Mathew Brady, "who united under his roof a brilliant constellation of American and foreign students," and later with Insley and Gurney, "studying all the improvements that were daily received, from the New World and the Old, by that daughter of Daguerre, the sorceress photography."[43] In Brady's office, Pacheco had as fellow-students Biranyi and Carlos Kornis, mentioned above. In addition to photography, Pacheco studied oil painting with the landscape artist Grazoffre. In 1853, after traveling

once more through the cities of northern Brazil, he arrived in Rio de Janeiro at the moment when the domination of the daguerreotype was ending, and that of the ambrotype beginning.

Settling in Rio de Janeiro in 1854, Insley Pacheco worked there until almost the end of the century. For a long time, he had his studio at 102 Rua do Ouvidor. He participated in a number of national and international exhibitions, winning fourteen medals with his portraits and landscapes made by the most up-to-date methods. Photographer of the Imperial House and Knight of the Order of Christ of Portugal, he was the advocate of the so-called *foto-pintura*, or painted photograph.

Insley Pacheco placed a curious advertisement in the *Correio Mercantil* of January 17, 1858. Because it reflects the taste of the period so well, part of it is transcribed here:

> The illustrious public can examine, in our ambrotype establishment, a portrait made on glass by this method that unites all the advantages of photography and oil painting with such perfection that neither the device of Daguerre by itself, nor the painter with his brush alone can achieve such likeness, such refinement of form, or such beauty. To this, add that one may obtain a perfect portrait, equal to that made by the finest painter, for a quite modest price. It is necessary to see the proof with one's own eyes to be convinced that there is, in our claim, neither exaggeration nor boast.

This excerpt illustrates the mentality of the artists of that time, who saw in the possible fusion of painting with photography a means to obtain a product superior to either alone.

Landscape photographs made by Insley Pacheco are extremely rare today. I know of only the eight at the Instituto Histórico e Geográfico Brasileiro depicting the grounds at São Cristóvão, taken soon after their remodeling by the botanist and landscape architect Auguste François Marie Glaziou in 1876.[44]

Joaquim Insley Pacheco and José Ferreira Guimarães, who will be discussed later, were among the photographers who profited most from painted photographs. These were enlarged photographs completely colored over by a painter with oil, gouache, or even pastel. When it was well done, such as those by Auguste Moreau, Ernesto Papf, J. Courtois, or H. Langerock, the results were passable. In most cases, however, the works executed by this technique lacked artistic merit, a fact that did not hinder the success of painted photography in Brazil. The Imperial family was portrayed in this medium on more than one occasion. I own a painted photograph that is a typical example of this process. In it, the Imperial Princes, seated in a ram-drawn cart, appear in a fictitious forest with Corcovado mountain rising amid the trees.

The "miniature," a small colored portrait, was also very much in fashion. Instead of drawing *d'après nature*, the miniaturist's labor consisted of mindlessly copying from a photograph to which a grid pattern had been applied. More than one painter was lost to this drudgery.

In 1862, the following advertisement began to appear: "Chaix Photography: ambrotypy and photographic portraits on artists' canvas—oil painted in life size, r. dos Ourives n.° 2." The last-mentioned technique clearly describes the painted photograph, which would enjoy enormous popularity in Brazil for nearly twenty-five years. Working in this same studio from 1866 to 1870 was José do Reis Carvalho, an artist and follower of the painter Jean Baptiste Debret. Carvalho was known for his paintings of flowers, as well as for his painted photographs. He is remembered for his work with the Scientific Exploration Commission, which traveled to northern Brazil in 1858 under the leadership of Francisco Freire Alemão and became known as the "Butterfly Expedition."

In the Palace of Grão-Pará in Petrópolis are portraits of Dom Pedro II, Empress Teresa Cristina, Princess Isabel, and the Count of Eu. These portraits are, in fact, photographs taken by Carneiro & Gaspar and meticulously painted over by J. Courtois. Two other portraits, made by Insley Pacheco of the Princesses Isabel and Leopoldina, taken when they were children, are magnificent examples of this

18. Insley Pacheco albumen 9 × 5.5 cm IHGB
Princess D. Leopoldina, second daughter of D. Pedro II, possibly on the occasion of her engagement to the Duke of Saxe, D. Augusto, in 1864.

19. Insley Pacheco carbon print 37.5 × 29.5 cm GF
20. Insley Pacheco carbon print 19 × 9.4 cm IHGB

Portraits of D. Pedro II and D. Teresa Cristina, in 1833, posed in the studio amid tropical plants.

Pacheco, Phot

18

PACHECO & FILHO
Rua do Ouvidor 102. RIO DE JANEIRO.

20

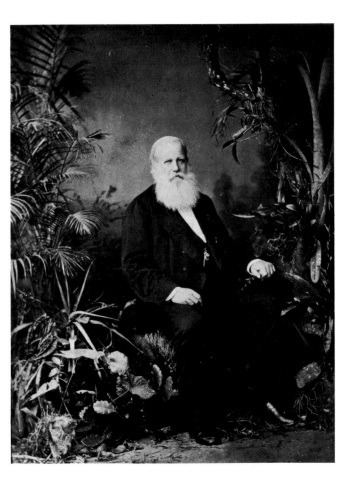

19

hybrid genre. Another example of painted photography is the portrait of José Joaquim Coelho, the Baron of Vitória, now in the collection of the Instituto Histórico e Geográfico Brasileiro. In this case, the photograph was made by Stahl & Cia. and painted in oil by M. Steffen in 1860. I myself own three painted photographs of excellent quality portraying members of my family, and the Imperial Princes. The photographs were taken by Marc Ferrez and painted by the Belgian artist Henri Langerock. In 1866, the great Brazilian painter of the nineteenth century Vítor Meireles had this to say about painted photographs:

> This [technique] consists of the art of making a life-size oil portrait without great inconvenience to the sitter, since a few minutes are all that is required in order to obtain a picture with the dimensions of a calling card that is then used to make an enlargement on paper, or directly on canvas. This preliminary work completed, it is given over to an artist who, using it as a sketch, proceeds to color it. This method of portraiture, so fashionable today, can only contribute to the regression of true art, which should only be exercised according to its rigid principles. All the pictures that we see exhibited together here with photography were made by this new method known as painted photography. . . . If they have any merit whatever, it is undoutedly due to the painter, and not to the photographer. . . .[45]

Apparently, painted photography had few adherents in the United States of America, where it was almost unknown.

Portrait painters were not the only ones to make use of photography. Since the golden age of daguerreotypy, lithographers had also employed it. Because daguerreotypes could not be inexpensively reproduced, and yet were an excellent medium for making landscapes and city views with rich architectural detail and full descriptive veracity, publishers soon began to copy and reproduce them by means of lithography. Several examples of this application are mentioned in the discussion of Biranyi, Kornis, and Klumb. Others are the beautiful lithographs by Eugenio Ciceri and Philippe Benoist (of the famous Lemercier lithography firm in Paris), the ones commissioned by Leuzinger, those of Rensburg, and many others who will be referred to throughout this text.

After 1850, the photographers in Rio de Janeiro who best knew how to promote their establishment were Carneiro & Smith (later Carneiro & Gaspar), who called themselves the "Kings of Photographers." They were the first to use caricature as a vehicle of commercial advertisement. Early on, they selected the best caricaturist of the period, Henrique Fleiuss, who delighted our grandparents for more than fifteen years, evoking their laughter with his celebrated *Semana Illustrada*. Along with the *Jornal do Commercio*, Fleiuss's review—with its cartoons, articles, and advertisements—is an indispensable source for the study of the political and social life of Rio de Janeiro in the second half of the last century. Two examples are reproduced here, dated 1862 and 1866 (Figures 23 and 25).

The following commentary appeared in the *Semana Illustrada* when the name of the business was changed from Carneiro & Smith to Carneiro & Gaspar:

> The photographic studio of Carneiro & Gaspar is now open. It is worth a visit.
>
> Messrs. Carneiro & Gaspar have spared no effort to make their establishment worthy of the capital of the Empire, where the photographic art is represented by a number of notable establishments.
>
> Everything there is orderly and sumptuous; the cameras are excellent and the artists skilled. I have seen works made by this studio, above all their life-size portraits, that command the attention and admiration of even the most skeptical.
>
> In these matters, it is best to see with one's own eyes. By giving an establishment such as that of Messrs. Carneiro & Gaspar the welcome it deserves, the public both encourages the arts and profits from this encouragement.
>
> Who among us nowadays does not wish to send, as a token of affection to friends and to posterity, his own image? Not even the homely—and I've seen a great number of portraits whose subjects were descendents of neither Apollo, nor Venus.
>
> But it's in fashion, and everybody goes to have his portrait made.
>
> So, go they must, to the studio of Messrs. Carneiro & Gaspar. [46]

The studio began its activities in 1852 and seemed to die out by around 1876. Apparently, they produced no landscape photographs, confining their work to portraiture.

21

22

21. Carneiro & Gaspar and J. Courtois painted photo-graph 54 × 42 cm DPOB
22. Carneiro & Gaspar and J. Courtois painted photo-graph 54 × 42 cm DPOB

D. Pedro II and the Count d'Eu portrayed in good painted photographs. Both portraits were taken by the photographers Carneiro & Gaspar and later painted in watercolor by J. Courtois, c. 1867.

23. H. Fleiuss 5.5 × 11.8 cm GF
"Several European newspapers are talking about a new discovery in the photographic art that Messrs. Carneiro and Gaspar, kings of our photographers, haven't tried yet. Our boy here, however, found the idea so appealing that from now on—says he, puffed up with pride—no picture will escape him." Advertisement for Carneiro & Smith, "kings of our Photographers," published in *Se-mana Illustrada*, November 2, 1862.

Algumas folhas da Europa fallam de uma nova descoberta na arte photographica, que os Srs. Carneiro e Smith, reis dos nossos Phothographos, ainda não experi-mentaram. O nosso moleque, porém, achou a idéa tão feliz que, d'ora avante, diz elle, com as bochechas inchando, não lhe hade escapar mais *retrato algum.*

23

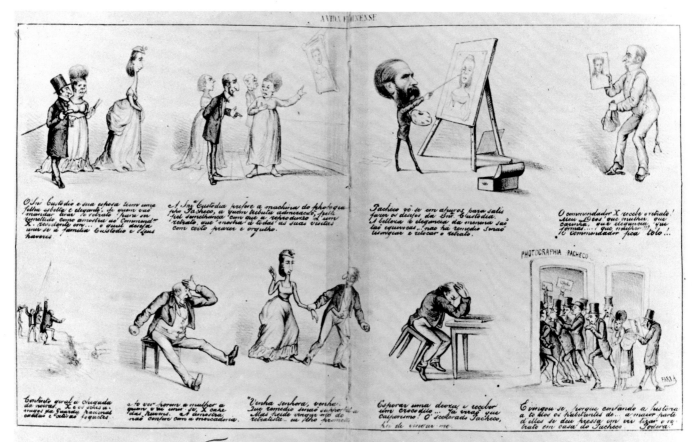

PHOTOGRAPHO.—Assim... quando eu abrir isto, você olhe para dentro do vidro.

— Agora... um, dous, tres, quatro....

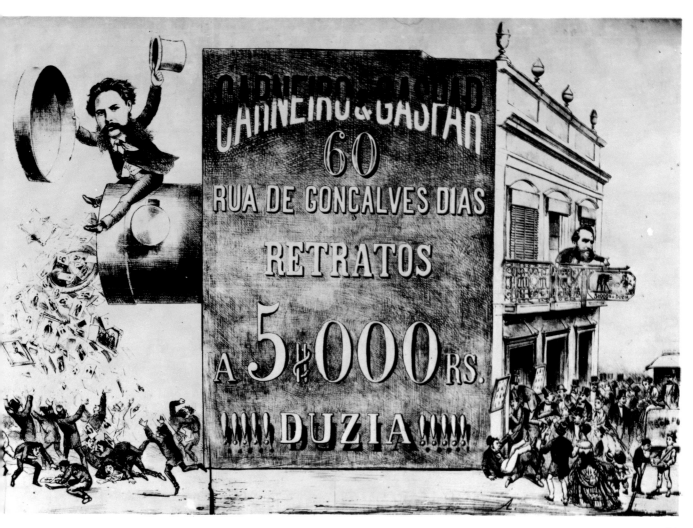

26

24. *Faria 31 × 45 cm BN*
"Successful results of retouched photography." Illustrated
satire of the Photografia Pacheco studio, published in *A
Vida Fluminense*, December 16, 1871.

25. *H. Fleiuss 10 × 17.2 cm GF*
"Photographer: Like this . . . when I open this, you look
inside the glass.
Now . . . one, two, three, four. . . ."
Illustrated satire published in *Semana Illustrada*, January
28, 1866.

26. *Angelo Agostini 47 × 64 cm BN*
". . . Portraits at 5 mil-réis per dozen!!!"
Unusual and clever advertisement for Carneiro & Gaspar,
published in Angelo Agostini's review, *A Vida
Fluminense*, January 1, 1870.

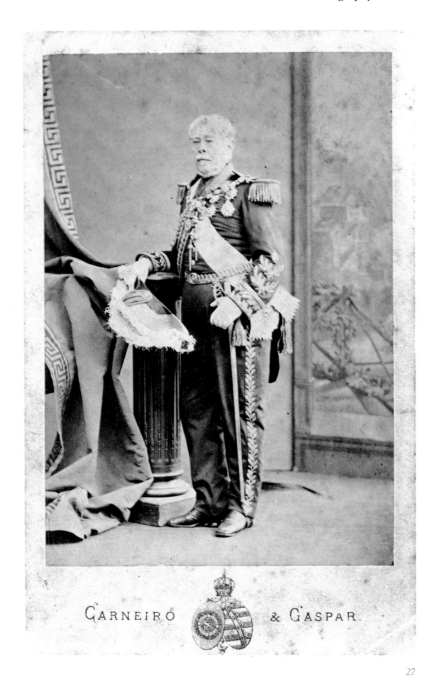

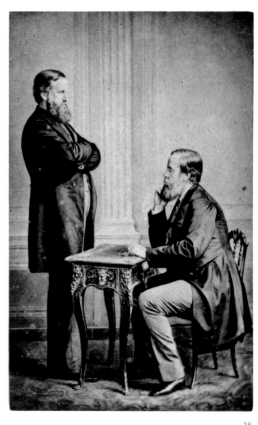

28

27

27. *Carneiro & Gaspar albumen 13.5 × 9.5 cm GF*
Portrait of the Duke of Caxias in full dress uniform and
wearing all his decorations.

28. *Carneiro & Gaspar albumen 9 × 5.7 cm DPOB*
D. Pedro II conversing with himself, c. 1867.

Victor Frond was a great landscape photographer. According to Afonso d'E. Taunay, Frond was an associate of Sisson, the well-known lithographer. Born in France, Frond lived for some time in Rio de Janeiro and had a studio at numbers 34 and 36 Rua da Assembléia. He traveled through the province of Rio de Janeiro, visiting coffee plantations and sugar mills. He also went to Bahia. From his excursions, he brought back a collection of photographs. There is no need to elaborate on these since they became widely known through the magnificent lithographic prints that lent so much distinction to Charles Ribeyrolles's book *Brazil pittoresco*.

When Frond visited Petrópolis to raise money for his project through the sale of advance subscriptions to *Brazil pittoresco*, he also took the opportunity to photograph several of the leading personalities of the city. He explained his project for the book in the local newspaper, *O Parahyba*, on January 21, 1858. Part of that text is reproduced below.

> In order to make our work as national [Brazilian] as possible, we have pledged to take under our supervision two Brazilian orphans at least sixteen years of age, from any orphanage whatever. We will train them in photography, and they will accompany us on the excursions that we make, receiving at the same time lessons in both theory and practice. After the completion of our project, the [Brazilian] government could then profit from their experience by employing them, either for contributing to official survey records or for artistic explorations through the beautiful provinces bathed by the Amazon River or extending to the South of the Empire.

It was an intelligent plan. We do not know if it was ever carried out. Frond attained such success as a portrait photographer that when he returned to Rio, he left a substitute—a Mr. Adolphe—in Petrópolis. He advertised the fact on March 11, 1858:

> Photographic Portraits: There is in town, as announced earlier, a person entrusted by Mr. Victor Frond with making portraits by a new method that renders a perfect and admirable likeness.
>
> Besides those persons who have already enrolled, subscriptions will be taken at the offices of this newspaper for those who wish to be photographed again; we implore that these clients act quickly, since the artist entrusted with this assignment will not remain in Petrópolis for more than 15 days.

According to Guilherme Auler's research in the

Imperial Account Books, Dom Pedro II bought more from Victor Frond that from any other photographer. His invoices from 1857 to 1862 add up. to the respectable amount of 12 *contos* and 27 *mil-réis*.[47]

Currently, Victor Frond has been overshadowed by the author of *Brazil pittoresco*, Charles Ribeyrolles. However, the success of the publication owes much more to the magnificent lithographs that make up the album, than to the text.

It was Victor Frond, maker of the photographs that served as models for the lithographs, who conceived the idea of the book. This is evident from a letter dated April 17, 1859, and signed by Frond, addressed to the Imperial Minister:

> At the head of a photographic establishment organized under my supervision, I conceived the idea last year of paying my debt to Brazilian hospitality by publishing a work that would make known the history of Brazil, its beauties and greatness. . . .
>
> With this idea in mind, I have brought from Europe *at my expense* [italics added], Mr. Charles Ribeyrolles, a friend of mine, who has willingly agreed to write the text. . . . [48]

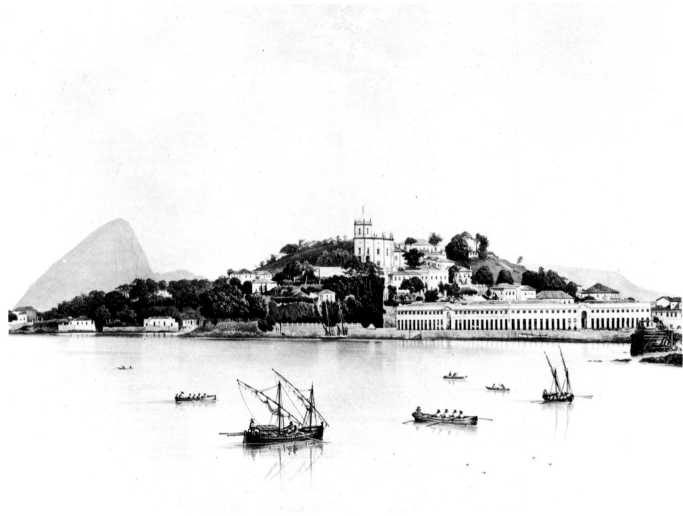

29

29. *Victor Frond lithographic reproduction*
36.5 × 48 cm GF
La Gloria—Rio de Janeiro. Lithograph by Jaime based on
a photograph by Victor Frond.
The Morro da Glória and the Igreja de Nossa Senhora
da Glória do Outeiro, in 1858. The building at right was
the new Glória market. Never used as such, it became a
slum tenement.

30. *Victor Frond lithographic reproduction*
24.8 × 32.2 cm GF
La cuisine à la roça. Lithograph by Ph. Benoist from a
photograph taken by Victor Frond in 1858.

31. *Victor Frond lithographic reproduction*
25.4 × 34.5 cm GF
Fazenda do Governo—Parahyba do Sul. Lithograph by H.
Clerget from a photograph taken by Victor Frond in
1858 for the album *Brazil pittoresco*.
The estate house is still there, well preserved.

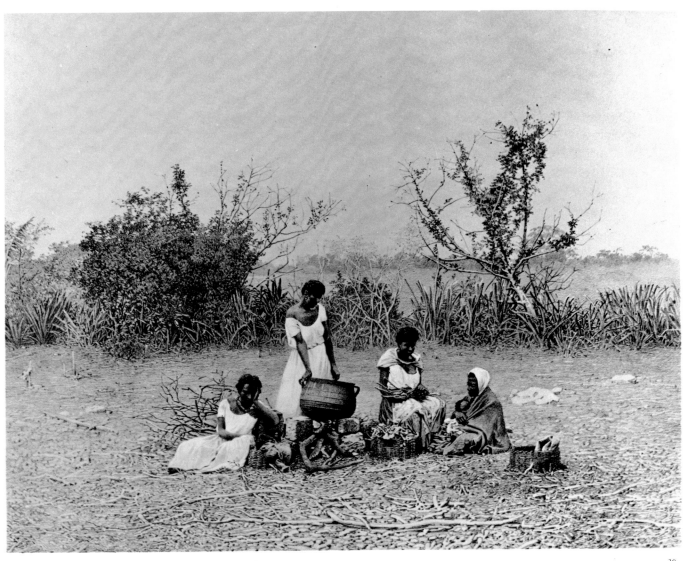

30

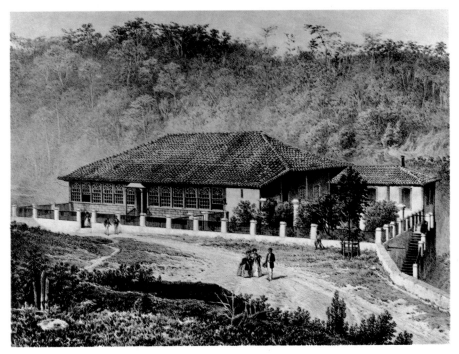

31

From time to time, I have come across old photographs on original paper [vintage prints], without any indication of the maker. Three interesting examples reproduced here are notable for their age, technical quality, and historical value. They are more unusual yet for their large format—uncommon for the time—and because they depict a region little explored by artists or photographers. They are captioned in German, and one is dated 1857.

32. Anonymous albumen 20 × 26 cm GF
The copy of the Northumberland gateway in the park at Quinta de São Cristóvão in 1857, before the addition of the landscaping designed by Glaziou. Also shown, the house of the Marquesa de Santos, the entrance to the swamp at Mangue, all of the Praia Formosa, and Pinto and São Diogo hills.

33. Anonymous albumen 12.5 × 27.5 cm GF
Vista da Praia Formosa —Rio de Janeiro, 1857. The harbor and the Morro do Pinto are also depicted here.

34. Anonymous albumen 17 × 28.5 cm GF
Ein Theil des Ufers von St. Christovão 1857—Kirche der Aussatzigen.
Rear view of São Cristóvão, 1857, Church of the Lepers. Also shown, Lazareto, formerly a recreational farm of the Jesuits, on Rua São Cristóvão, next to the Praia das Palmeiras in Rio de Janeiro; on the other side of the swamp, the São Diogo quarry.

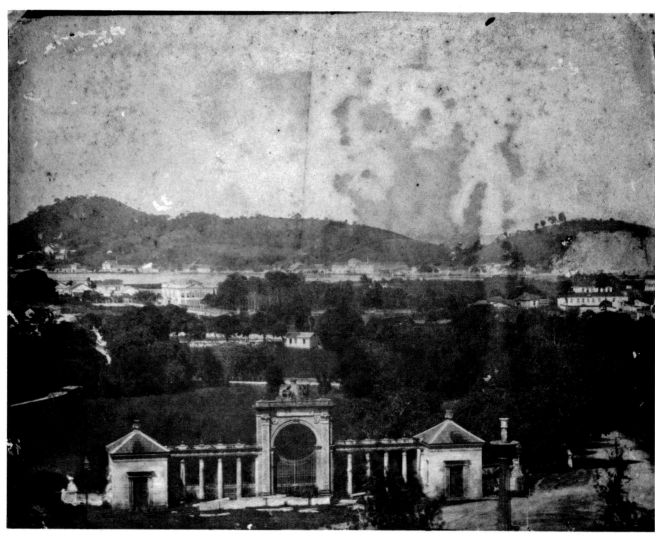

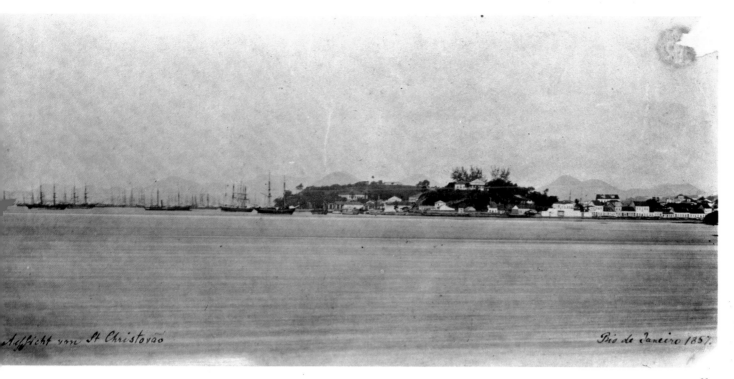

Aussicht von St Christovão

Rio de Janeiro 1857.

33

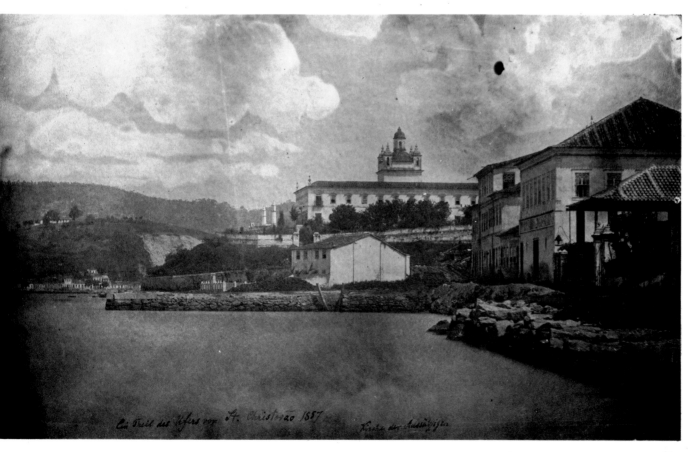

Ein Theil des Hafens von St. Christovão 1857.

Kirche der Ausländer

34

Stahl & Wahnschaffe, whose studio was located at 117 Rua do Ouvidor, were photographers to H.M. the Emperor. Augusto Stahl, who will be discussed in the section of this book dealing with photographers active in Recife, arrived in Rio de Janeiro between 1860 and 1862, when he went into partnership with Wahnschaffe. His cityscapes of Rio and the surrounding area are extremely rare today. Wahnschaffe, who was responsible for the decoration of portraits and miniature photographs made by his associate, was a mediocre painter. This opinion is corroborated by two works executed by their firm in 1864. Presently located in the Palace of Grão-Pará, they are portraits of Princess Isabel and her husband, the Count of Eu. Both exhibit a pronounced bad taste.

35. Stahl & Wahnschaffe albumen 20.2 × 25.9 cm GF
Morro da Glória and the adjacent area, seen from Santa Teresa, Rio de Janeiro, c. 1864. In the foreground, Rua Hermenegildo de Barros intersecting Cândido Mendes, gardens of the villas of Baía and S. Cornélio, the smokestack of the City Improvement plant which had just been opened, the market of Glória that never opened, the Morro de Nossa Senhora da Glória de Outeiro, the surrounding houses, and part of Catete. In the distance, the entrance to the bay and the Morro Cara de Cão.

36. Stahl & Wahnschaffe albumen 19.8 × 25.5 cm GF
The east and south sides of the Largo do Rocio (now Praça Tiradentes), in Rio de Janeiro. Very clearly seen are the escarpment of the Morro de Santo Antônio and the famous building of Zur Stadt Coblenz, to the right of the statue of Pedro I; at left, the end of Rua do Piolho (now Rua da Carioca), c. 1865.

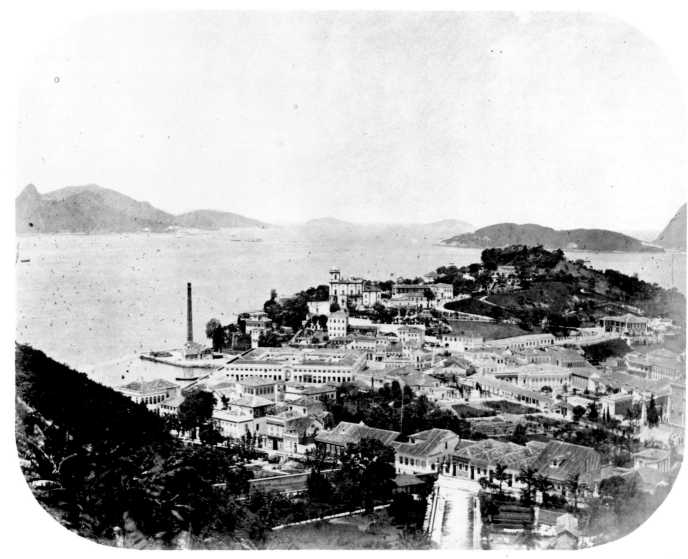

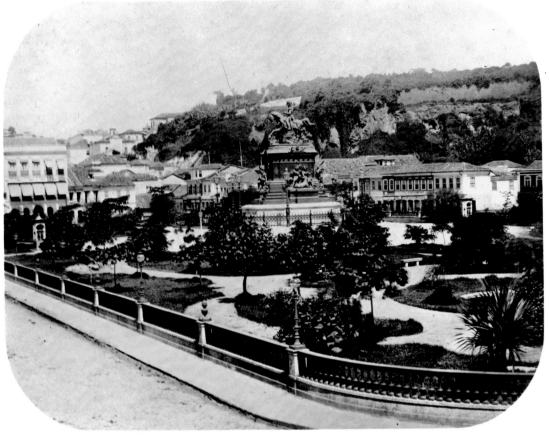

36

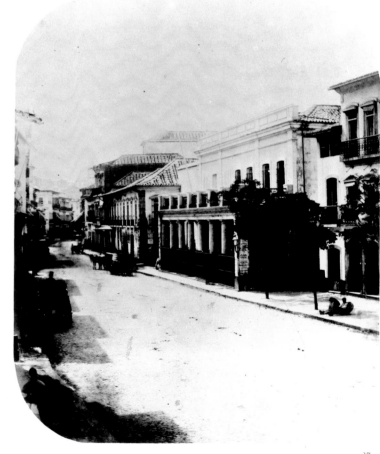

37. *Stahl & Wahnschaffe albumen 23.1 × 19.6 cm GF*
Rua Direita (now 1.º de Março), in Rio de Janeiro, c.
1862. At right, Praça do Comércio, the former customs-
house with its remodeled façade designed by Grandjean
de Montigy, and, just beyond, the former residence of the
Governors, later the Casa dos Contos and present loca-
tion of Banco do Brasil. Notice, at right, the house only
1.5 m wide.

37

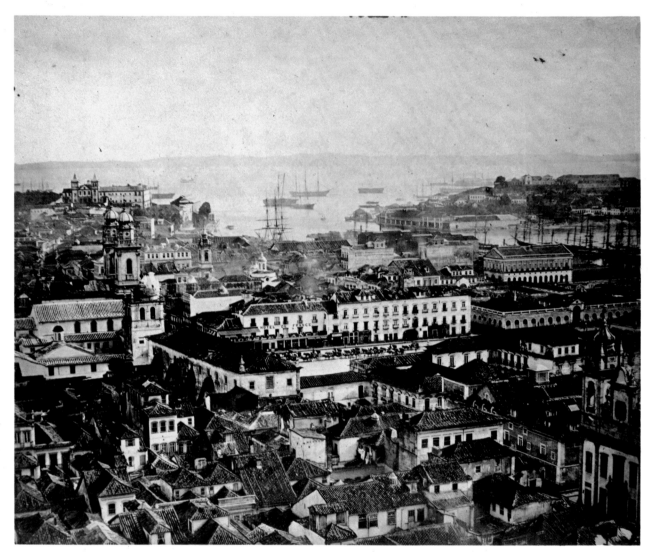

38

38. *Stahl & Wahnschaffe albumen 20.5 × 25 cm GF*
Remarkable photograph of the center of Rio de Janeiro,
c. 1865, made from Morro do Castelo. It is almost identi-
cal to the drawing made by William John Burchell in
1825. In the foreground, houses on Rua São José and Rua
Assembléia; then the tower of the cathedral, and the old
Convento do Carmo with the covered passageway joining
it to the Paço da Cidade. In the Largo do Paço are: the
Hotel de France, the Arco do Teles, the market, and the
line of horse-drawn tilburies—the taxis of the time. Be-
yond these, the towers of the Ordem Terceira do Carmo
and the Cruz dos Militares, São Bento, the Maxwell
warehouse, and the Ilha das Cobras.

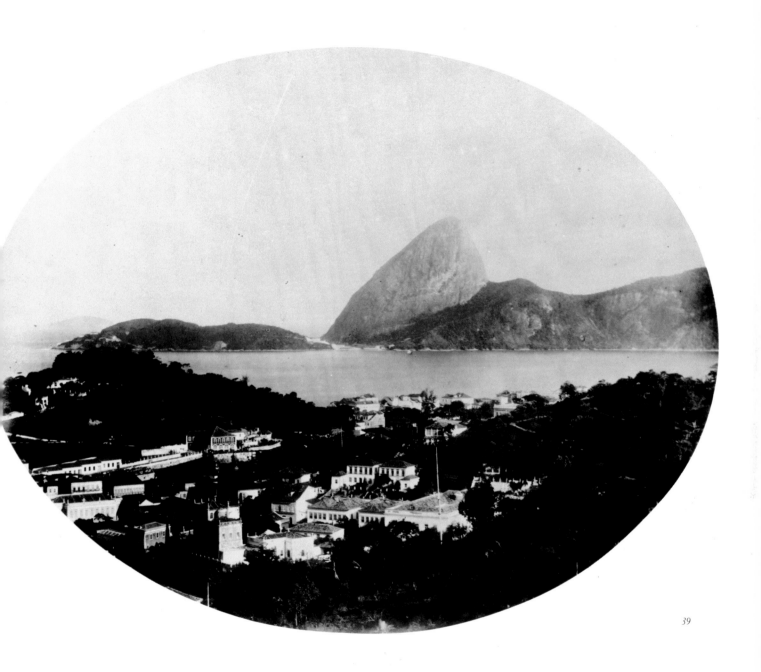

39

39. Stahl & Wahnschaffe albumen 19.4 × 25 cm GF
Rio de Janeiro: Morro da Glória and the Catete quarter
seen from Santa Teresa. In the distance, the hills of Cara
de Cão, Pão de Açúcar, and Urca. Beneath Morro da
Glória, at the end of the avenue, the Baroness of So-
rocaba's house, demolished by its owner—an act of fla-
grant irresponsibility—upon learning that the building
would enter the national historical patrimony.

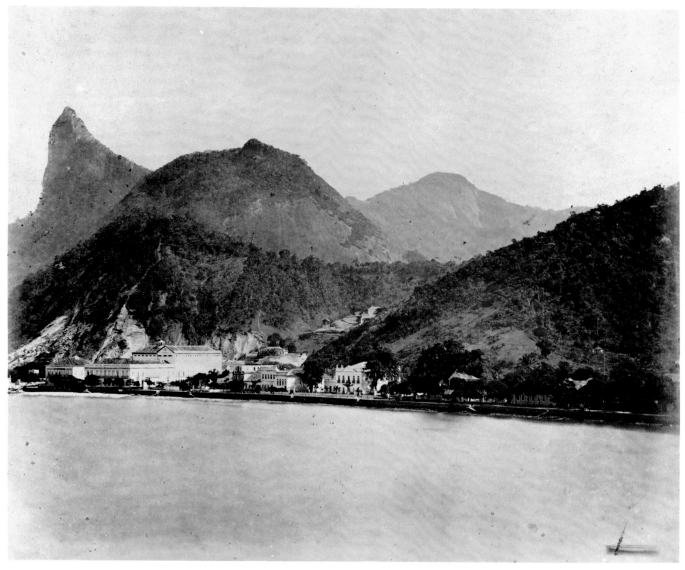

40

40. *Stahl & Wahnschaffe　albumen　19.9 × 25 cm　GF*
Praia de Botafogo in Rio de Janeiro in 1862 with its
buildings, and behind them, from left to right, Cor-
covado, the hills of D. Marta, Novo Mundo, Serra da
Carioca, and Morro Azul. The two large structures on
the left belong to the former school of the Associação de
S. Vicente de Paulo (currently the Imaculada Conceição),
founded and established there in 1854.

41. *Stahl & Wahnschaffe　albumen　20.5 × 25 cm　GF*
Rua da Floresta, which started there at Rua Catumbi,
and ended at the Morro de Paula Matos. This was taken
in front of the cemetery of S. Francisco de Paula, in
Catumbi. Rio de Janeiro, c. 1865.

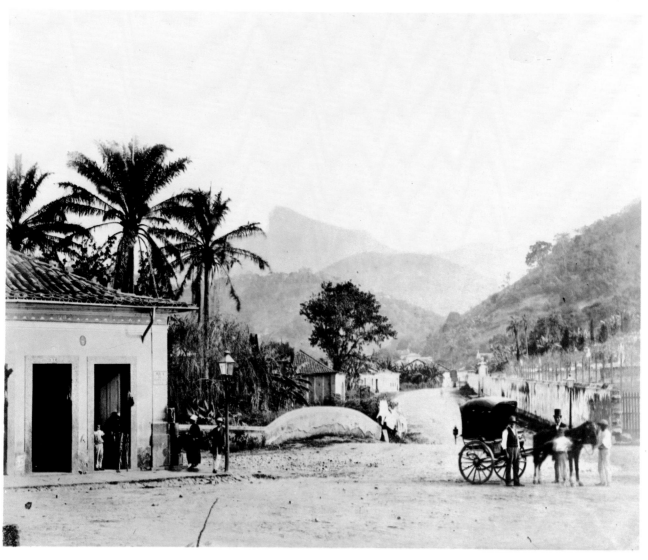

41

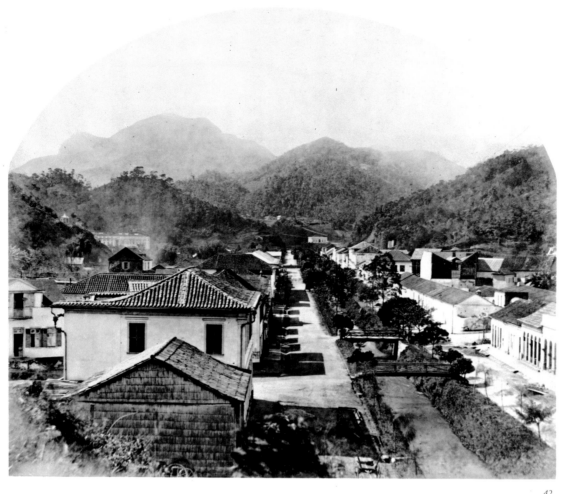

42

42. *Stahl & Wahnschaffe albumen 20.7 × 25 cm GF*
Petrópolis, c. 1865. Rua do Imperador at the intersection
with Rua Barbosa (later Ruas Cruzeiro and João Pessoa)
and looking in the direction of the residence of Baron of
Ubá (now the Colégio Sacré-Coeur). To the right, Rua D.
Francisca (now Rua General Osório) and Colônia storage
buildings. The Sixel ironworks was located in the first
building on the left.

43. *Stahl & Wahnschaffe albumen 20 × 25 cm GF*
Petrópolis in 1862. In the foreground, Rua Princesa D.
Januária (now Rua Marechal Deodoro). Shown, from left
to right, are the house of the old Córrego Seco farm, and
those of Viscount d'Araguaia, and Count d'Estrela (and
later of Jerônima Mesquita). In the distance, the Palácio
do Imperador (now the Museu Imperial), and the Casa
dos Semanários (now the Palácio do Grão-Pará).

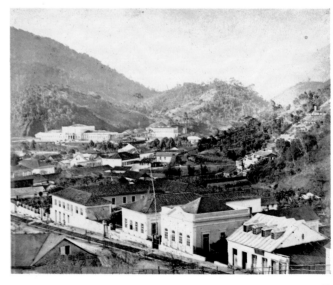

43

A photographer whose name is not mentioned in the newspapers or almanacs of the period was the Italian who signed himself *Camillo Vedani*. Beginning in 1853, he operated a photographic business, first at 76 Rua da Assembléia and later at 43 Rua do Ouvidor. In addition to photography, he offered his services as a teacher of drawing and Italian. I own two albums of photographs taken by Vedani between 1863 and 1875. Measuring twenty-three by thirty-two centimeters, they contain twenty views of Rio de Janeiro and Bahia.

44. Camillo Vedani albumen 15.4 × 21.5 cm GF
Rio de Janeiro, c. 1865–70. This photograph together with numbers 45 and 47 form a panorama of the city's shoreline, from Calabouço point to Candelária and the beginning of Rua Visconde de Inhaúma. In the middle plane, just beyond the harbor, is the Arsenal de Guerra (now the Museu Histórico Nacional), the Charity Hospital, the Moura barracks, the ferry boat station, the Hotel Pharoux, and the fish market docks. Atop the Morro do Castelo are the old Jesuit school and church.

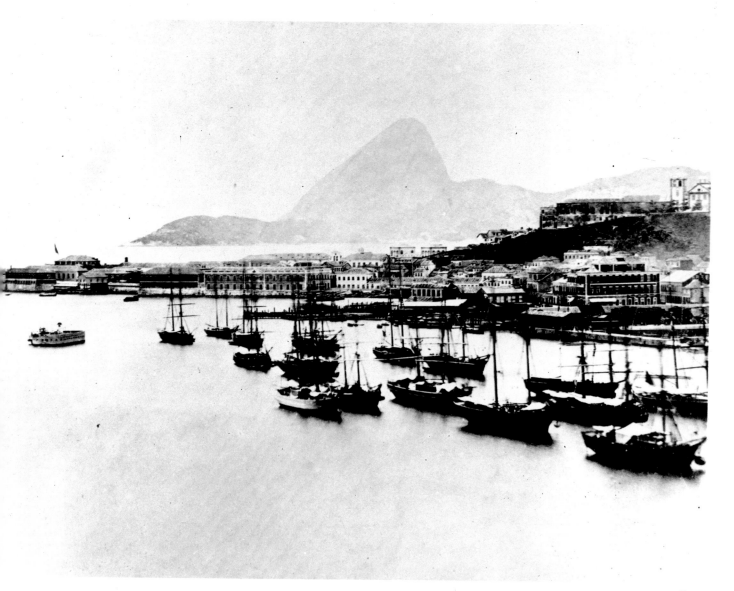

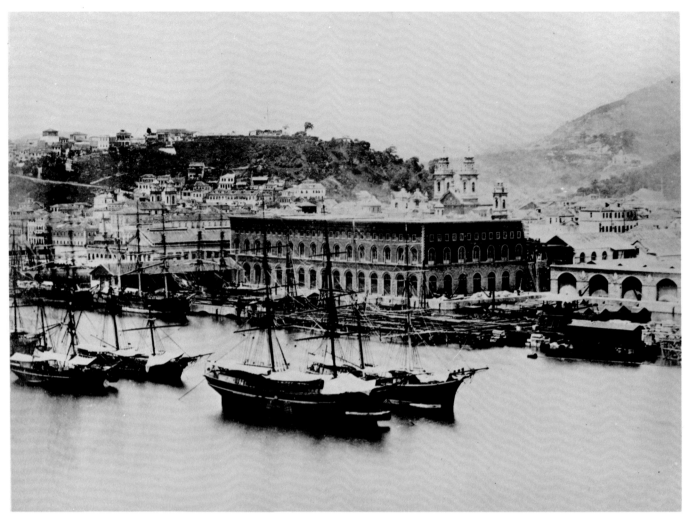

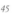

45. Camillo Vedani albumen 16.5 × 23 cm GF
Rio de Janeiro, c. 1865–70. Shown are the Maxwell ware-
house and Lloyd's building, with its pier under recon-
struction and its warehouses.

46. Camillo Vedani albumen 15.4 × 21.5 cm GF
Rio de Janeiro, 1865. Largo do Paço, until 1900, the prin-
cipal meeting place of the city. At right, the side of the
palace, the fountain by Mestre Valentim, and the façade
of the Mercado da Cidade. At that time, the square was
still divided into diamonds by cobblestone walkways,
built as they were in the time of the administration of
Luís de Vasconcelos e Sousa and in accordance with a
project created by Jacques Funck in 1789. In the distance,
the Ilha das Cobras.

47. Camillo Vedani albumen 16.5 × 23 cm GF
In the foreground, the continuation of Lloyd's dock and
warehouses, facing Rua Visconde de Itaboraí. In the mid-
dle plane, the convent and churches of Santo Antônio,
the Ordem Terceira da Penitência, and Candelária—
during the construction of its dome.

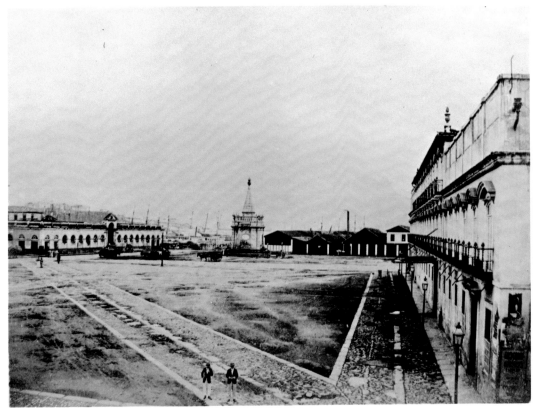

46

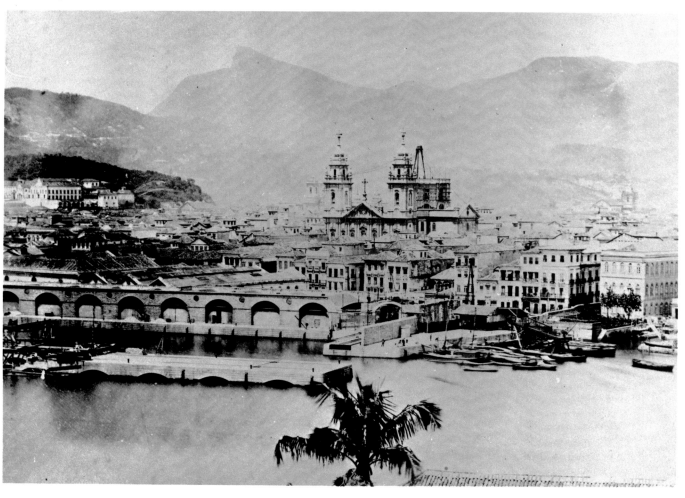

47

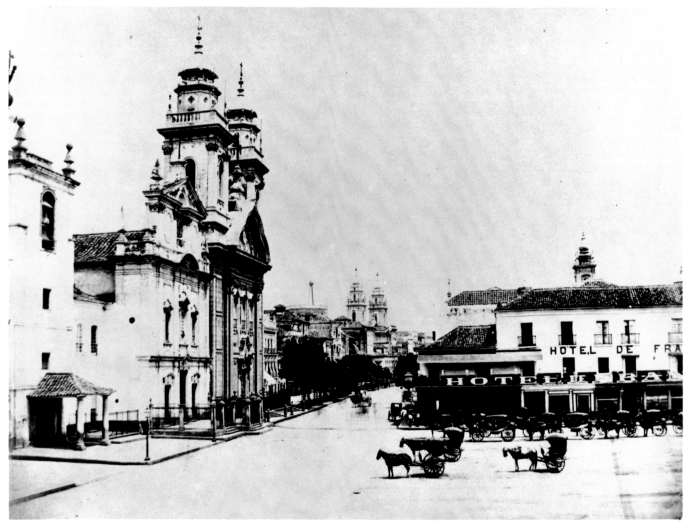

48

48. *Camillo Vedani albumen 15.4 × 21.5 cm GF*
Largo do Paço and Rua Direita, in Rio de Janeiro, 1865.
From left to right, the Cathedral (note the covered en-
tranceway to the tower), the Igreja da Ordem Terceira de
Nossa Senhora do Monte do Carmo, the two towers of
the Igreja da Candelária, the Hotel de France, the tower
of the Igreja da Cruz dos Militares. The tramway didn't
exist yet, but the tilbury cabs were in circulation.

49. *Camillo Vedani albumen 21.5 × 15.5 cm GF*
Rio de Janeiro, c. 1865. Rua São Clemente, dominated by
Corcovado peak, at the corner of the present Rua Edu-
ardo Guinle. The building at right was demolished in
1981 to give place to a high-rise building. At the place
where the palms appear, the Jesuit school and church are
located today.

Fritz Büsch, who was German, is another photographer who was unknown until recently. I acquired some twenty albumen prints of Rio de Janeiro, Petrópolis, Friburgo, what appears to be Santos, and the surrounding areas made by Büsch approximately from 1870 to 1875. They attest to the work of an excellent photograper.

50. Fritz Büsch albumen 15.1 × 20.5 cm GF
The road to Petrópolis, in the Serra da Estrela, at that moment the finest macadam highway in the country, 1870–75.

51. Fritz Büsch albumen 21.1 × 15.6 cm GF
The tree-lined avenue of Jardim Botânico in Rio de Janeiro, c. 1870–75. The marvelous examples of royal palm (*Oreodoxa oleracea*) form a veritable natural gothic arch.

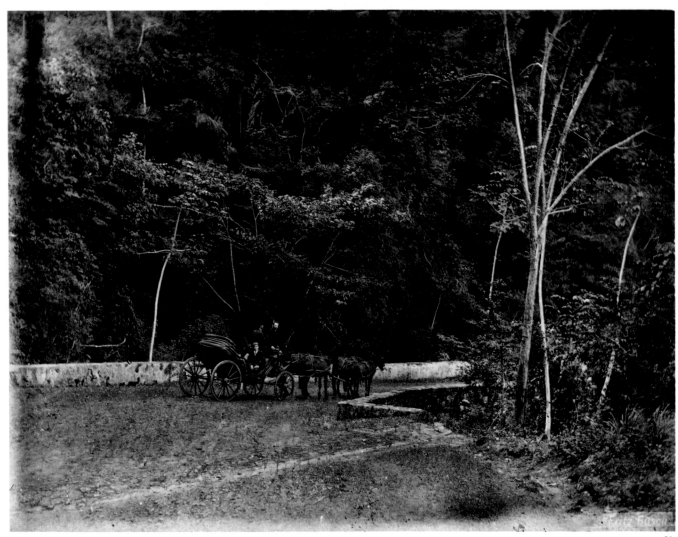

50

By 1840, George Leuzinger—a native of Glaris, Switzerland—already owned the well-known printing and publishing firm that bore his name. The graphic arts in Brazil are greatly indebted to this firm, which is still in operation today. Noting the popularity of photography, Leuzinger opened, around 1861, "a specialized studio with the finest English cameras for landscapes, panoramas, views of all types, stereographs, and studies of native types which were intended for distribution in the firm's publications." The author is familiar with several albums containing views of Rio, Niterói, and Teresópolis taken between 1860 and 1870 that prove the high degree of technical perfection attained by the Leuzinger Studio at that time.[49] These are listed in a small catalog in vigesimo-quarto, very rare today, that was printed by the Leuzinger firm, and entitled *Officina Photographica de G. Leuzinger. 36 Rua do Ouvidor. 337 Photographias diversas.* In this interesting little catalog, which must date from around 1865, we learn that a beautiful panorama of Rio mounted on a forty-by-sixteen-inch card cost 15 *mil-réis*; that one could obtain a photograph measuring eleven by fifteen inches—a record for the period—for 2,500 *réis*; but for those of Teresópolis, customers had to pay 3,000 *réis* (presumably because of the distance that had to be traveled to make it); one dozen photographs in *cartes-de-visite* format, went for 8,000 *réis*. The Leuzinger Studio participated in a number of exhibitions at the Imperial Academy of Fine Arts and other national and international competitions, receiving numerous awards.

In his book *Voyage au Brésil*, the famous Swiss-American naturalist Louis Agassiz lavishly praises the works of this studio, and with good reason, since he used views taken by the Leuzinger studio and by Stahl to illustrate his book.[50]

It is known that, early on, Leuzinger brought Franz Keller from Mannheim, Germany, under contract, that Keller launched the firm's work in photography, and that his assistant was Marc Ferrez. It is almost certain that, some time later, Ferrez became the company's chief photographer before leaving to open his own photographic business. This supposition is reinforced by a comparative study of several views by the Leuzinger Studio with later works by Ferrez. Some photographic views of Rio and Teresópolis have every appearance of being the work of Ferrez, yet bear the imprint *Casa Leuzinger*, and vice versa. In a great number of these photographs, the viewpoint, angle, and process are identical.

Leuzinger knew, better than anyone else, how to publicize the natural beauties of Rio de Janeiro. His firm commissioned lithographs to be made in Paris from daguerreotypes, transforming them into large-scale panoramas. Today these are high-priced rarities. In order to make them more artistic, he had the idea of having the foregrounds retouched by such European academic artists as Hagedorn, Martinet, and others in a manner that intensified the illusion of deep space. Always the law-abiding citizen, Leuzinger faithfully submitted copies of these works to the Biblioteca Nacional, even taking care to record, on the back of each, the name of the artist who had made it.[51]

The Leuzinger studio was the first to publish prints of black slave "types" and Amazonian Indians. The latter were reproduced from photos made by A. Frisch in approximately 1865, according to captions mounted below the images.

By 1866, José Ferreira Guimarães, from Portugal, was established in his photographic studio at 40 Rua dos Ourives. As the great *portraitiste* of the Court, he served a large and prosperous clientele and became a wealthy man. His portraits received awards at Brazilian exhibitions (including those of the Imperial Academy of Fine Arts) for their delicacy, clarity, and finish. He was a specialist in photographic portraits on ceramic: "vitrified portraits, fired in the manner of Sèvres and Limoges." He was made a Knight, Official, and Commander of the Order of the Rose. In 1886, he built a palatial studio at 2 Rua Gonçalves Dias, at the corner of Rua da Assembléia. The four-story building was for many years the tallest in the city. The first three stories were occupied by the photographic business, the remaining area being used as living quarters.

Luís Musso was another photographer who enjoyed a large clientele. He worked at Casa Ferreira Guimarães, later becoming an associate and, finally, owner of that studio. When he died, the firm was taken over by his brother, Alfredo Musso.

In its criticism of the Art Section at the Second National Exhibition, the *Semana Illustrada* of November 18, 1866, published this accurate appraisal of the works and artistic merit of Brazilian photography :

> In the room just next to the paintings are the photographs, which form a distinctive part of this Exhibition. The exhibitors in the artistic-industrial division are Messrs. Carneiro and Gaspar, Christiano Jr., Guimarães, Jacy and Lobo, Leuzinger,

Modesto, van Nyvel, Pacheco, Stahl and
Wahnschaffe, etc.

There is no doubt that the photography practiced
here [in Brazil] is excellent and has nothing to fear
from comparison with European works. All, or
nearly all, are perfect; some are extraordinary. Un-
consciously, the viewer naturally seeks to compare
these works, to discover which are best. After ex-
amining them with the requisite attention, however,
one soon abandons this idea. Carneiro and Gaspar
excel in the tonal clarity and harmony of their por-
traits, as well as in the poses selected. Pacheco's rep-
utation as a superb photographer is unchallenged.
Stahl and Wahnschaffe are masters of landscape and
city views, as skilled in this as they are in portrai-
ture. In landscape photography, Leuzinger equals
them. Guimarães makes beautiful portraits, as does
van Nyvel. Modesto's portraits are well executed,
and some are tastefully colored. Jacy and Lobo also
have pretty portraits [in the exhibition]. Christiano
Jr. exhibits excellent portraits and extraordinary re-
productions of a dozen engravings. . . .

52. *Casa Leuzinger albumen 19 × 24 cm GF*
Rio de Janeiro, c. 1875. Houses in the Lapa district, the
Santa Teresa aqueduct, and the Igreja da Glória, seen
from the Morro de Santo Antônio; in the distance, the
entrance to the bay and Pão de Açúcar.

LOJA DE PAPEIS
de G. LEUZINGER.
Fabrica de livros de Conta
e Encadernação.
Rua do Ouvidor, 36,
RIO DE JANEIRO.

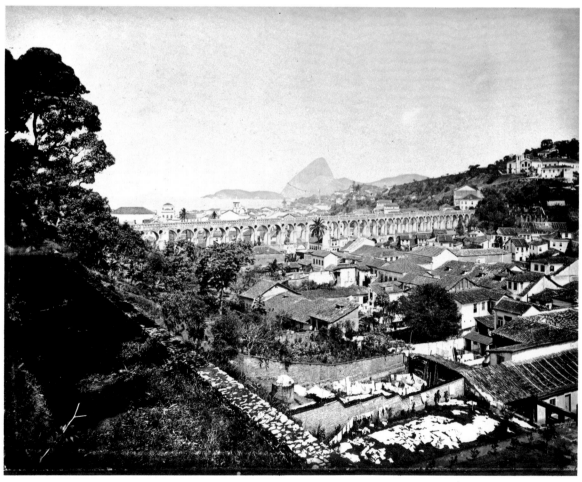

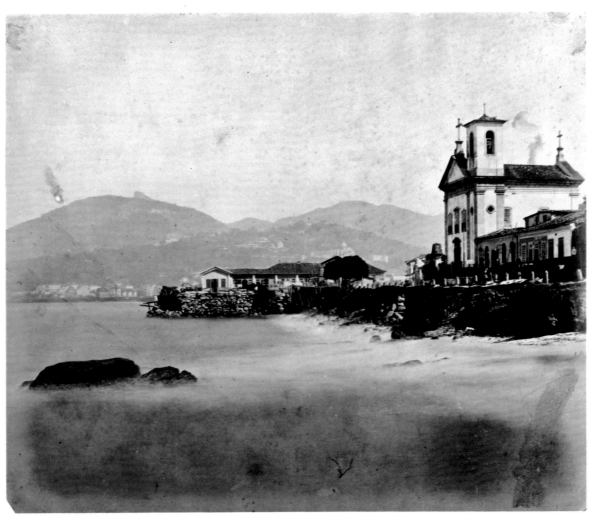

53

53. *Casa Leuzinger albumen 17.8 × 21.5 cm GF*
Rio de Janeiro, 1860. The Igreja de Santa Luzia, when
the sea broke beneath it and its two towers had not yet
been built. The bell tower seen here was temporary. In
the distance, the Igreja do Desterro and the hills of Santa
Teresa, Nova Cintra, and the Serra da Carioca.

54. *Casa Leuzinger albumen 19 × 24.1 cm GF*
Rio de Janeiro, c. 1875. The convent and church of Santo
Antônio and the church of the Ordem Terceira de Nossa
Senhora da Penitência, seen from atop the Morro do Cas-
telo. Toward the right are the mint and the theaters S.
Pedro (now João Caetano) and Provisório, in the Campo
de Santana. In the distance, the Pedra do Conde, Tijuca,
the Pedra do Grajaú, and the São Diogo quarry.

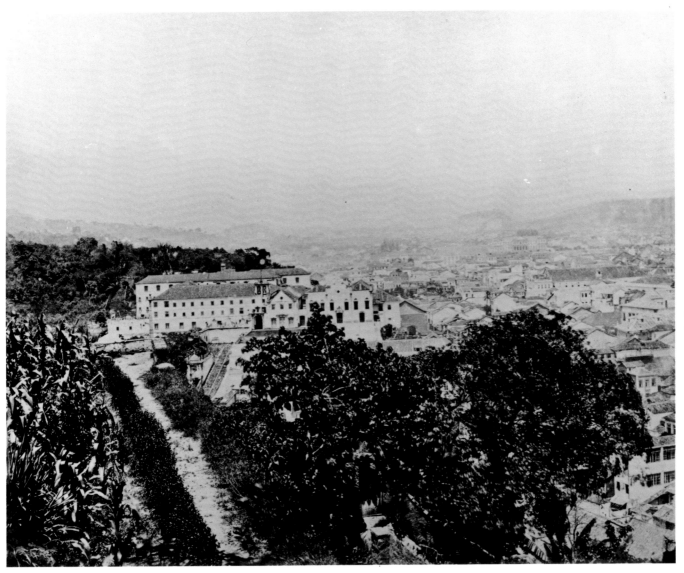

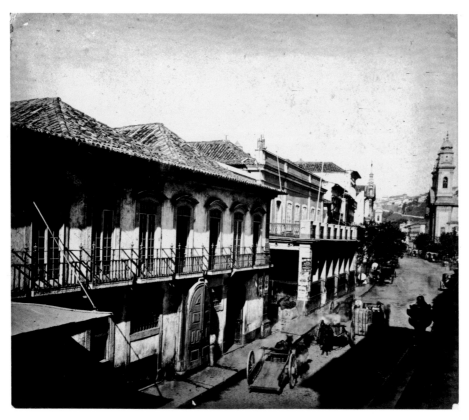

55

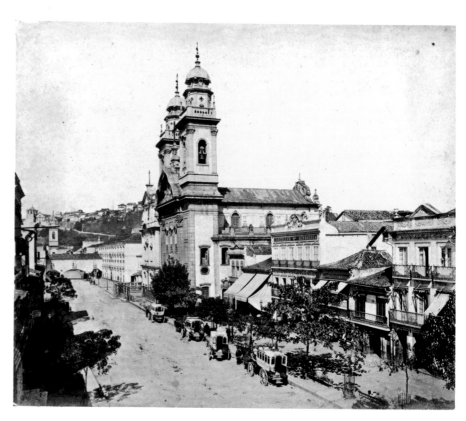

56

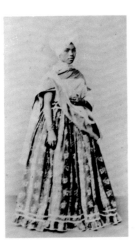

57

55. *Casa Leuzinger albumen 17.9 × 21.3 cm GF*
The principal thoroughfare of Rio de Janeiro before the
opening of Avenida Central: Rua Direita (now Rua 1.º de
Março), c. 1860. From left to right: a 17th-century house;
the Casa dos Contos, present site of the Banco do Brasil;
the old customshouse, then the Praça do Comércio; on
the other side of the street, the towers of the Igreja do
Carmo, and, in the background, the Morro do Castelo.
Notice the means of transportation at that time, before
the existence of the tramway.

56. *Casa Leuzinger albumen 18.3 × 21.6 cm GF*
Rio de Janeiro, c. 1865. Rua Direita (later 1.º de Março),
the stretch known as Carceler, and the first burro-drawn
buses, called Gôndolas, lined up at their stand. This part
of the street extends from Largo do Paço to Rua do
Ouvidor. In the establishment Carceler, owned by
Schroeder, the first ice creams in the city were sold. In
the distance, the Morro do Castelo with the Jesuit church,
the tower of Igreja de São José, and the covered overhead
walkway that linked the Paço da Cidade and its depen-
dencies to the former Convento do Carmo, the cathedral
and the Igreja da Ordem Terceira do Carmo, their
churchyards protected by fences.

57. *Casa Leuzinger albumen 9 × 5 cm GF*
Six cartes de visite. Street vendors of Rio de Janeiro, c.
1865.

Descendent of a family of artists, Marc Ferrez oc-
cupies a special place in the history of Brazilian
photography owing to his extrordinary sensibility, as
well as the fact that he dedicated himself almost ex-
clusively to landscape photography. This decision
required a considerable devotion and commitment
on the part of the photographer since portraiture
was a much more lucrative application of photogra-
phy at that time. However, this is not to say that
Ferrez was not also a distinguished portraitist. The
proof of this resides in the photographs he made of
his family and several of his closest friends, as well
as those that he made, at the Emperor's request, of
the Royal Family at home. They are informal pho-
tographs. In some, the backdrop is merely a simple
white sheet that does not even appear to have been
pressed.

The life and works of Marc Ferrez are dealt with
in greater detail in the last part of this book.

61

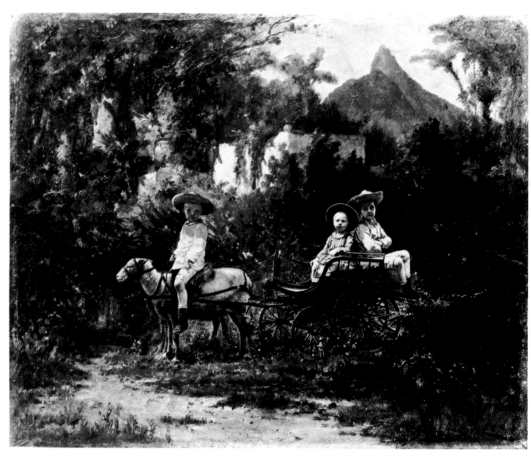

62

61. *Marc Ferrez pni 5.3 × 10.3 cm DPOB*
The children of Princess Isabel and the Count d'Eu: D.
Pedro de Alcântara, D. Luís Felipe, and D. Antônio Gas-
tão.

62. *Langerock painted photograph 53 × 64 cm*
A beautiful and rare painted photograph. The photo-
graph by Marc Ferrez was enlarged and painted by the
artist Langerock in 1885. Only the children and the cart
were in the photograph. The landscape is the painter's
creation.

63. *Marc Ferrez albumen 18 × 14.5 cm DPOB*
The private office of D. Pedro II at the São Cristovão es-
tate, c. 1885. Photographs of the palace interiors are rare.

64. *Marc Ferrez albumen DPOB*
Carte de visite. Princess D. Isabel with her three sons, D.
Pedro de Alcântara, D. Luís, and D. Antônio Gastão, and
the Countess of Barral,
c. 1888.

65. *Marc Ferrez albumen 9.2 × 12.6 cm DPOB*
Princess D. Isabel playing piano in the company of Bar-
oness de Muritiba, in the Palácio das Laranjeiras, Rio de
Janeiro, c. 1886.

63

64

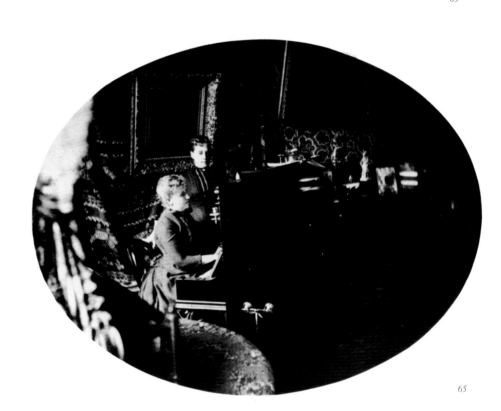

65

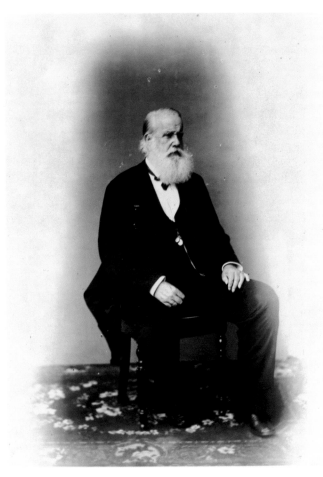

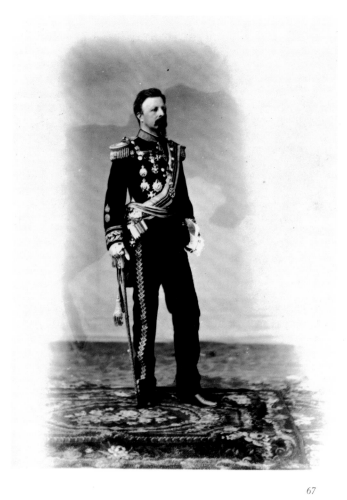

66

67

66. *Marc Ferrez mc 24 × 18 cm GF*
Informal photograph of D. Pedro II in the Paço de São
Cristóvão, c. 1875.

67. *Marc Ferrez mc 24 × 18 cm GF*
The Count d'Eu at the Paço de São Cristóvão in 1885 at
the age of 43, wearing the uniform of a field marshall in
the Brazilian Army, the sash of honorary orders of the
Empire, and all his decorations, as well as the insignia of
Counselor of State on his sleeve.

68. *Marc Ferrez mc 16.5 × 22.2 cm GF*
Ambassadors' Hall at Quinta de São Cristóvão. At center,
Mima, a statue sculpted by Arthur Gobineau, minister
of France to Brazil, and presented by the artist to
D. Pedro II.

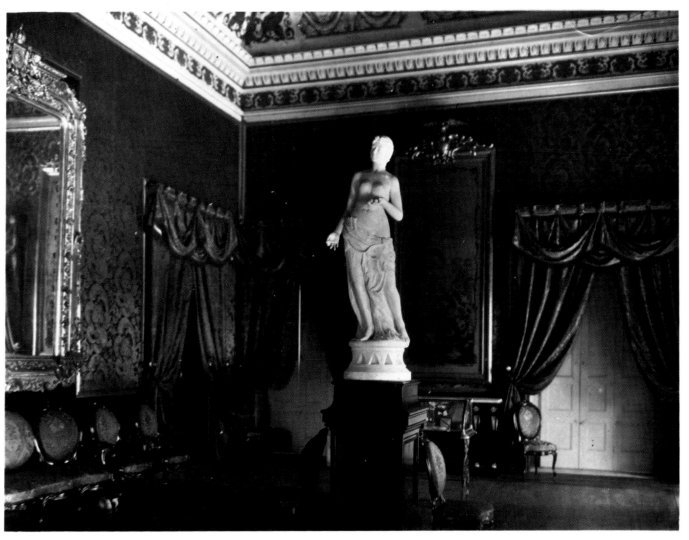

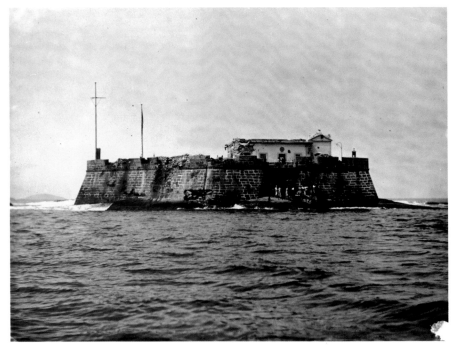

69

69. *Marc Ferrez mc 16.5 × 22.2 cm GF*
The Laje fort after the Naval Revolt in 1893. This is the
only photograph (to my knowledge) of the old Laje fort,
built in 1730.

70. *Marc Ferrez albumen 15.7 × 22.3 cm GF*
Entrance to the bay of Rio de Janeiro, seen from outside,
c. 1880. In the background, from left to right, the moun-
tainous countours of Dois Irmãos, Gávea, Pedra Bonita,
Serra da Carioca, Corcovado, and Pão de Açúcar.

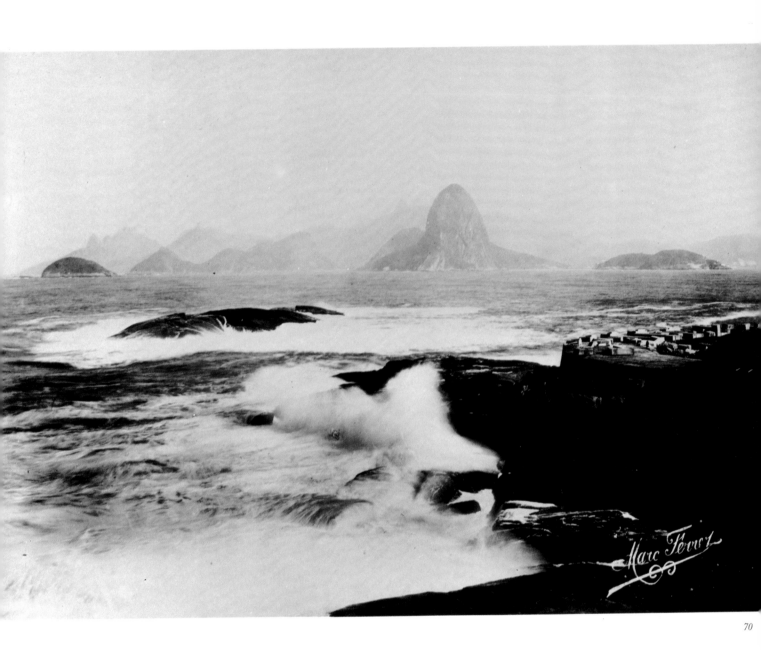

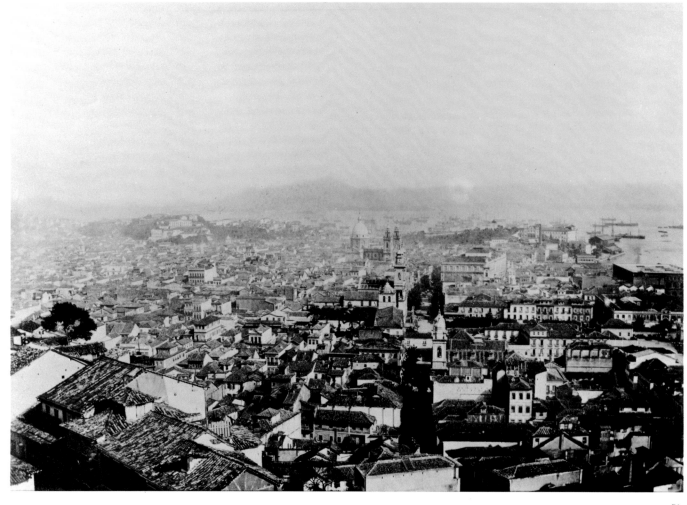

71

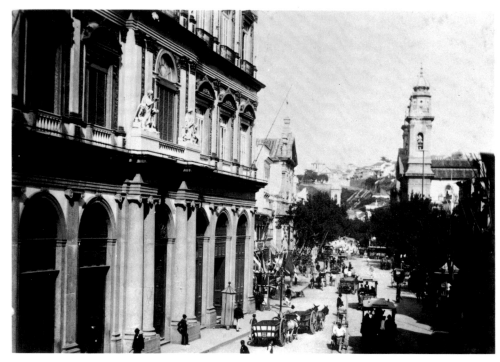

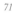

72

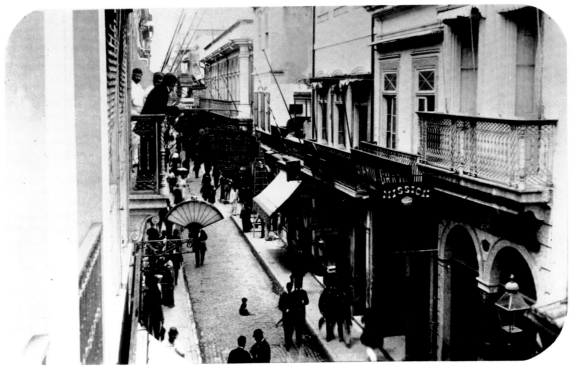

73

71. *Marc Ferrez albumen 16 × 22.2 cm GF*
The center of Rio de Janeiro in 1880, seen from Morro do
Castelo at the intersection of Ruas da Misericórdia and
1.º de Março. Only the church towers can be distin-
guished amid the compact mass of roofs.

72. *Marc Ferrez albumen 16 × 22.3 cm GF*
Animated view of the principal artery of Rio de Janeiro
in 1883, Rua 1.º de Março. It was the street of big busi-
ness, banks, the customshouse, the Central Post Office
(visible at left), and the churches Cruz dos Militares, the
Ordem Terceira de Nossa Senhora do Monte do Carmo,
and the Cathedral. Note the burro-drawn trams and the
kiosks.

73. *Marc Ferrez gelatin silver (?) 11.5 × 18 cm GF*
Rua do Ouvidor, in 1892, was the most fashionable street
in Rio de Janeiro, following the opening of the ports. Lo-
cated there were the newspapers, luxury stores, pastry
shops, and bookstores. It was among the first to be paved
with cut stones.

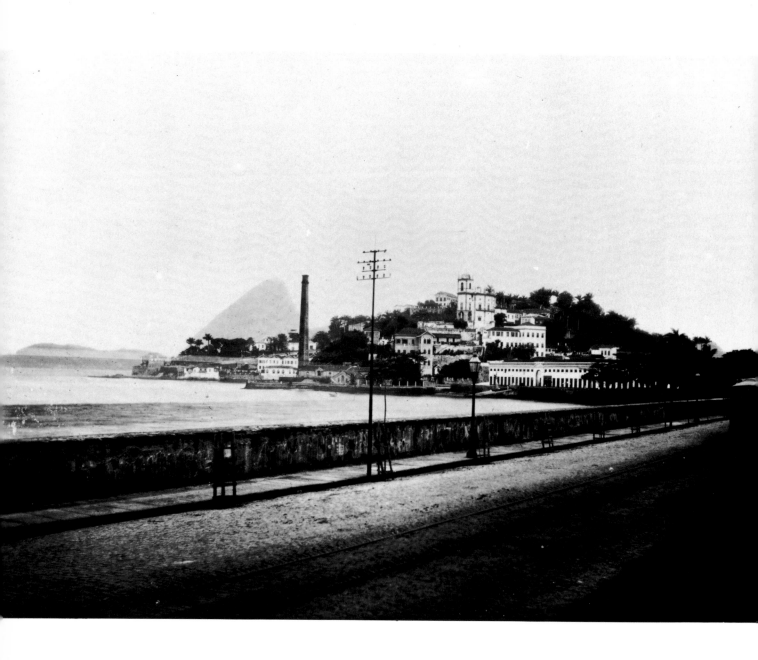

74. Marc Ferrez albumen 16 × 22.3 cm GF
The beach, hill, church, and market of Glória, Rio de
Janeiro, in 1875. Note that the tram is still pulled by
burros. The chimney belongs to the City Improvement
station.

75. Marc Ferrez gelatin silver (?) 11.5 × 18 cm GF
Rio de Janeiro. Praia de Botafogo, with Corcovado and
the Morro de D. Marta visible in the distance. Taken in
1875 when one went fishing dressed in a suit and hat.

76. Marc Ferrez gelatin silver (?) 11.5 × 18 cm GF
Rio de Janeiro. Praia de Botafogo in 1885, in the days of
the burro-drawn trams.

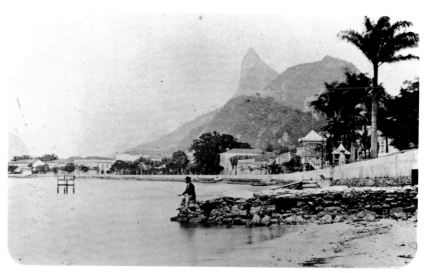

75

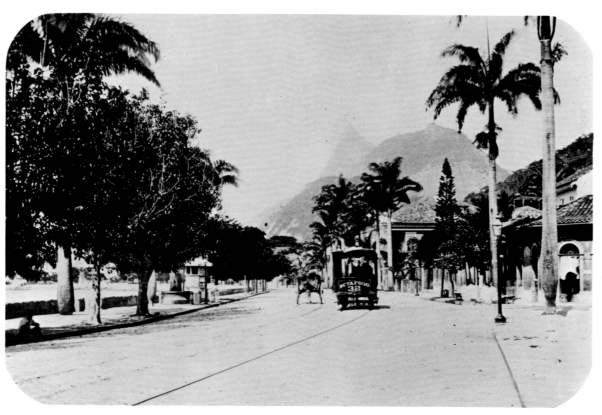

76

77

77. *Marc Ferrez gelatin silver 11.5 × 18 cm GF*
Petrópolis. Westphalia in 1875.

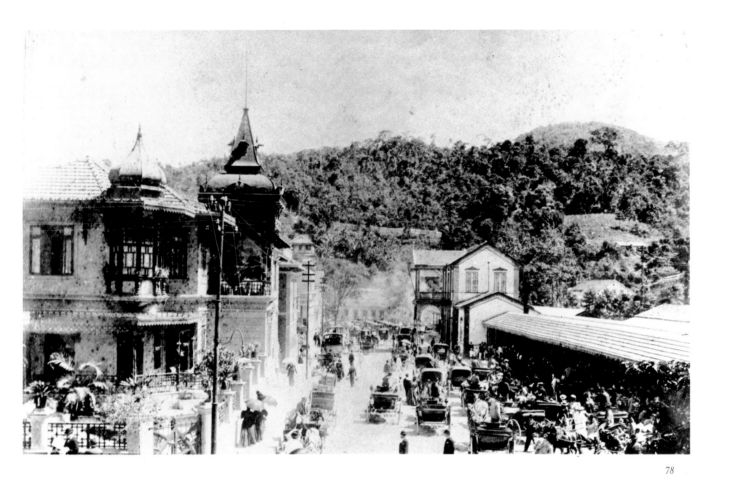

78

78. Marc Ferrez albumen 16 × 22.5 cm GF
Arrival of the train in Petrópolis, c. 1895. Apparently,
there was already a traffic problem!

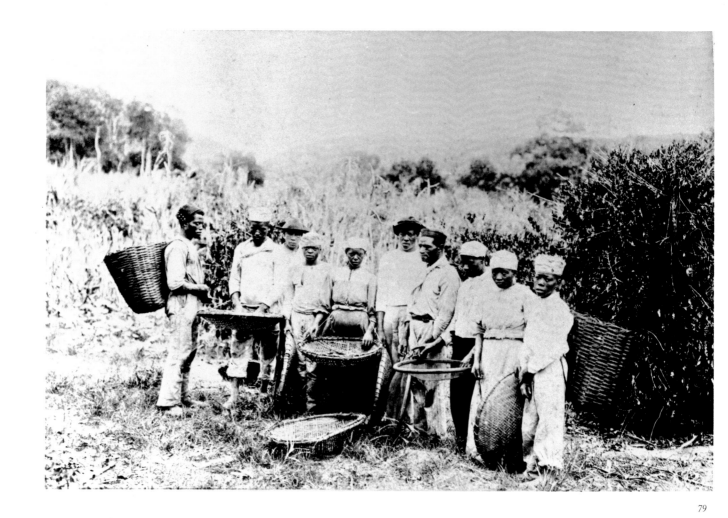

79

79. *Marc Ferrez* albumen *16 × 22 cm* GF
Slaves gathered for the coffee harvest, c. 1882, Rio de Janeiro State.

80. *Marc Ferrez* mc *16 × 22 cm* GF
Slaves harvesting coffee on a plantation in the Paraíba Valley, c. 1882.

81. *Marc Ferrez* mc *16 × 22 cm* GF
Coffee plantation: plantation house, terraces for drying coffee, and slave quarters, c. 1882.

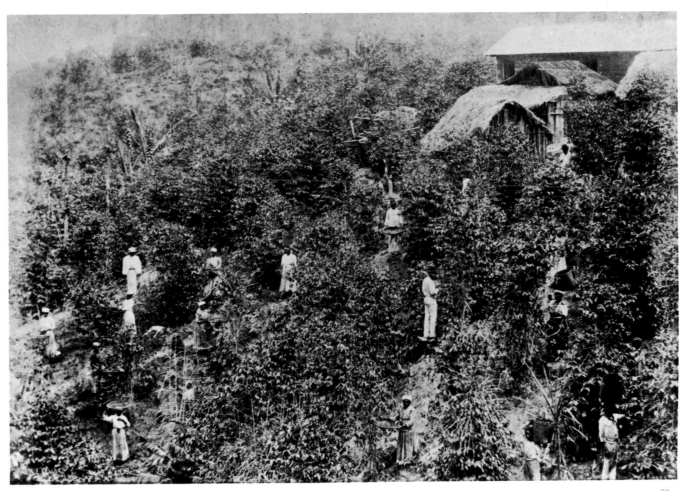

80

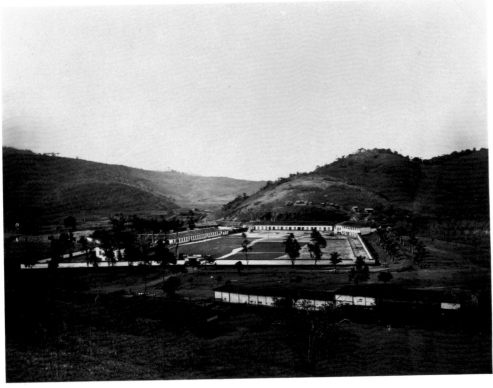

81

Appearing for the first time in the *Almanak Laemmert* of 1871 was the firm of Alberto Henschel & Co., photographers to the Imperial Family. Henschel had studios in a number of locations throughout Brazil: in Rio de Janeiro, at 40 Rua dos Ourives; in Salvador [Bahia], at 16 Rua Direita da Piedade; and in Recife [Pernambuco], at 2 Largo da Matriz de Santo Antônio. Henschel, who was German, arrived in Rio in 1870. On December 25 of the same year, he announced in the *Jornal do Commercio*:

> The opening of the German Photographic establishment of Alberto Henschel & Co., successors of Mangeon and van Nyvel.
>
> The great esteem that our photographic establishments in Pernambuco and Bahia have enjoyed for a number of years has encouraged us to open another, here in the capital, with all the popular sizes [necessary] to satisfy the most demanding clientele in matters of this art.

Henschel photographed Rio and the surrounding area, going as far as Nova Friburgo and even to the mountainous region of Itatiaia, which attracted few travelers in those days. He made landscape photographs, but, above all, he was an outstanding portrait photographer. There is hardly an old family album in Brazil that does not include portraits of grandparents taken by Alberto Henschel. Dom Pedro II and his family were good customers of this artist-photographer. Henschel exhibited in the Imperial Academy of Fine Arts and in various local and national *salons*. In the Exhibition of 1875, he showed an oil portrait of the Prince of Grão-Pará. The Biblioteca Nacional has a copy of his album *Lembrança de Nova Friburgo* in the collection of Empress Teresa Cristina. It contains photographs taken around 1875, and eight unbound views of Itatiaia. The Instituto Histórico e Geográfico Brasileiro possesses a large panorama of Rio that was taken by Henschel, while I myself own a number of loose views of Itatiaia. Later, the firm changed its name to Henschel & Benque. Carlos Ernesto Papf, who worked for Henschel for many years making painted photographs, eventually took over the business.

A ARTE PHOTOGRAPHICA

Photographo. — Se V. Ex. quizesse permittir, pagaria este pequeno signal.
Dama. — Lá isso não; se quizer mudar alguma cousa, póde mudar no penteado.

Eis a mudança pequena que o Sr. Henschel fez, afim de não comprometter as suas officinas. E dizem ainda que a photographia não é capaz de lisongeiar!

The Photographic Art
Photographer: "If Madame would allow me to touch up this little 'beauty mark?'"
Lady: "Certainly not. If you wish to change something, you may adjust my coiffure."
This is the small change that Mr. Henschel made, so as not to jeopardize his business.
And they say that photography is incapable of flattery!

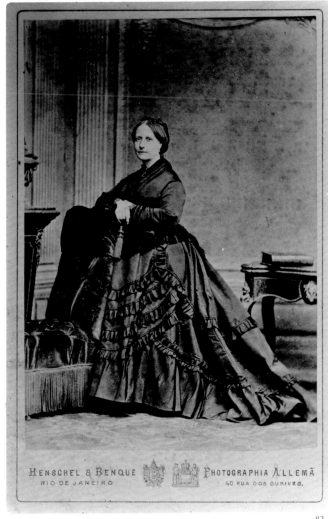

82

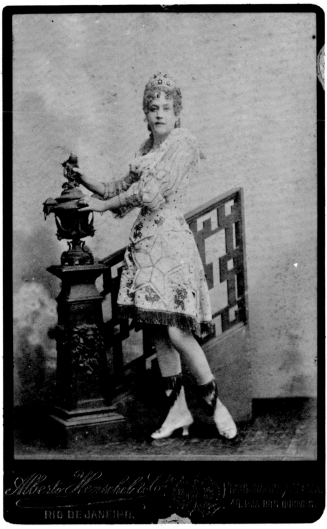

83

82. *Henschel & Benque albumen DJOB*
83. *Henschel & Benque albumen 14.1 × 10 cm GF*

Two examples of portraits taken by Alberto Henschel
and Francisco Benque: one of the Empress Teresa
Cristina, c. 1875, the other of an anonymous chorus girl.
The sitters are posed beside the ever-present column or
table bearing the ornate vases then used as studio props.

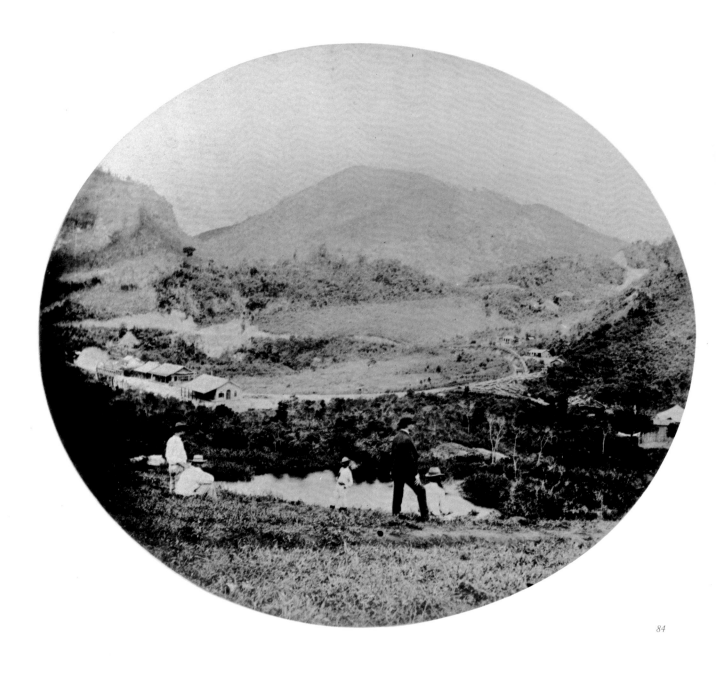

84

84. *Henschel & Benque albumen 20 × 23.5 cm BN*
Valley and station in Rio Grande, near Nova Friburgo,
Rio de Janeiro State, c. 1875.

85. *Henschel & Benque albumen 20.5 × 26 cm GF*
The Prateleiras seen from Silvério Valley, in Itatiaia, Rio
de Janeiro State, c. 1870.

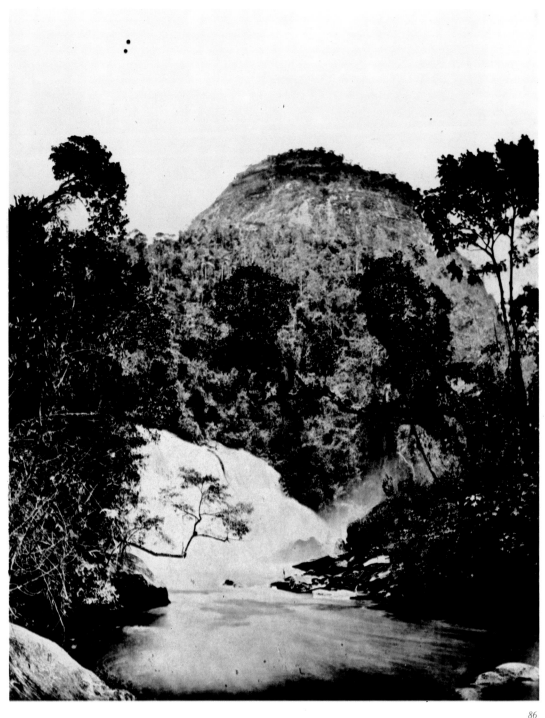

86. *Henschel & Benque albumen 26 × 21 cm BN*
Pinel Falls, in Nova Friburgo, c. 1875.

87. *Henschel & Benque albumen 20 × 27 cm GF*
Panorama of the city of Friburgo, c. 1875.

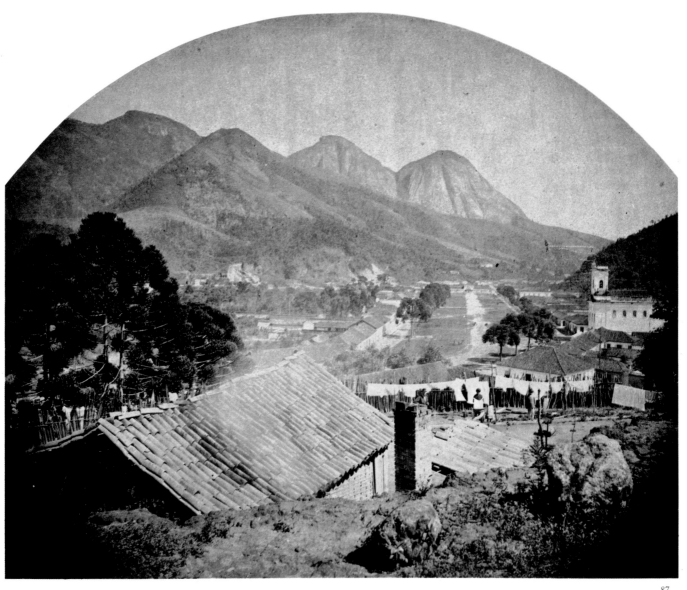

Like every city of distinction, Petrópolis had its photographers, some of real merit. During the second half of the nineteenth century, Petrópolis functioned as the de facto capital of the country during the summer months. From November until May, the Emperor, his family, the Court, officials, and summer vacationers all moved there. Several foreign legations even had their permanent headquarters in Petrópolis, so great was the fear of yellow fever which raged intermittently in Rio de Janeiro.

Of the photographers working in Petrópolis during the period covered by this study, one—Revert Henrique Klumb—has already been mentioned among those active in the city of Rio de Janeiro.

Another was Ernesto Papf, a painter of good portraits and excellent landscapes. Like so many others, he fell in love with the new art once it appeared and became a convert to photography. In 1855, he lived on Rua do Barão do Amazonas, next to the Hotel Orleans (later the Palace) and advertised his professional services in the *Guia de Petrópolis* by Th. C. (Cameron). He specialized in group portraits and views of Petrópolis and of the railroad. He was succeeded by his son, Jorge Henrique Papf, whose photographs illustrated the *Guia da Cidade de Petrópolis*, published around 1920 under the direction of Júlio Pompeu de Castro Albuquerque. Copies were sold for the price of 3,000 *réis*.

The *Almanak Laemmert* of 1869 contains references to the photographic studio of a certain Nogueira, on Rua Paulo Barbosa. Located on Rua Dom Afonso was the studio of Pedro Hees (1841–80). His views of nearly every street in Petrópolis, taken between 1865 and 1875, are indispensable for the study of that city. His children carried on their father's work. Otto Hees (1870–1941) served as the photographer for the firm of Hees Irmãos [Hees Brothers], which remained in business, producing excellent work, until 1915. An advertisement dated 1892 announced that the firm would receive clients at 8 Praça Dom Afonso [present-day Liberdade], where photographs were made using "the most modern methods." The Hees Studio made the group portraits of the Imperial family that were taken on the entrance staircase of Princess Isabel's palace in Petrópolis just days before their exile. Many families in Petrópolis, among them my own, have works by Hees in their albums.

The Biblioteca Nacional has two albums entitled *Vistas de Petrópolis* in which fifteen albumen prints by Pedro Hees can be identified. The albums are well preserved. One belonged to the collection of Empress Teresa Cristina.

88

88. Otto Hees albumen 27 × 21.5 cm DPOB
The Imperial Family a few days before the proclamation of the Republic. From left to right: Empress D. Teresa Cristina, D. Antônio, Princess Isabel, D. Pedro II, D. Pedro Augusto, D. Luís, the Count d'Eu, D. Pedro—Prince of Grão-Pará.

89. Pedro Hees albumen 22 × 28.5 cm BN
Petrópolis, 1867. The palace of Emperor D. Pedro II, the only residence he ever had built for himself, shortly after its inauguration. In the foreground, Rua da Imperatriz (now Rua 7 de Setembro).

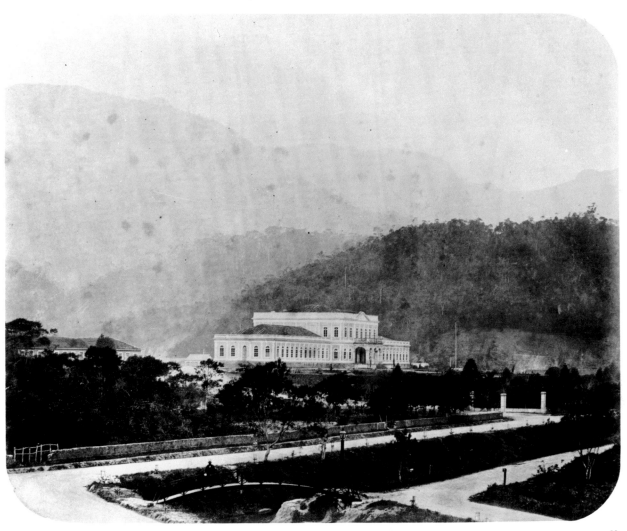

89

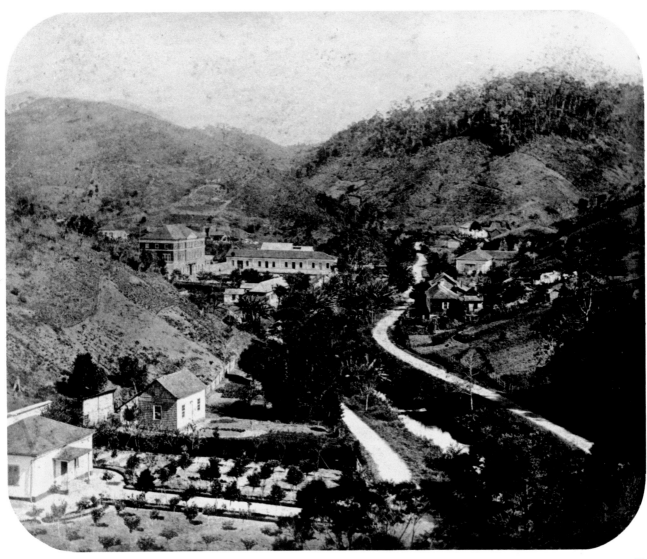

90

90. *Pedro Hees* *albumen* *19.7 × 24.5 cm* *BN*
Rua Nassau (now Rua Piabanha), in Petrópolis, 1867.
The large building at left was the main building of Co-
légio Kopke, then one of the best in the state of Rio de
Janeiro. Here, too, the deforestation was extensive.

91. *Pedro Hees* *albumen* *20 × 22.5 cm* *BN*
Rua do Imperador in Petrópolis, 1867. In the right-hand
corner, Ruas D. Januária and D. Francisca (now Ruas
Marechal Deodoro and General Osório); in the back-
ground, at left, the house of the Baron d'Ubá.

92. *Pedro Hees* *albumen* *19.5 × 25.5 cm* *BN*
Rua da Renânia (now Rua Coronel Veiga) in Petrópolis,
1867. Note the process of deforestation already under
way at that time.

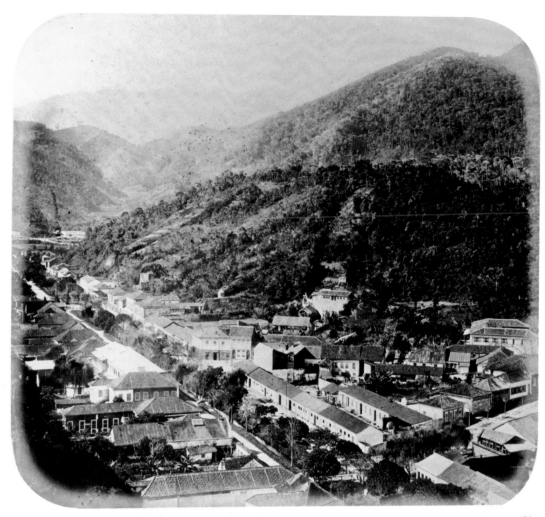

91

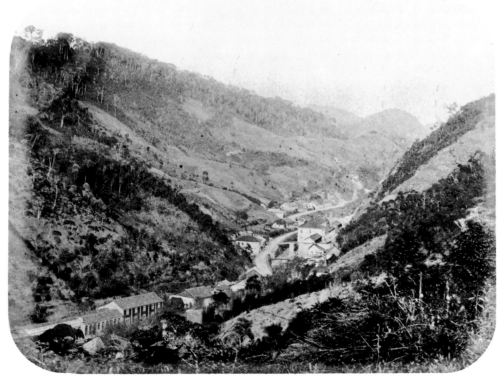

92

93

93. *Pedro Hees albumen 20 × 48 cm BN*
Cemitério Novo, in Petrópolis, 1867.

94. *Pedro Hees albumen 25 × 20.5 cm BN*
Cascatinha do Retiro, c. 1867, presently known as Cas-
catinha de Petrópolis. Located beside the Estrada União
Indústria, opposite the entrance to Vale do Retiro.

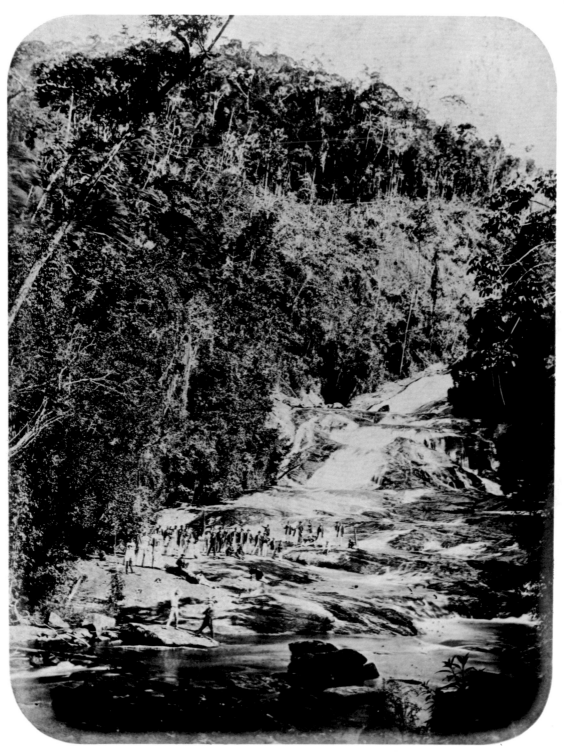

The historic photographs of May 13, 1888 [the
date of the abolition of slavery in Brazil] were taken
by the photographer Luís Ferreira, about whom we
know nothing. His name does not even appear in
listings of professional photographers established in
Rio de Janeiro, leaving us to suppose that he worked
for one of the newspapers of the period.

95

96

97

95. *A. Luís Ferreira albumen 23 × 18 cm DPOB*
Rio de Janeiro. May 13, 1888, in front of the offices of *O Paiz,* one of the most important newspapers of the period.

96. *A. Luís Ferreira albumen 28.7 × 51.5 cm IHGB*
Rio de Janeiro, 1888. Outdoor Mass offered in thanks for the abolition of slavery in Brazil, attended by the entire Imperial Family, on the grounds of São Cristovão.

97. *A. Luis Ferreira albumen 18 × 23 cm DPOB*
Rio de Janeiro. Princess Isabel, with the Count d'Eu, acclaimed by the crowd on the balcony of the Paço da Cidade, following the signature of the Lei Áurea [Golden Law, abolishing slavery], May 13, 1888. The photograph is signed, at right.

J. Gutierrez was a little-known Spaniard who is remembered for his photographic coverage of the destruction that resulted from the Naval Revolt led by Admiral Custódio José de Mello in 1893. He allegedly died photographing the campaign of Canudos (1896–97). The Biblioteca Nacional, the Museu Histórico Nacional, the Biblioteca da Marinha, and the author all possess works by this photographer. His studio was located at 40 Rua Gonçalves Dias.

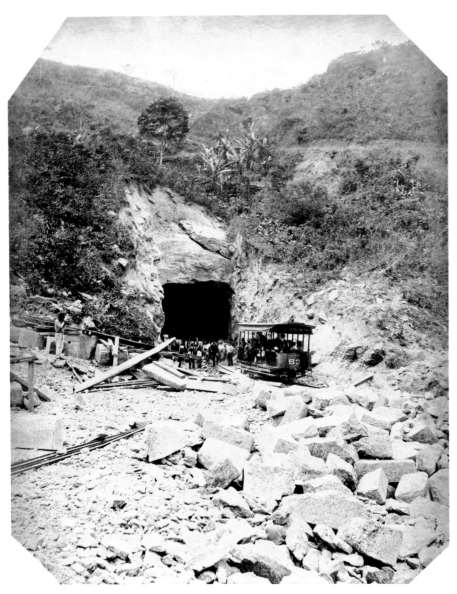

98

99

98. J. Gutierrez albumen 25.5 × 20.5 cm GF
Rio de Janeiro. Inauguration of the tunnel known today
as Túnel Velho and of the tramway to Copacabana, on
July 1, 1882.

99. J. Gutierrez albumen 18 × 27 cm GF
Rio de Janeiro. Praia de Copacabana in 1892. Note, at
left, what would become the future Avenida Nossa
Senhora de Copacabana. In the distance, the Morro dos
Cabritos and the Garganta do Cantagalo.

100

100. J. Gutierrez albumen 18 × 27 cm GF
Unusual photograph of the Igreja de Sta. Luzia, seen
from the Morro do Castelo, c. 1882. In the distance, Pāo
de Açúcar and the Morro da Glória.

Minas Gerais

Photography came early to Minas Gerais. Five years after Compte's demonstrations in Rio, photography was already being practiced in Ouro Preto. It had been brought there from the nearby city of Pouso Alegre, where the Frenchman Hippolyte Lavenue made his residence, having "brought with him the celebrated machine for making portraits, the amazing invention of the distinguished painter Daguerre."[52] The previously mentioned daguerreotypes, exhibited by Lavenue's wife in 1842 at the Imperial Academy of Fine Arts, must have been the first, anywhere, to be included in an official, government-sponsored, artistic *salon*.

In 1856, M. F. de Abreu established a photographic studio in Ouro Preto, at 34 Rua Direita. There, he made portraits "toned or colored, in every known size, with all the perfection that the art has attained and at very reasonable prices. Commissions accepted for photographic views of cities, villages, farms, buildings, monuments, death portraits, reproductions of paintings, prints, statues, etc. . . . [as well as for] oil portraits and lessons in daguerreotypy, both practice and theory."[53] Apparently, Mr. Abreu was quite versatile. The prices of daguerreotype portraits from his studio began at 5,000 *réis*.

Aside from those already mentioned, there were other photographers in Minas Gerais. Their work, however, was limited to portraiture. Like many provincial photographers who added the "new art" to the services they already offered the public, a resident of the parish of São Miguel de Piracicaba, advertised "portraits made using photographer [sic] and ambrotype with every perfection, cleanliness, and promptness . . . also, false teeth affixed by every system known today. . . ."[54]

In 1868, Augusto Riedel, who accompanied the Duke of Saxe and his brother Don Luís Felipe on their visit to Brazil, organized an interesting photographic album illustrating their long trip through the Brazilian countryside. In the collection of forty photographs are views of Ouro Preto, Mariana, Sabará, the mines of Morro Velho (St John d'El Rey Mining Co.), the house of Wilhelm Lund [the Danish anthropologist] in Lagoa Santa, the first steamboat on the Rio das Velhas, Diamantina and

its mines, and, finally, scenes on the São Francisco River—the route that took them to Penedo and, later, to Bahia, the terminal point of their expedition. The photographs were composed to be artistic and, at the same time, contain sufficient detail to convey information, for those who wished to study them for this purpose, about the various methods of exploration of the gold and diamond mines of the area. The photograph of Carnival in Sabará is delightful (Figure 111).[55]

The Office of the Patrimônio Histórico e Artístico Nacional owns a collection of ten panoramic views of Ouro Preto, taken approximately between 1870 and 1875 and printed on albumen paper measuring eighteen by twenty-four centimeters. Because of their remarkable sharpness and clarity of detail, these photographs are of great iconographic value to historians seeking information about the appearance of the city, its structures, streets, and vegatation at the time that these photographs were made (Figures 117 and 118). Unfortunately, the identity of the photographer is not known.

A certain Louis Bartolomeu Calcagno traveled through the cities of Minas Gerais in 1875. He was no more than an unskilled amateur, judging from the photographs that he exhibited in 1881 at the Biblioteca Nacional. Nevertheless, these photographs have documentary value today—especially one showing the Rua Municipal in the city of Uberaba in 1876, and the very unusual *charanga* [a small brass band of street musicians] that depicts these alms collectors at the Festa do Divino celebrations in the parish of Nossa Senhora da Abadia do Bom Sucesso, in the municipality of Monte Alegre in 1875.[56]

In the Instituto Histórico e Geográfico Brasileiro, there is an important collection of sixteen photographs of the mines at Morro Velho. Undated and of unknown authorship, they were taken sometime between 1875 and 1880.[57]

In 1882, Marc Ferrez put together a beautiful album (later acquired by the Biblioteca Nacional) that contains twenty-eight photographs of the Minas & Rio Railroad. The glass-plate negatives from which these photographs were printed belong to me.[58]

Around this same time, the photographer Guilherme Liebenau settled in Ouro Preto. He is responsible for an album, extant today, with seventeen views of Ouro Preto and Mariana. Sharp images of considerable iconographical value, they remain perfectly preserved. They are representative of the production of this artist who worked up until the day of his death. The album, which once belonged to Dom Pedro II, is now located in the Biblioteca Nacional.[59]

101. Augusto Riedel albumen 29.5 × 39.5 cm BN
Title page of the album of photographs taken by Riedel during a trip by the Duke of Saxe and his brother D. Luís Filipe to the Brazilian interior. Another copy of the album exists in the Bosch Foundation in Stuttgart.

102. Augusto Riedel albumen 23 × 28 cm BN
Diamond mine of Sr. Vidigal in the Rio Jequitinhonha (removal of the gravel). Minas Gerais, 1868.

103. Augusto Riedel albumen 22 × 26 cm BN
Diamond mine in Ribeiro do Inferno, Minas Gerais, 1868. The bed of the Rio Jequitinhonha was completely drained.

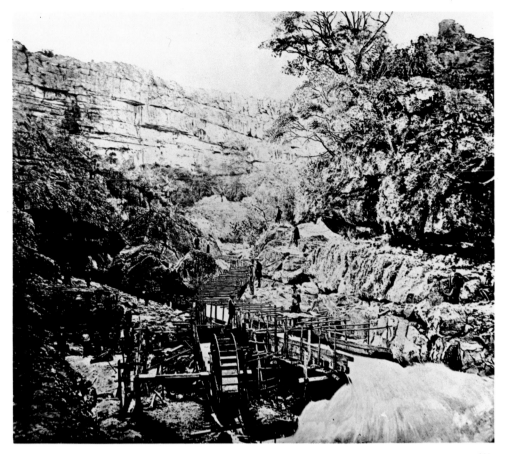

102

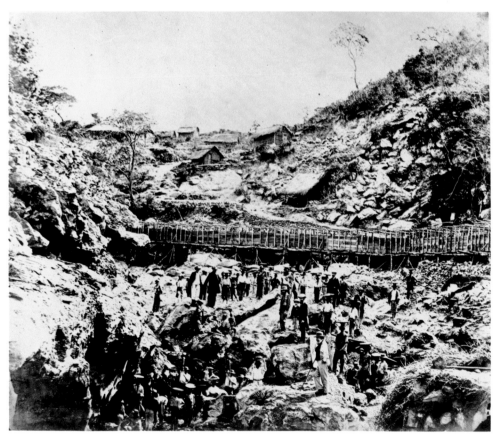

103

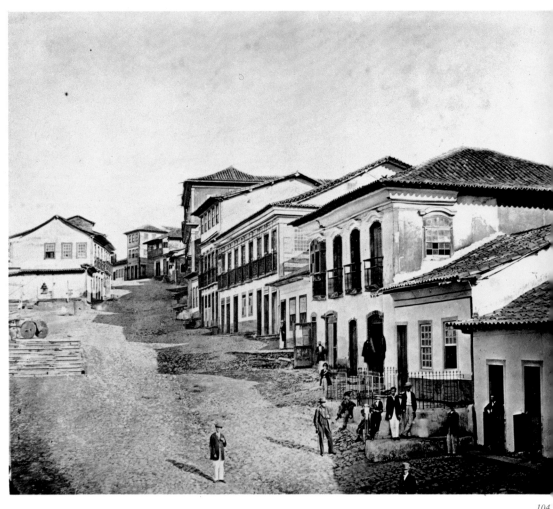

104

105

104. Augusto Riedel albumen 23.3 × 28 cm BN
Rua Direita in Diamantina, Province of Minas Gerais,
1868. The street is currently called Rua Tiradentes. The
town of Diamantina is under the protection of SPHAN.

105. Augusto Riedel albumen 22.2 × 28 cm BN
Lodgings of Their Highness the Duke of Saxe and Luís
Felipe at the house of Major Brant. Diamantina, Province
of Minas Gerais, 1868. Also visible are Rua Direita (now
Rua Tiradentes) and the back of the cathedral.

106. Augusto Riedel albumen 23 × 27.2 cm BN
City of Diamantina, 1868. From left to right: the market,
the church towers of Amparo, the cathedral, and São
Francisco.

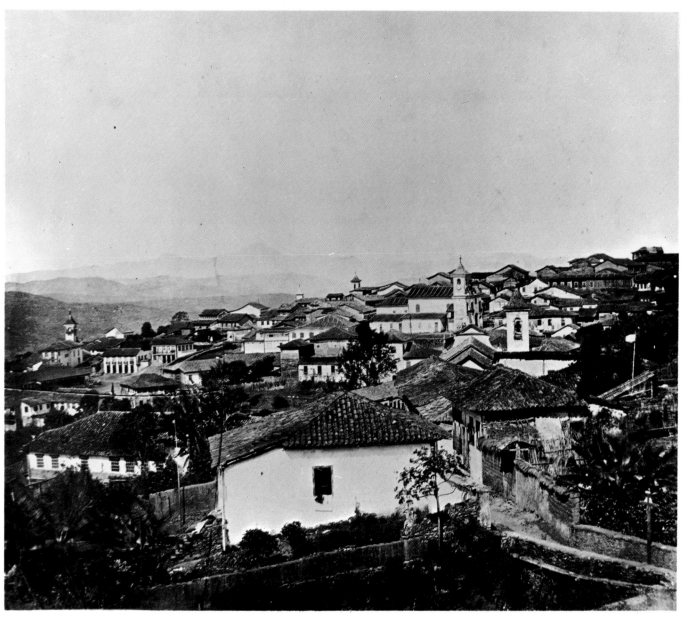

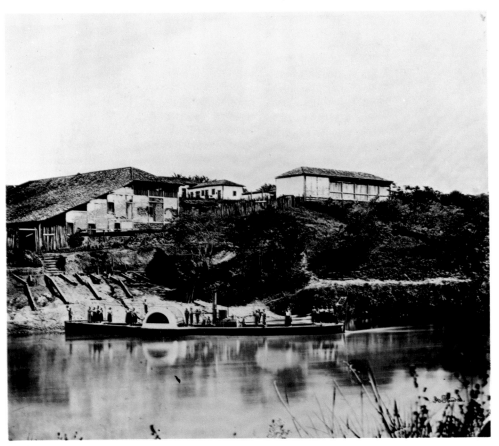

107

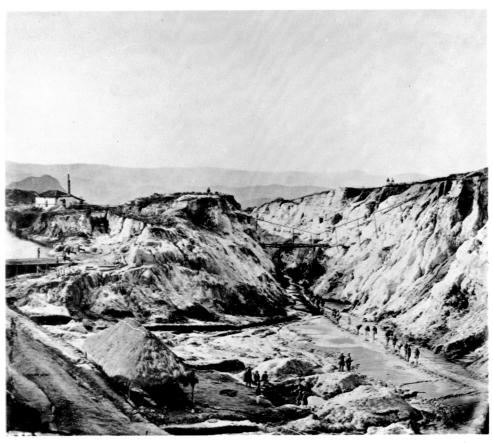

108

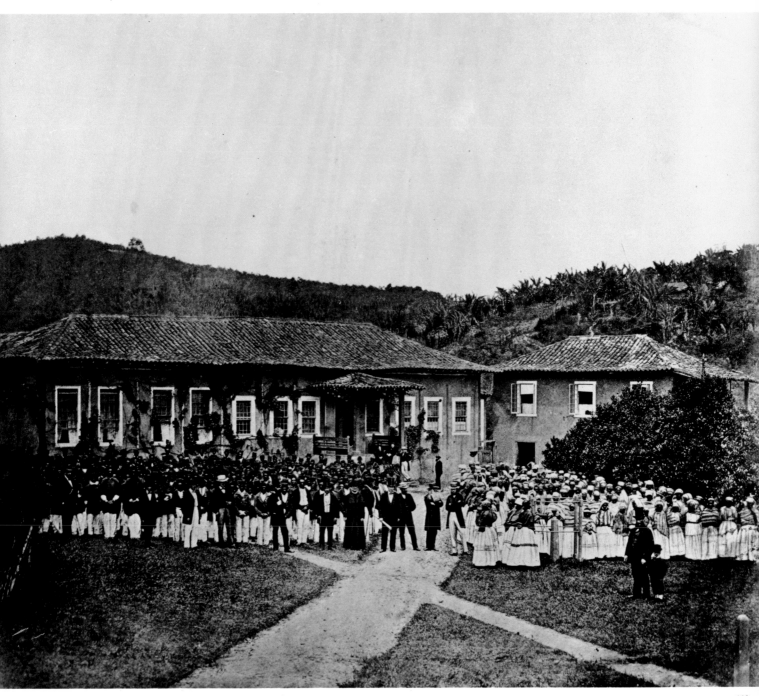

107. Augusto Riedel albumen 23.3 × 28 cm BN
The first steam-powered vessel to travel the Rio das
Velhas in Minas Gerais, in 1868. The site is the estate of
Sr. Dumont.

108. Augusto Riedel albumen 23.3 × 28 cm BN
Diamond mine of Felisberto d'Andrade Brant, in S. João
da Chapada, in Minas Gerais, 1868.

109. Augusto Riedel albumen 23.3 × 28 cm BN
Inspection at Morro Velho. Fortnightly inspection, in
front of the master's house, of all the slaves and the em-
ployees of the St John d'El Rey Mining Company, in
Morro Velho. This gold mine is still in operation and
quite profitable. It is one of the deepest in the world:
2,400 meters.

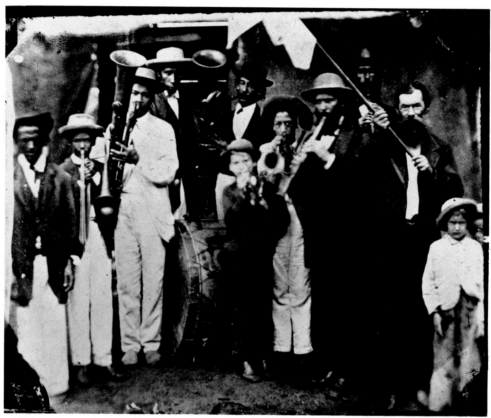

110

110. Calcagno albumen 10 × 12.7 cm BN
Musicians from the church of Nossa Senhora da Abadia
do Bom Sucesso, collecting money for the festival of the
Divino Espirito Santo, in 1875.

111. Anonymous pni 18 × 24 cm GF
Carnaval, 1898. The Clube Velho Mundo de Sabará.

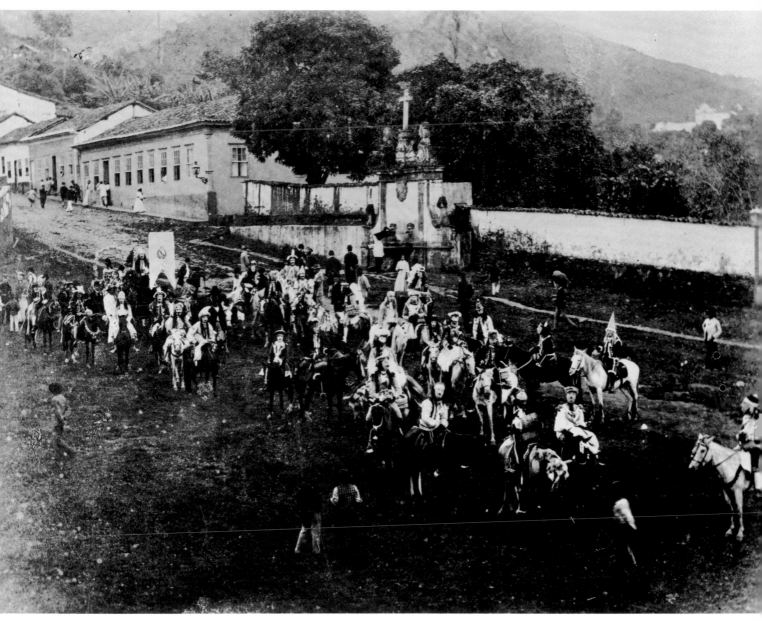

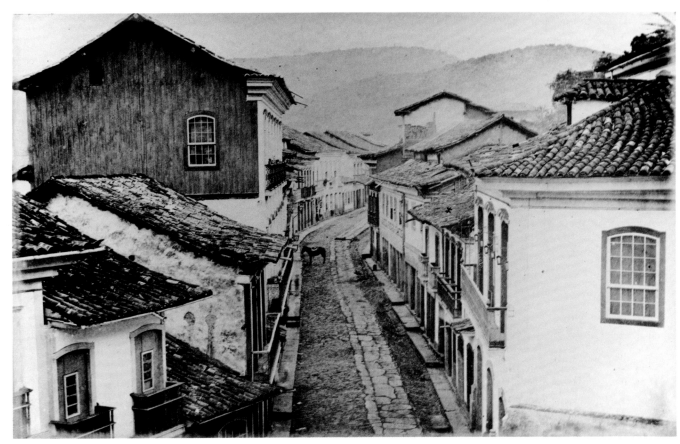

112

112. *Liebenau albumen 14 × 22 cm BN*
Rua Tiradentes, in Ouro Preto, 1875–80. Today the en-
tire city has been designated as part of the country's his-
torical patrimony and is under the protection of SPHAN
and UNESCO.

113. *Liebenau albumen 14 × 22 cm BN*
Ouro Preto, 1881. The plaza opposite the Matriz de An-
tônio Dias. Just beyond the crossroads, the Ponte de An-
tônio Dias, or Suspiros. On the other side, behind the
large building at left, the little house that had been the
residence of Marília de Dirceu. (The house was later de-
stroyed.) The steep pathway, called Vira-Saia, leads to the
Igreja de Santa Efigênia, atop the hill.

114. *Liebenau albumen 14 × 22 cm BN*
Rua Tiradentes and Rua Direita, in Ouro Preto, 1875–80.
At top, from left to right, the Esola de Minas, the former
Governors' palace, Tiradentes, the town hall and jail
(now the Museu da Inconfidência), and the Igreja do
Carmo. Below, at left, the fountain of the Casa dos
Contos.

113

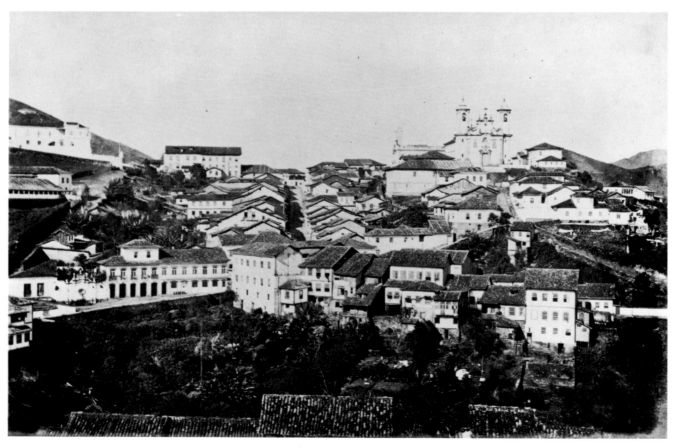

114

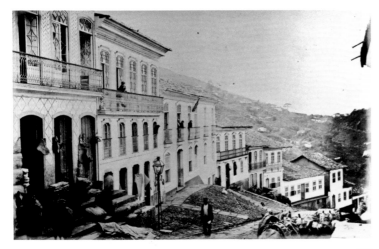

115

115. Liebenau albumen 14 × 22 cm BN
Rua do Ouvidor (now Rua Cláudio Manuel da Costa) in
Ouro Preto, 1881. The building at center, with three peo-
ple at the windows, served as the residence of the poet
Tomás Antônio Gonzaga.

116. Liebenau albumen 14 × 22 cm BN
Largo da Praça—Assembléia—Câmara—Cadeia, today,
Praça Tiradentes, Ouro Preto, 1881. At the center of the
square, the original column in memory of Tiradentes. In
the background, the Governors' palace (now Escola de
Minas); at right, the assembly building, then courthouse,
destroyed by fire and long since rebuilt with alterations,
the Casa da Baronesa, local office of SPHAN, and the
building of the Prefeitura.

117. Anonymous albumen 19.4 × 23.7 cm SPHAN
Panorama of Ouro Preto, c. 1875: at left, the Igreja do
Rosário; atop the hill, that of S. Franciso de Paulo; at bot-
tom, the Ponte do Rosário. At right, on top, the Igreja
das Mercês de Cima and the former Governors' palace,
and, just below, the back of the Igreja de São José and
residential buildings typical of the city.

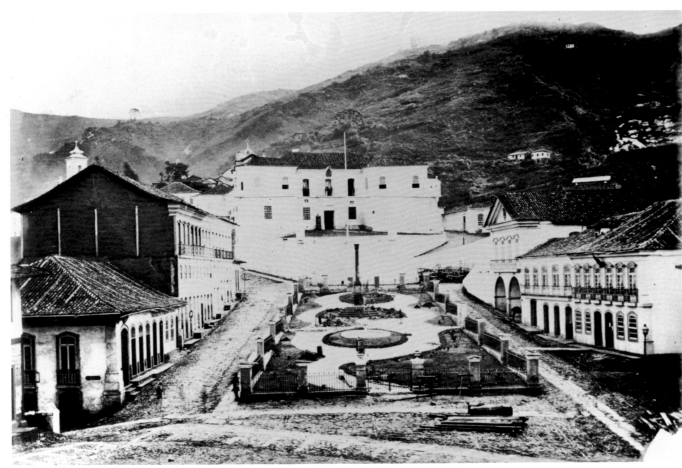

116

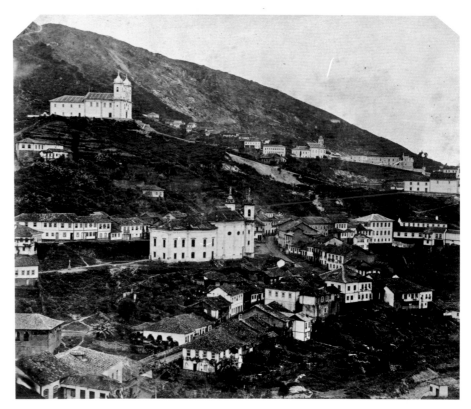

117

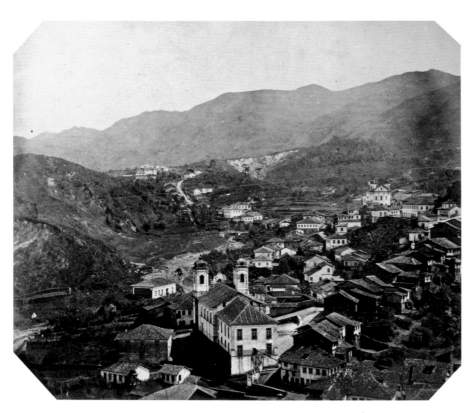

118

118. Anonymous albumen 19.7 × 24.3 cm SPHAN
Back of the Matriz de Antônio Dias and of the houses on
Rua Santa Efigênia, and Igreja das Dores, in Ouro Preto,
c. 1875.

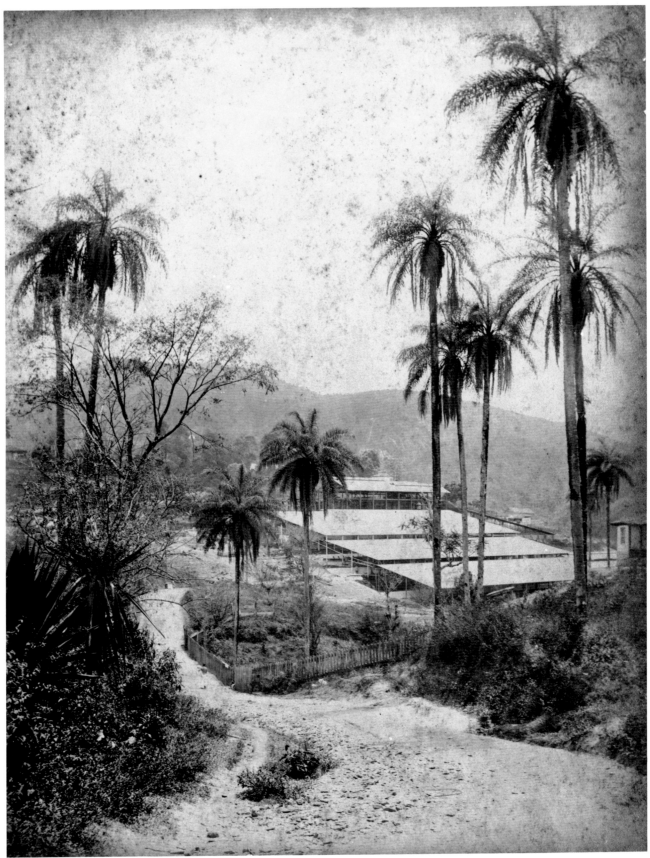

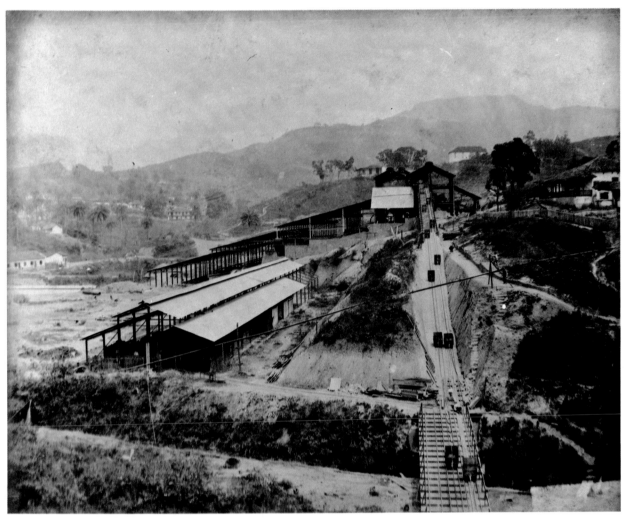

120

119. *Anonymous albumen 25 × 20 cm IHGB*
The storage sheds of the Morro Velho gold mine, property of the St John d'El Rey Mining Co., seen through a grove of palm trees, 1884.

120. *Anonymous albumen 19.5 × 21.8 cm IHGB*
The Morro Velho mine, belonging to the St John d'El Rey Mining Co., 1884. The cars loaded with ore were brought to the top of the storage area, where the process of extracting the gold was carried out.

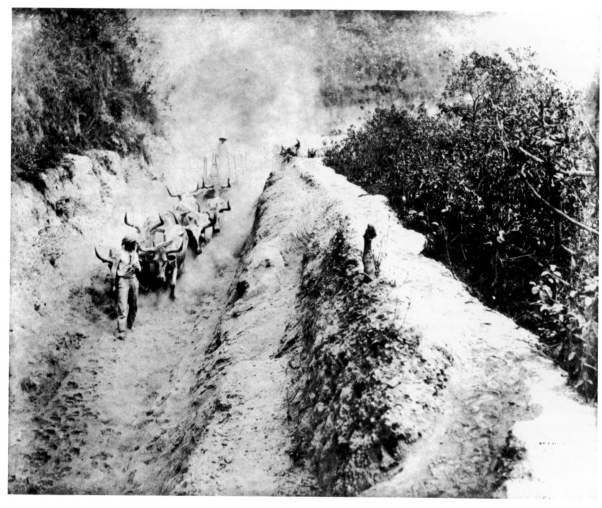

121

121. *Anonymous albumen 24.5 × 19.5 cm IHGB*
Ox cart traveling a dusty path at the gold mining in-
stallations of Morro Velho, 1884.

122. *Marc Ferrez mc 16.4 × 21.5 cm GF*
The sanctuary of Congonhas do Campo, c. 1880. The
Igreja do Senhor Bom Jesus de Matozinhos and the
chapels of Passos da Paixão de Cristo.

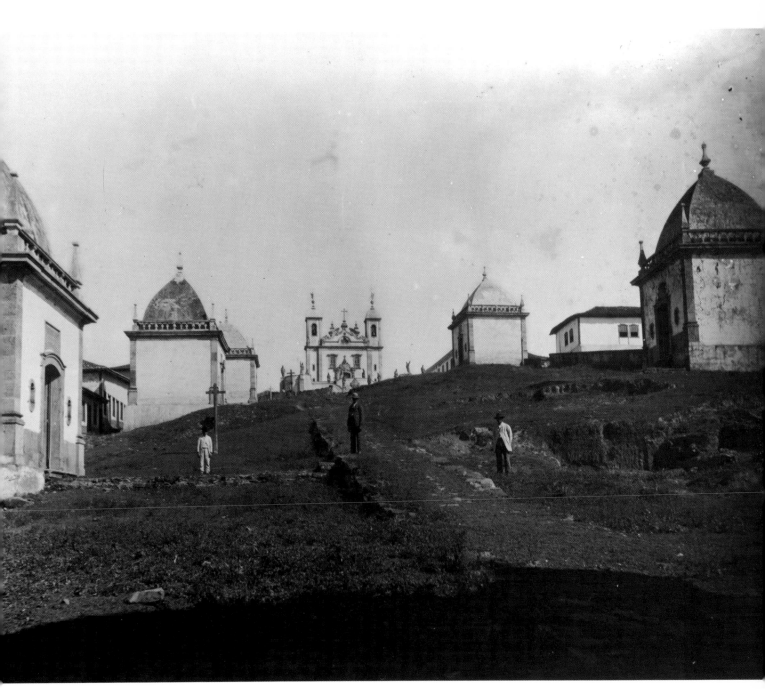

123

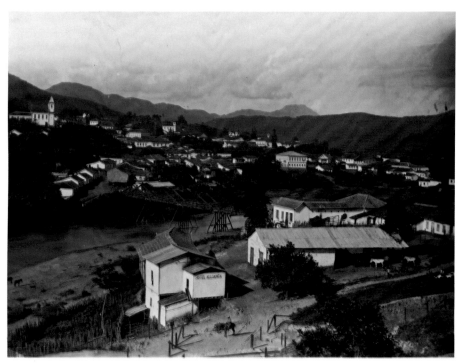

124

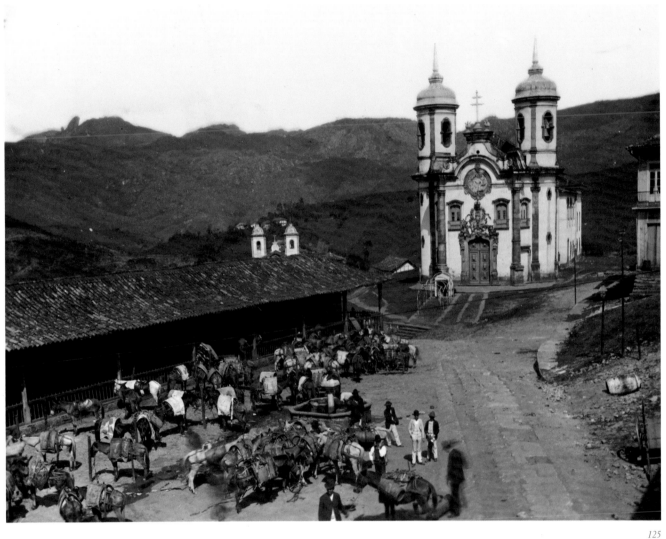

125

123. *Marc Ferrez mc 16.4 × 22 cm GF*
In this photograph one can see the former disposition of
the figures carved by Antônio Franciso Lisboa [Alei-
jadinho], and his assistants, when the works were still in
a perfect state of conservation and the majority of the ob-
jects had not yet disappeared.

124. *Marc Ferrez mc 16.4 × 21.9 cm GF*
General view of the city of Sabará, c. 1880.

125. *Marc Ferrez mc 16.4 × 21.9 cm GF*
Ouro Preto, 1880. The market and church of São Fran-
cisco, the finest work of Aleijadinho. Unfortunately, the
market no longer exists. On the site of the fountain, there
was once a pillory. Visible are the towers of the Igreja das
Mercês de Baixo and, in the distance, Itacolomi.

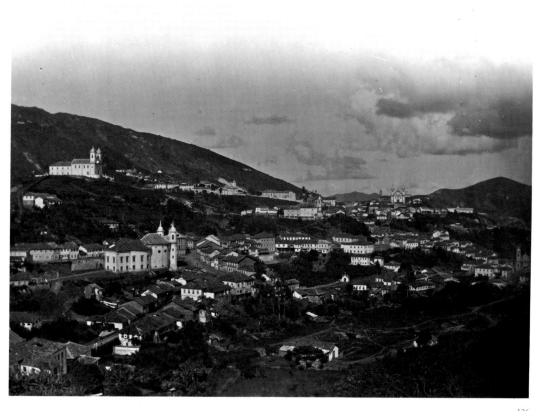

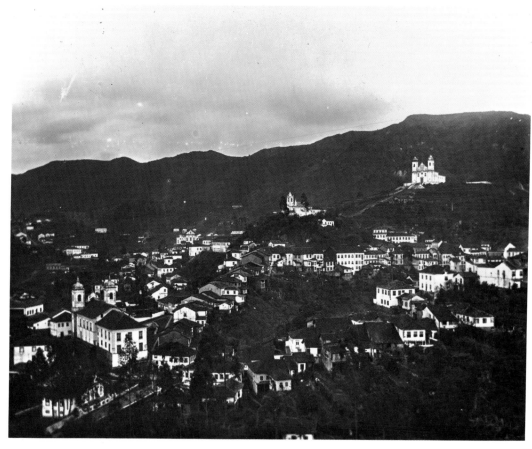

128

126. *Marc Ferrez mc 21.8 × 27.7 cm GF*
Ouro Preto, 1880. Compare this photo with that by an
anonymous photographer (plate 117), c. 1875. Both were
taken in the same place. The photograph by Marc Ferrez
includes, at right, the present Museu da Inconfidência
and the Igreja do Carmo.

127. *Marc Ferrez mc 21.8 × 27.7 cm GF*
Another panorama of Ouro Preto in 1880. From top to
bottom, at left, the churches of São Francisco de Paula,
São José, and Matriz do Pilar.

128. *Marc Ferrez mc 16.5 × 21.9 cm GF*
Minas Gerais, 1880. A river, its bed completely dug up by
miners in search of gold.

129

129. *Marc Ferrez mc 22 × 16.4 cm GF*
The oldest known photograph of the interior of an iron-
works, Betim Paes Leme's mill at Boa Esperança, c. 1880.

Espírito Santo

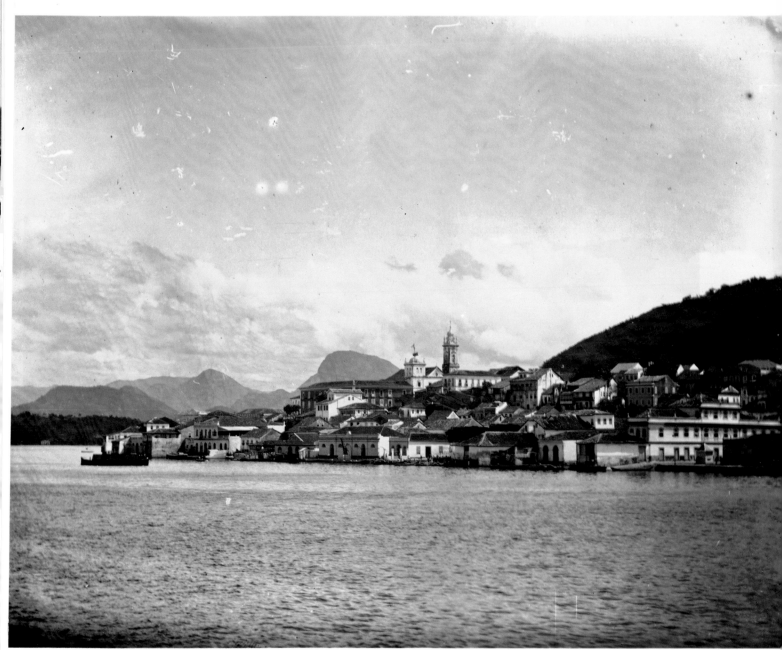

130. *Marc Ferrez* *mc* 16.3 × 22 cm GF
Scene of arrival at Vitória, 1884. The view is entirely
dominated by the former Colégio, then the Palace of
Governors, and the Jesuit church, before the renovations
that completely changed their character.

140

141

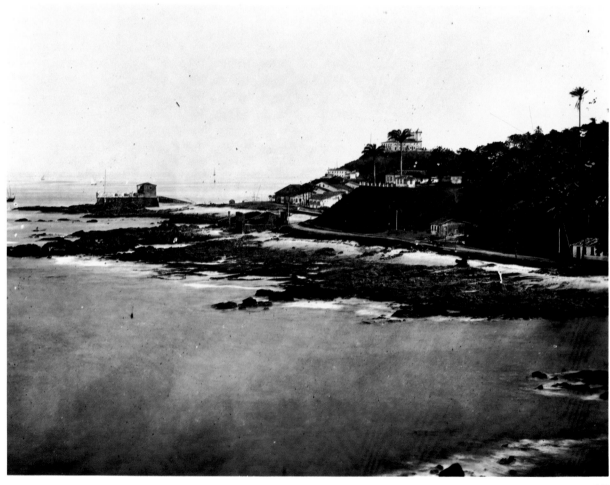

142

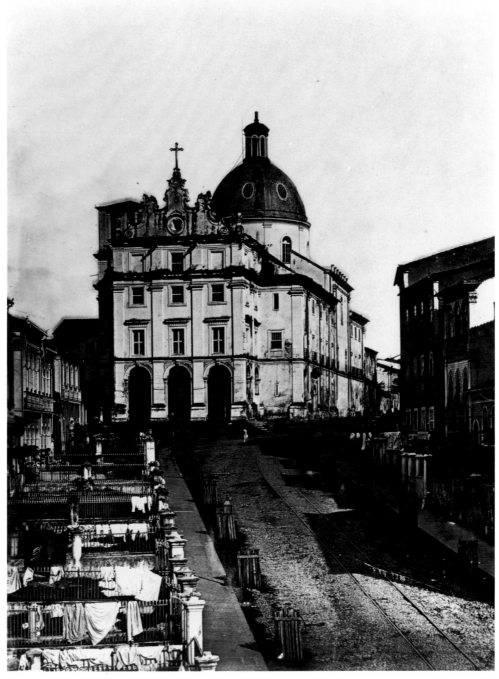

143

140. *Marc Ferrez albumen 12 × 8 cm GF*
141. *Marc Ferrez albumen 12 × 8 cm GF*

Black vendors. Lace blouses, African shawls, bracelets of gold or silver, rings, necklaces, and amulets—all of silver worked in Bahia. Lastly, the little bench of rosewood to sit on. The first woman is probably a domestic servant and, besides her shawl, wears many beaded necklaces and earrings. Salvador, 1875.

142. *Marc Ferrez albumen 16.5 × 22 cm GF*
The Fortaleza de Santa Maria and the Igreja de Santo Antônio da Barra. Salvador, 1875.

143. *Marc Ferrez albumen 24.5 × 19 cm GF*
Ladeira and Igreja do Mosteiro de São Bento, in Salvador, 1875.

144. Camillo Vedani albumen 15.3 × 21.8 cm GF
The Teatro São João, later Castro Alves, in Salvador, c.
1868. It was inaugurated on June 13, 1812, by the Count
of Arcos. Destroyed by fire in 1923, the Secretaria de Es-
tado was built on the site. Rua Direita (now Rua Chile) is
visible at the point where it meets the Praça Castro Alves
(formerly Praça do Teatro) and the doors of São Bento.

145. Guilherme Gaensly pni (15.3 × 11 cm) GF
Black woman with typical clothing and adornments, pho-
tographed in the studio. Salvador, c. 1880.

146. Guilherme Gaensly pni (15.6 × 10.6 cm) GF
Black man whose facial markings indicate to which Afri-
can nation he belonged. Salvador, c. 1880.

G. GAENSLY E R. LINDEMANN,

145

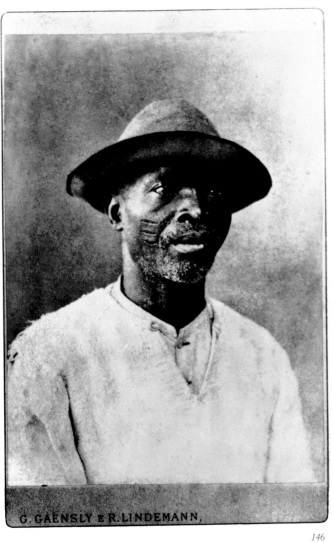

G. GAENSLY E R. LINDEMANN,

146

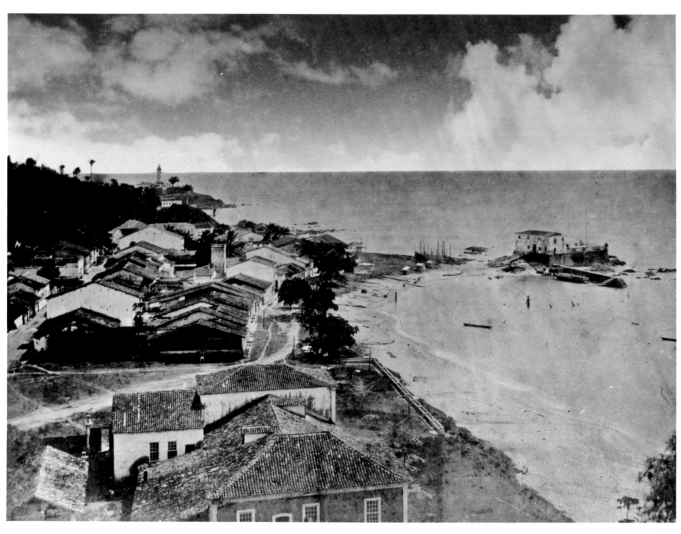

147

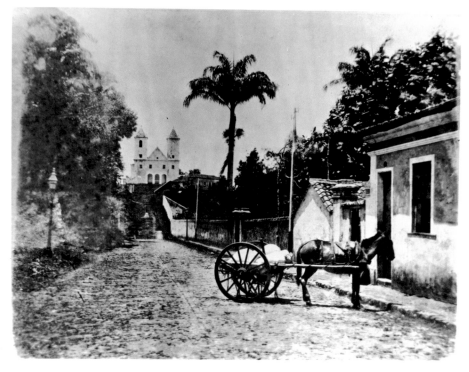

148

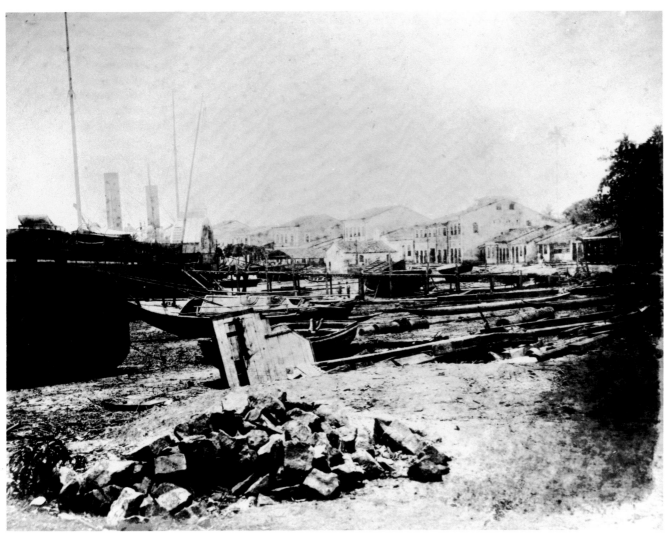

149

147. *Guilherme Gaensly albumen 18 × 24 cm BN*
Porto da Barra, the Forte Santa Maria, and the Santo An-
tônio da Barra lighthouse, in Salvador, 1880. At this
beach, where Tomé de Sousa disembarked, the Dutch
also came ashore—in 1624.

148. *Guilherme Gaensly albumen 18.5 × 24.7 cm BN*
Igreja de Santo Antônio da Barra, in Salvador, 1860.

149. *Guilherme Gaensly albumen 18.7 × 24.3 cm BN*
Itapagipe, Salvador, c. 1870.

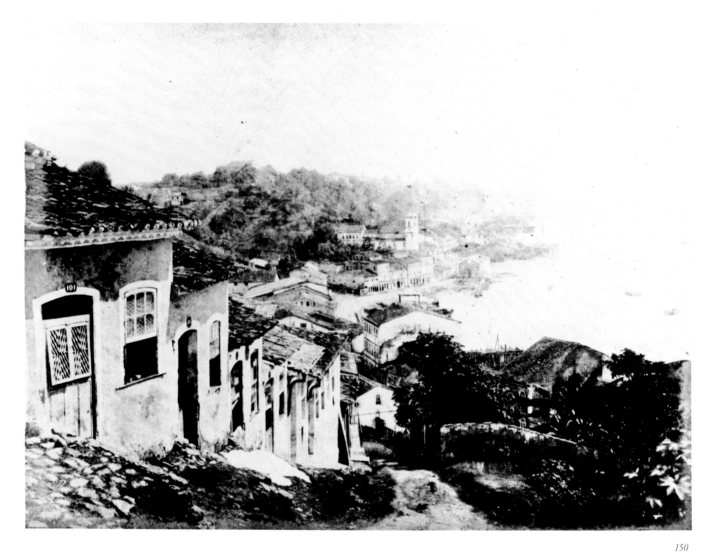

150

150. *Guilherme Gaensly albumen 18.5 × 25 cm BN*
City de Salvador, 1860. Estrada das Boiadas and, in the
distance, the area of Agua dos Meninos and the Igreja da
Santíssima Trindade.

151. *Alberto Henschel albumen 9.5 × 5.8 cm GF*
Black woman—a domestic servant—adorned with beau-
tiful necklaces and bracelets, displaying a small pair of
scissors. Salvador, 1885.

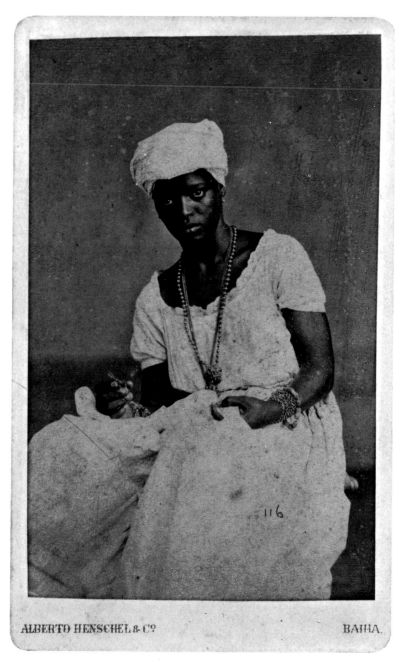

ALBERTO HENSCHEL & Cº BAHIA.

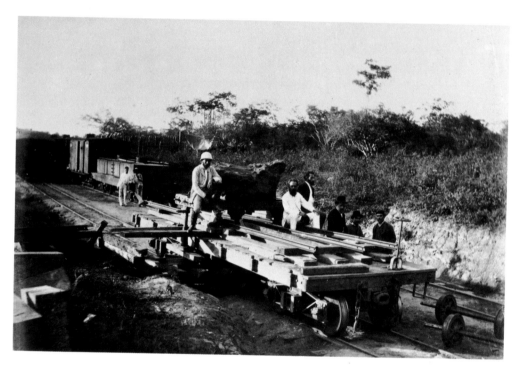

153

153. Antunes albumen 15.5 × 21.5 cm GF
The Bendengó meteorite being taken away on the Bahian
Railroad Extension by the engineers that went to look for
it in the inhospitable interior of Bahia, 1887.

Alagoas

At one time, the Instituto Histórico e Geográfico of Alagoas had a good collection of views of Maceió, the city of Pilar, and the São Francisco River taken by an unidentified photographer, and others by a certain Albino, dated 1869. This information was reported in the *Catálogo da Exposição de História do Brasil, 1881–1882*.[64] Unfortunately, this collection no longer exists, since it was considered to be of no interest!

In 1868, Augusto Riedel photographed the city of Penedo, the Paulo Afonso Falls, and the steamboat *S. Salvador* on the São Francisco River.

A notable photographer who worked in Alagoas was A. Coutinho. I own an album of his work containing several good prints. Around 1860, Coutinho photographed views of Maceió and Penedo, focusing especially on houses and buildings typical of the region. From there, he went on to photograph towns and settlements along the banks of the São Francisco, from the mouth of the river to Paulo Afonso. The beauty and refinement of technique apparent in these photographs affirm Coutinho's love for his native land.

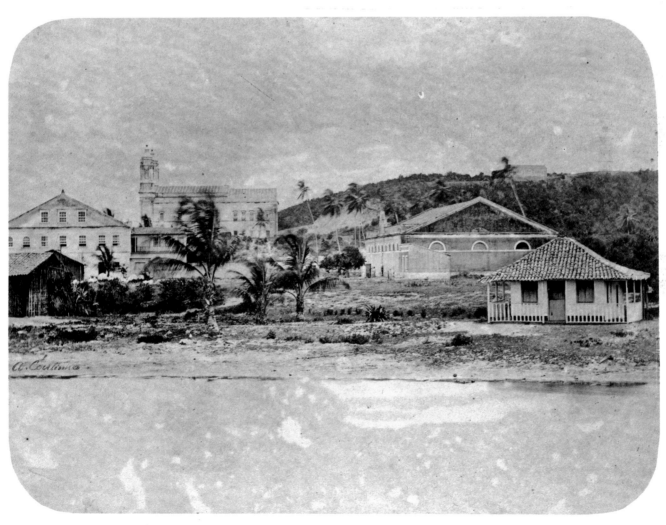

154

154. *A. Coutinho albumen 19.5 × 26.5 cm GF*
Maceió, c. 1882. The photo bears the signature of A. Coutinho in the left-hand corner.

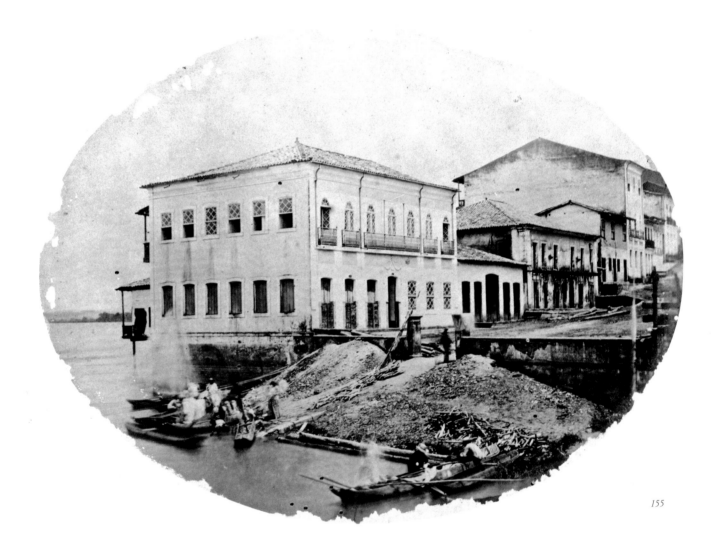

155

155. *A. Coutinho albumen 16.5 × 21.5 cm GF*
Rua da Matriz, in the city of Penedo, c. 1860.

156. *A. Coutinho albumen 16.5 × 21.7 cm GF*
Town of Traipu, on the Rio São Francisco, c. 1870.

157. *A. Coutinho albumen 16.3 × 21 cm GF*
City of Propriá on the Rio São Francisco (on the Sergipe
side), c. 1870. All these photos are from an album, assem-
bled by Coutinho, that belongs to the author's collection.

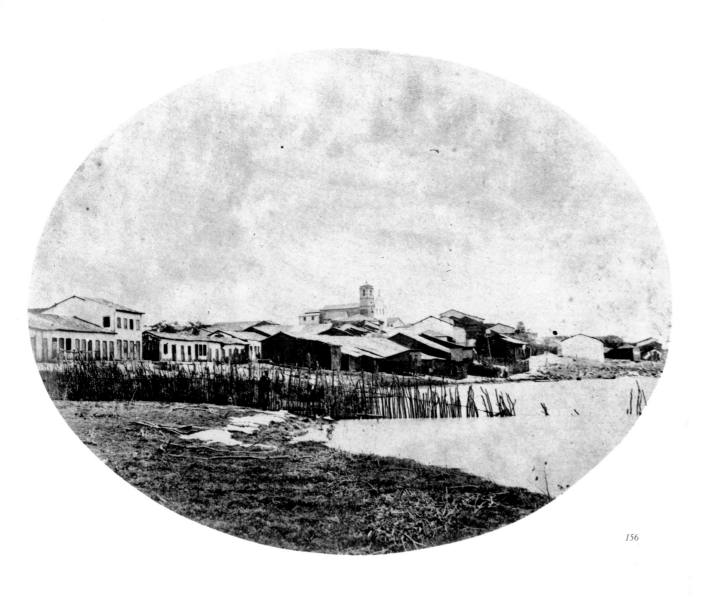

156

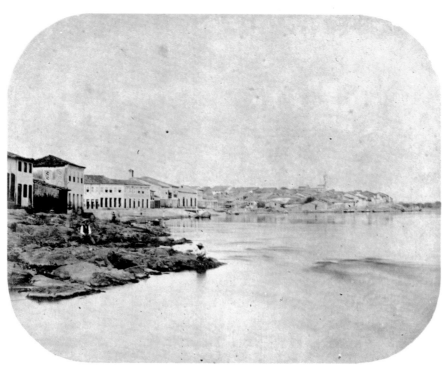

157

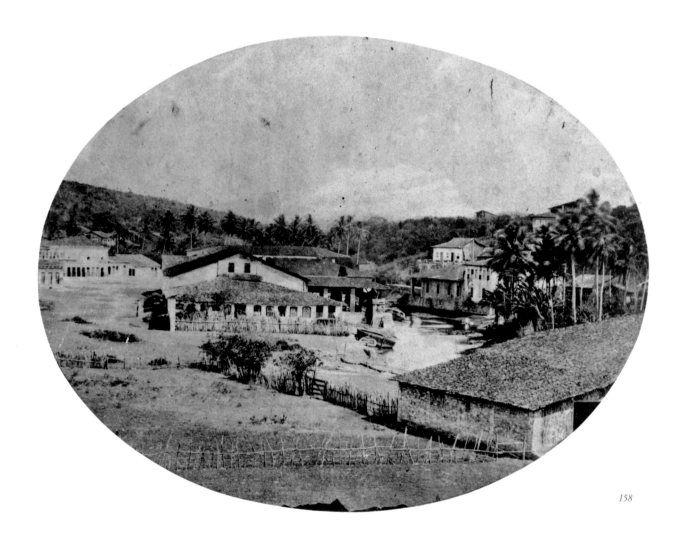

158

158. Anonymous (A. Coutinho?) albumen
17 × 21.5 cm GF

Pernambuco

"The daguerreotype appeared in Pernambuco only a few years after its marvelous discovery on the Old Continent. It was in 1841 or 1842 that the first daguerreotyped images were produced. . . . Their creator was a Frenchman. . . ."[65]

In 1845, a daguerreotypist, a Frenchman named J. Evans, was working in Recife. His studio was located at 14 Rua Nova. Four years later, there is evidence of another photographer, J. F. Waltz, working in that city. No works by Waltz are known to be extant.

On December 31, 1853, according to the research of historian José Antônio Gonsalves de Mello, the landscape photographer Augusto Stahl arrived in Recife. A relatively large body of work by Stahl has survived. From an artistic point of view, it is among the very finest of nineteenth-century Brazilian photography. His stay in the capital of Pernambuco for nearly seven years was very fruitful. Outstanding among the works that he produced is a beautiful album entitled *Memorandum pittoresco de Pernambuco offerecido a S.M.I. o Sr. D. Pedro II pelo Instituto Photographico de Stahl & Cia.*, containing thirty-four photographs, albumen prints, taken between 1854 and 1859.[66] Aside from their considerable documentary value, these views attest to the high standards of photographic quality attained in Pernambuco under the influence of Stahl. Three of the photographs in this album depict the November 1859 arrival in Recife of the Emperor, who was then making his first trip to northern Brazil. Others portray old wooden bridges, the Santa Isabel Theater, numerous places in the center of the city, and picturesque spots in the countryside near Recife. On December 1, Stahl had the "honorable permission" to photograph Their Majesties.[67] The photographer made additional copies of the photographs in the album. Both the Instituto Histórico e Geográfico Brasileiro and myself hold collections of these prints.[68] Another album organized by Stahl contains photographs of the construction of the stretch of railroad from Recife to the neighboring city of Cabo. This was part of the Great Western line, the second railway built in Brazil. I also own one of the copies of this second album. It previously belonged to one of the engineers responsible for the construction of the railroad.

On June 30, 1858, Adolph Schmidt and German Wahnschaffe arrived in Recife. They promptly became associates of Augusto Stahl. The *Diário de Pernambuco*, which had taken note of the arrival of the two men, published this announcement on September 23:

> Augusto Stahl & Cia. photographic establishment. The respectable public of this city is informed that a contract has been made with Mr. Adolfo [sic] Schmidt, photographic chemist, and Germano [sic] Wahnschaffe, painter, both recently arrived from Hamburg. The new firm, Stahl, Schmidt & Company, hopes to merit the same confidence as the the one it replaces. . . .

On December 31, 1861, Stahl closed his studio in Recife and moved to Rio de Janeiro, departing aboard the steamer *Paraná* on February 4, 1862.[69] The *Almanak Laemmert* of 1863 shows Stahl in Rio, in partnership with Wahnschaffe.

In 1855, the Pernambucan photographer João Ferreira Vilela settled in Recife.[70] He placed an advertisement in the *Almanaque administrativo, mercantil e industrial da Província de Pernambuco para o ano de 1861*, calling himself "ambrotypist to the August Imperial House." He went on to inform the public that his studio was located at 18 Rua do Cabugá (upstairs, entrance through the main patio), and that he made portraits by means of all known systems of photography. The advertisement, reproduced below, offers a veritable panorama of the development and technical possibilities of photography at that time.

> Portraits on glass, paper, or waxed cloth. The latter are especially well suited for sending inside letters, since they combine the beauty of the print with the flexibility of cloth. Portraits on polished leather, and sheets of metal or mica. These are especially suited for placing inside brooches, lockets, buttons, and rings. They can be made as small as the head of a pin. Portraits in daguerreotype or ambrochromotype. This system is very new, and unknown to any other portraitist in Pernambuco. Portraits in oil. Life-size, and at reasonable prices. Also offered for sale: photographic equipment, assorted chemicals, cases, and frames.

Obviously, one could not ask for a larger choice!

This same Vilela sent four photographic views, without any attribution of authorship, to the Exposição de História do Brasil da Biblioteca Nacional in 1881. The subjects portrayed in the photographs were Recife and the Apolo quays, the Presidential Palace and the bridge between Recife and Santo Antônio, the Customs House and the Sete de Setembro bridge, and, finally, the Santa Isabel Theater before the fire.

Vilela witnessed the arrival of Dom Pedro II in Recife in 1859. On that occasion, he presented the Emperor with "six gilded frames containing the following views taken by himself [Vilela] on metal plates by means of daguerreotype: 1st, pavillion constructed by order of the city council for the reception of Their Imperial Majesties. 2nd, port of debarkation of Their Imperial Majesties—kiosk and two warehouses—fountain—quays of the college. 3rd, continuation of view no. 2—the nothern flagstaff of the council pavillion—[the district of] Mosqueiro, with all the ships anchored there. 4th, a seascape—outfitted ship—Porto das Canoas in Santo Antônio. 5th, the English church—Rua da Aurora. 6th, end of the Rua da Cruz—beginning of the naval arsenal—observatory."[71] The Emperor was so pleased with these works that he expressed, through his steward, his desire to obtain views of other places in the provinces that he would be visiting. This greatly flattered the artist and gained him the title of Photographer of the Imperial House. Vilela participated in a several national exhibitions as a photographer and a painter, as well as a manufacturer of photographic chemicals.[72]

In 1867, Alberto Henschel & Cia. was operating a photographic business in the square of the church of Santo Antônio and, in 1881, at 52 Rua Barão da Vitória. The firm had studios in both Recife (1867–81) and in Rio de Janeiro (1869–90). Henschel's photographer in Recife was Carlos Gutzlaff, a "name already known and appreciated by those who recall the neatness and elegance of the works of Mr. Henschel's [studio] Photographia Allemã, thanks to the skill of Mr. Gutzlaff."[73]

The Biblioteca Nacional owns a large and voluminous album with a beautiful, elaborately worked binding, dedicated to Dom Pedro II and entitled *Ansichten Pernambuco's. Recife Photographia Allemã.* It contains a number photographs made by Maurício Lamberg.[74] It carries no date but must have been made around 1880.

Active in Recife in 1881, the landscape photographer Alfredo Ducasble was responsible for several good views in the previously mentioned book, *Le Brésil*, by E. Levasseur and Rio Branco. Alfredo Ducasble established his business at 65 Rua Barão da Victória, the street of photographers in that city. He later dealt in antiques as well. The following announcement below appeared in the advertising section of the *Jornal de Recife* of February 22, 1885: "Antiques—We buy antiques of every kind: dishes, leather chairs, bronze vases and candelabras, old and modern paintings, and any artistic object; interested parties may address themselves to the Galeria Ducasble, 65 Rua do Barão Vitória."

The Galeria Ducasble acquired pieces so beautiful and original that they were sent, in great quantity, to Paris for display in the Exposition Universal of 1889. Ducasble was, perhaps, the first to send Brazilian or Luso-Brazilian antiques for exhibition abroad.

Concurrent with the operation of Ducasble's studio was that of Francisco Labadie & Cia., located at no. 12 of the same street. This firms's advertisement stated:

> [We are] presently the only studio capable of producing the famous and inalterable *Carbon Portraits,* superior not only to oil painting, but to any other system known today. Photographs made at your home, of every type: death portraits, sick persons, country homes, etc. etc. Views of the city and the countryside.[75]

The works of these photographers admirably complement those of artists working in other graphic media who also recorded the appearance of Recife between 1830 and 1890. During this period Luís Schlappriz produced his unusual drawings and F. H. Carls made lithographs. These works offer evidence that, in graphic arts, Pernambuco was then as advanced as the capital of the Empire. In my opinion, the superb prints produced in the lithographic studios of F. H. Carls were copied from photographs taken by Stahl and João Ferreira Vilela. For this reason, the name of the draftsman does not appear: it was unnecessary.

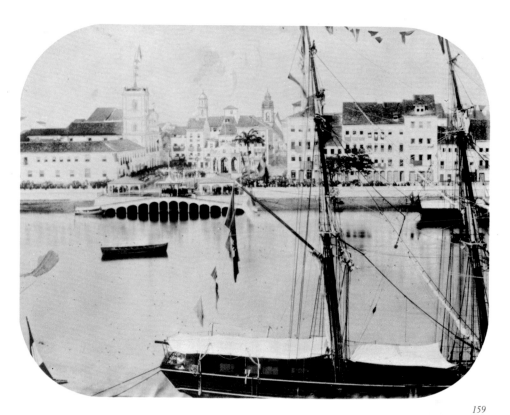

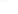

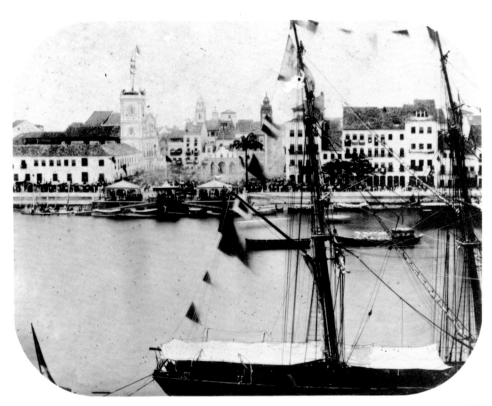

159. Stahl albumen 16.7 × 21.7 cm GF

160. Stahl albumen 16.4 × 20 cm GF
Two photographs taken, respectively, ten minutes before
and ten minutes after the arrival of D. Pedro II and D.
Teresa Cristina at the Praça do Colégio, in Recife, in
1859. At left, the former Jesuit School, which then served
as the Law School, and its church (now the Igreja do Es-
pírito Santo), whose tower was used for sending signals.

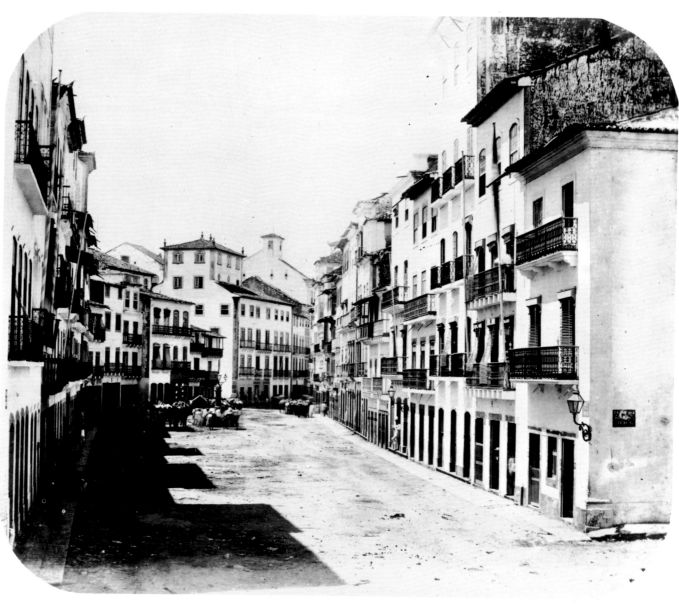

161

161. *Stahl albumen 19.8 × 23.6 cm IHGB and GF*
One of the streets most typical of old Recife in 1859, Rua
da Cruz (later Rua do Bom Jesus). Note the height of the
buildings, the iron balconies supported by stone corbels
(characteristic of the buildings of Recife), the Chinese
shades, the vestiges of Moorish balconies, the miradors,
and new gas-burning street lamps.

162. *Stahl albumen 20 × 26 cm GF*
Recife, 1858. Rua do Crespo, with its old buildings. At
center, the Praça da Independência. Note the miradors,
cast-iron balconies, and fanlight windows—some of
which are protected from the sun by Chinese shades.

163. *Stahl albumen 18.5 × 25.5 cm GF*
The second locomotive to operate in Brazil, on the Recife
& S. Francisco Railway Co. line, in 1858. The first was
the Baronesa, on the Estrada de Ferro Mauá line, in Rio
de Janeiro.

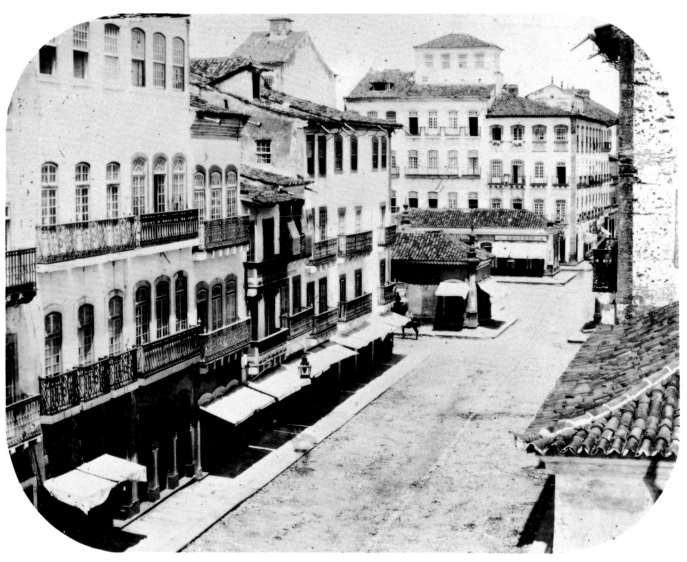

162

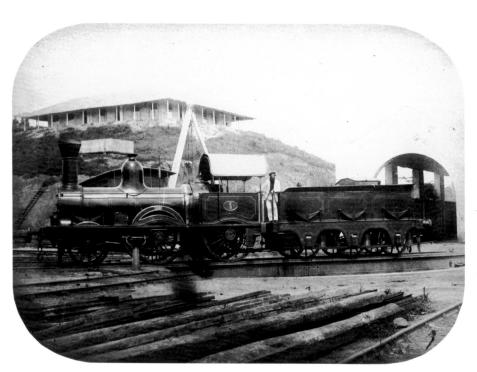

163

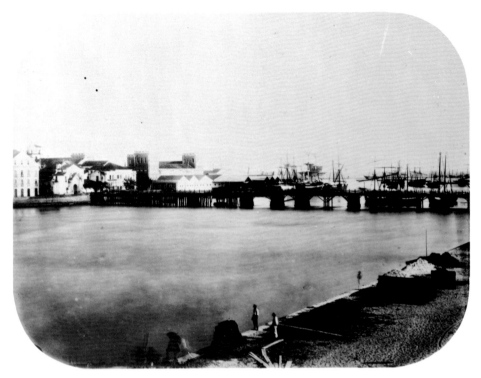

165

164

166

164. *Stahl albumen 16 × 21.5 cm GF*
The Recife's Ponte Velha in 1858. Its foundations date
from the time of Maurice of Nassau. The bridge was re-
modeled many times over the years. In 1865, it was re-
placed by one made of iron and came to be called Ponte 7
de Setembro. Clearly visible are the Arco da Conceição,
the sacristy of Madre de Deus, the customshouse and its
warehouses.

165. *Stahl albumen 20 × 26 cm BN*
Olinda seen from above in 1860. In the second plane, the
plaza and the Igreja de São Pedro dos Clérigos. Farther
back, at left, the Mosteiro de São Bento. In the distance,
Recife.

166. *Stahl albumen 22 × 17 cm GF*
A beautiful still-life of tropical fruits from Recife, 1857.

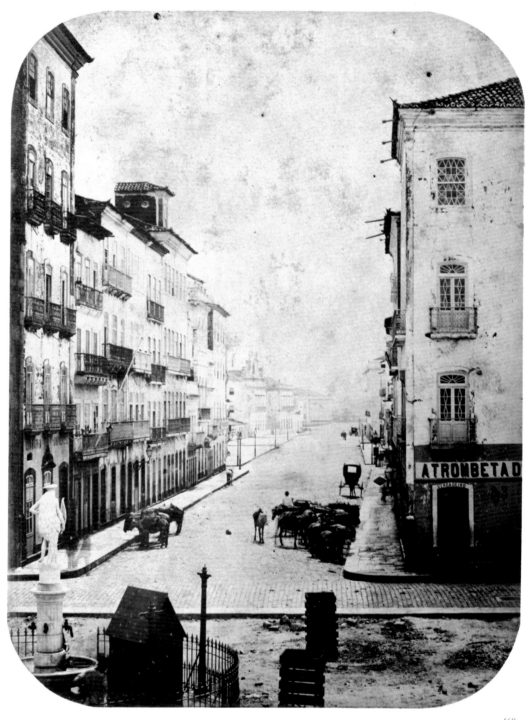

169

169. *Vilela albumen 26.4 × 20 cm IHGB*
Recife, c. 1865. View of Rua do Imperador, formerly Rua da Cadeia Nova, taken from Praça do Imperador, formerly Praça do Colégio and now called Praça Dezessete. In the foreground, the fountain that was previously located on the quays of the Colégio. Notice the height of the buildings, the balconies, the street paved with cut stones, and the gas lamps.

170. *Vilela albumen 18.7 × 25 cm I*
View of housing in the Recife quarter, c. 1860. Visible are the Hôtel de France and the Grand Hôtel de l'Univers on the quays of the Arsenal de Marinha.

171. *Vilela albumen 19.6 × 26 cm IHGB*
Rio Capibaribe, in Recife. Under construction, the Ponte de Santa Isabel. Note, at left, the date "18 Jan[uary] '62."

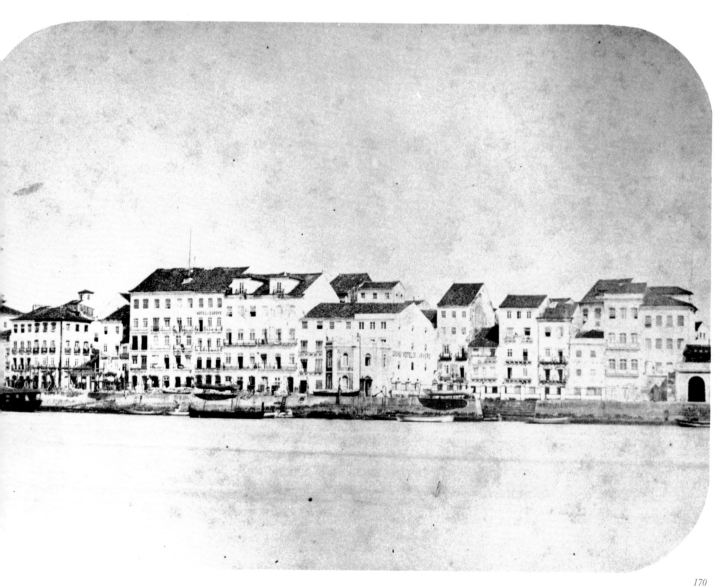

170

171

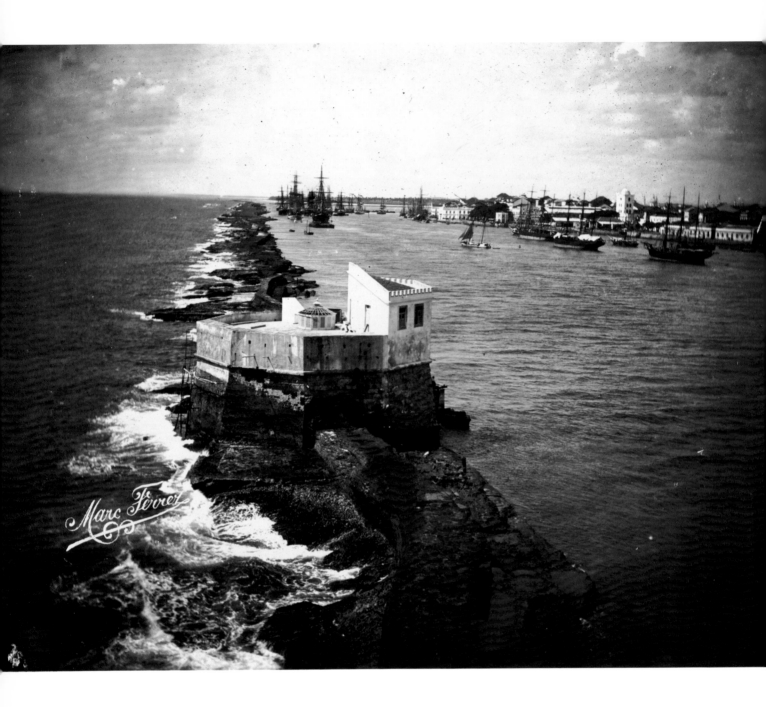

172. *Marc Ferrez mc 16.5 × 22 cm GF*
View of Recife and the port of Recife, 1874. Photo taken
from atop the lighthouse, looking south. In the fore-
ground, the Forte do Picão. Beyond it, sailing ships an-
chored in the mosqueiro, the Malakoff tower in the Arse-
nal de Marinha, and the Lingüeta area.

173. *Marc Ferrez mc 15 × 21 cm GF*
Recife, 1875. The Campo das Princesas (now Praça da
República), after it had been landscaped and protected by
an iron fence. Shown are the Teatro Santa Isabel, the
newly built town hall, the secondary school, and the Pa-
lácio do Governo.

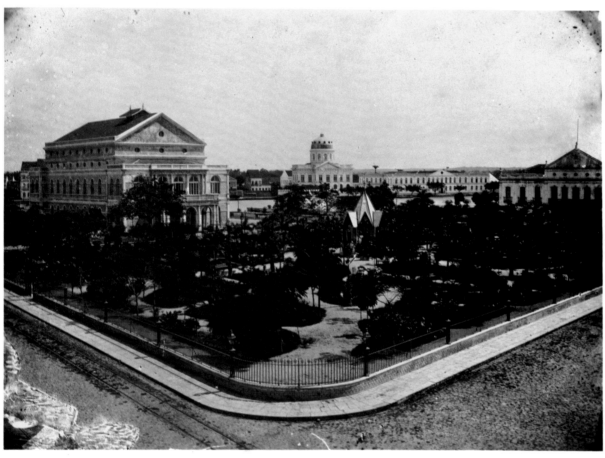

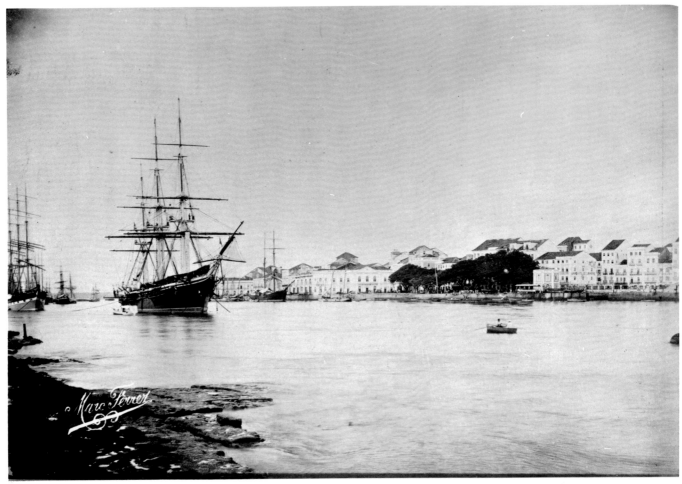

174

174. Marc Ferrez gelatin silver 17.1 × 24.9 cm GF
Another view of the port of Recife, in 1874, with the
building of the Associação Comercial Beneficente, in Lin-
güeta, at the center of the photograph.

175. Lamberg albumen 15.5 × 20.5 cm BN
The 22 de Novembro quays, in Recife, c. 1880. At left,
the building of the former Jesuit School and, in the dis-
tance, the Ponte 7 de Setembro.

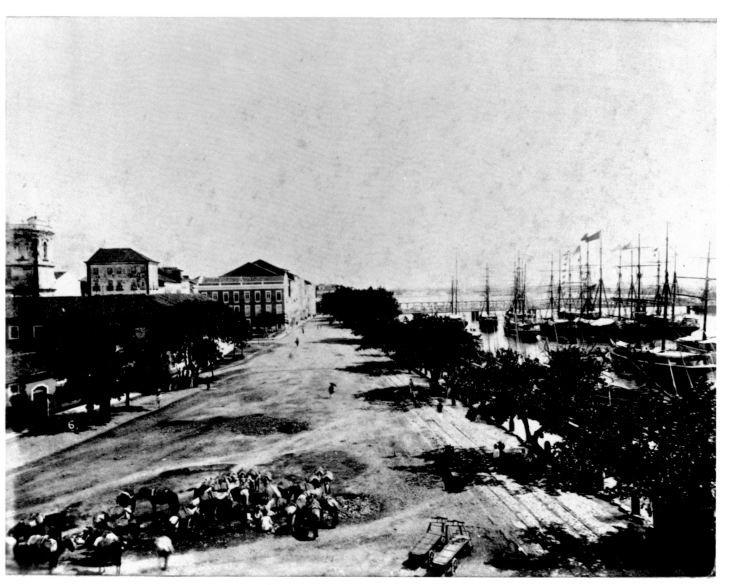

176

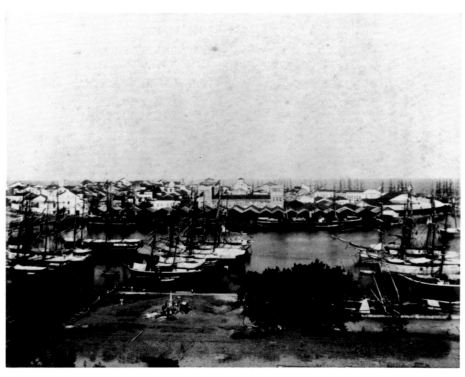

177

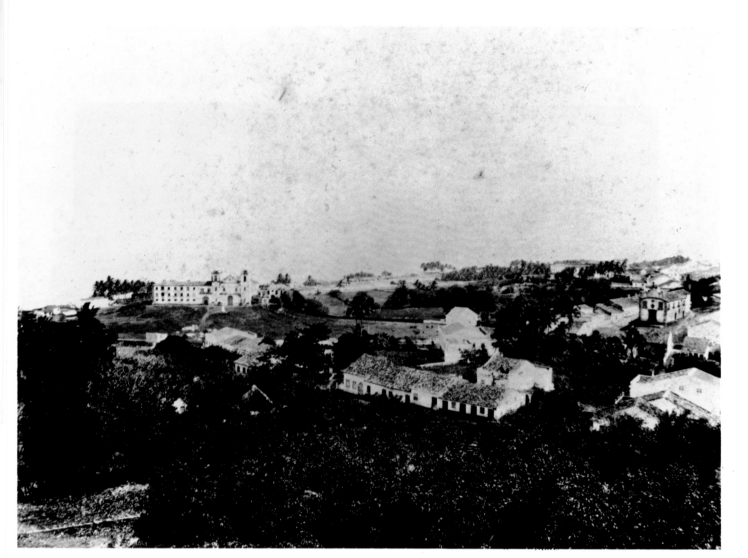

178

176. *Lamberg albumen 15.2 × 20.5 cm BN*
Rua do Barão da Vitória (now Rua Nova), in Recife, c.
1880. The trams have already begun obstructing the
street. Note the proximity of the gas lamp posts.

177. *Lamberg albumen 15 × 20.5 cm BN*
Recife, c. 1880. The former quays of the Colégio, later
called Cais D. Pedro II. Photo taken from atop the Igreja
do Colégio (now Igreja do Espírito Santo). On the other
side of the river and the boats, the Ponte 7 de Setembro,
the Arco da Conceição, the Igreja da Madre de Deus, and
the customshouse, with its turrets, all in the Recife quar-
ter. The port is solidly filled with ships.

178. *Lamberg albumen 15.3 × 20.5 cm BN*
Olinda, c. 1880, including, from left to right, a very rare
visual record of the Convento do Carmo (which fell into
ruin at the turn of the century), the Igreja do Carmo, and
the Capela de São Pedro dos Clérigos.

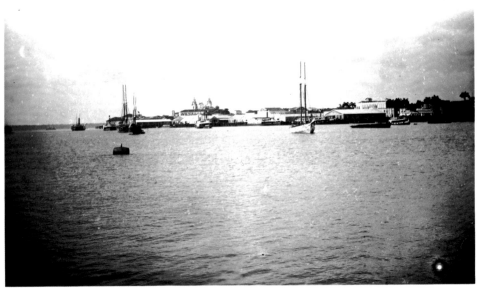

185

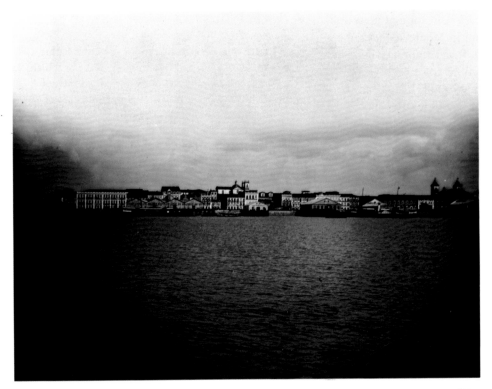

186

185. *Marc Ferrez mc 16.5 × 22 cm GF*
Panorama of Belém do Pará, 1875. Near the docks, the
ship Trombetas and, further on, the cathedral towers.

186. *Marc Ferrez mc 16.5 × 22 cm GF*
Arrival in Belém do Pará in 1875. The warehouses and
the church towers of Santa Ana and Mercês.

187. *Marc Ferrez mc 16.5 × 22 cm GF*
Doca do Reduto in Belém do Pará, 1875. Note the first
building at left, the Hotel Fraternidade.

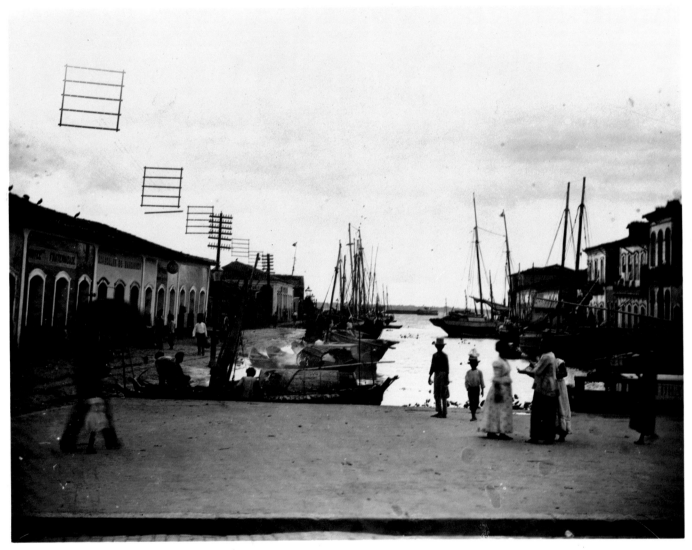

188

189

190

188. *Marc Ferrez mc 16.5 × 22 cm GF*
Water reservoir in Belém do Pará, 1875. A fine example
of French industrial construction, it stood until a few
years ago. It was 53 meters high and, before the advent of
skyscrapers, was the city's highest structure and its land-
mark.

189. *Marc Ferrez mc 16.5 × 22 cm GF*
Belém do Pará, 1875. Teatro da Paz, in the Largo da Pól-
vara, built in the Neo-Classical style by the engineer José
Tibúrcio Pereira Magalhães. The photo was made one
year after the completion of construction.

190. *Marc Ferrez mc 16.5 × 22 cm GF*
Rua do Conselheiro João Alfredo, in Belém do Pará,
1875. In the distance, the towers of the cathedral.

191

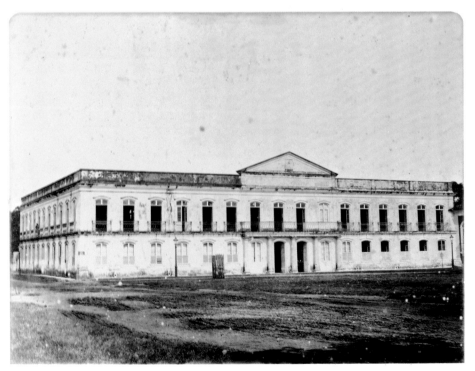

192

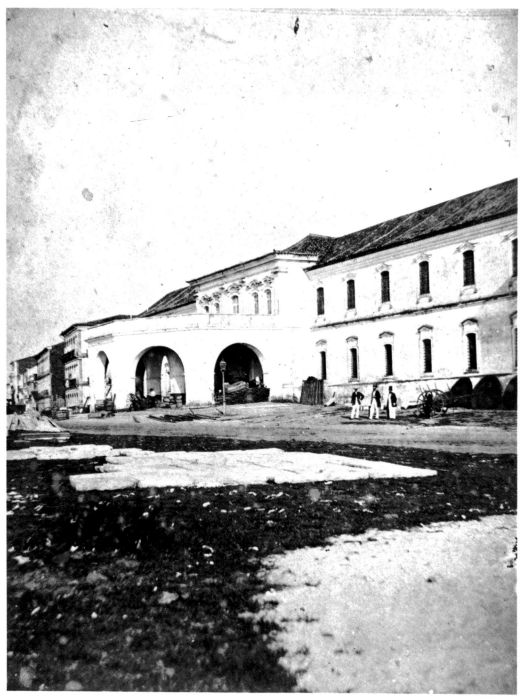

191. *Fidanza albumen 19.5 × 25 cm GF*
The governmental palace that housed the assembly, the
municipal council, and the provincial treasury, in the
Praça de Belém do Pará, c. 1885. In the foreground, the
monument to General Gurjão, inaugurated in 1882.

192. *Fidanza albumen 22.5 × 30 cm*
Belém do Pará, 1875. Liceu Paraense, secondary school
designed by the Italian architect Antônio José Landi.

193. *Fidanza albumen 18 × 14 cm GF*
View of the customshouse seen from the river in the
Província do Pará, c. 1875.

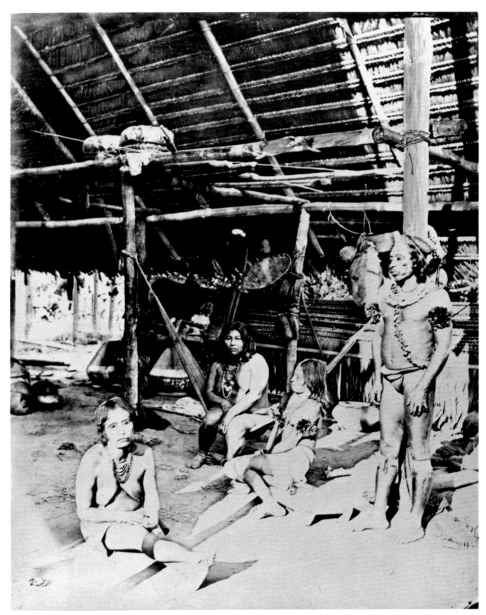

196

196. *A. Frisch albumen 24.2 × 19.2 cm GF*
Frisch was among the first to photograph Indian villages
in Amazonas, around 1865. This photo and the others by
him reproduced in this book are the oldest presently
known of this subject.

197. *A. Frisch albumen 18 × 22.5 cm GF*
Indian village on the Amazon River, just above Manaus,
in 1865.

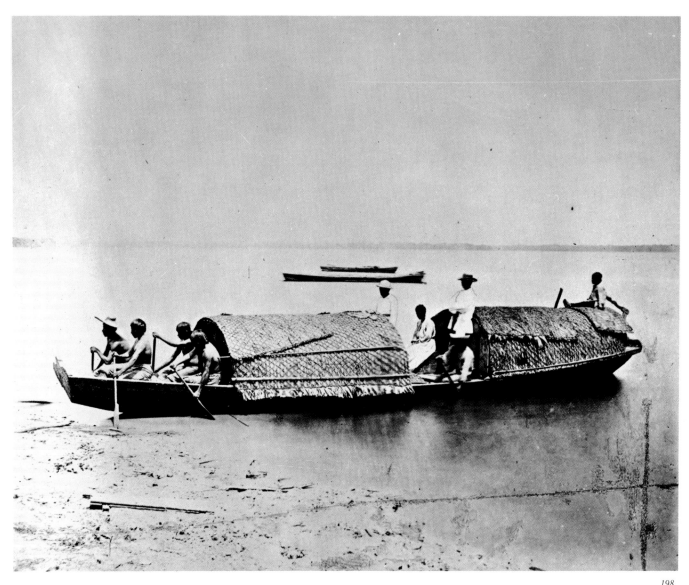

198

198. *A. Frisch albumen 19 × 23.8 cm GF*
Rio Japurá, c. 1865. Canoe arriving from Nova Granada
loaded with goods for a twelve-month trip, en route to
Coari to sell its cargo there and then return by the Içá
River.

199. *A. Frisch albumen 18.3 × 24 cm GF*
Indians of Alto Amazonas or Solimões, c. 1865. The vil-
lage cooking area was always located near the dwelling.

Estação dos Bondes.

Edição de George Huebner, Dresden-Allemanha.

200. *Fidanza albumen 18.5 × 28 cm GF*
Igreja de N. Sr.ª da Conceição Matriz de Manaus,
c. 1885.

201. *Anonymous 9.8 × 14.5 cm GF*
Tramway station in Manaus, c. 1890. Postcard published
by George Huebner of Dresden, Germany.

São Paulo

In São Paulo, the daguerreotypist Manuel José Bastos advertised in 1852: "taken, with every perfection, colored portraits using plates ranging in size from that of the palm of the hand to that of the button on a jacket."[77] In 1856, another photographer, Inácio Mariano da Cunha Toledo, was operating a studio on Rua da Freira (the actual Rua Regente Feijó). Unfortunately, no works by these photographers are known to have survived.

The finest views of São Paulo taken between 1860 and 1887 were made by the Portuguese photographer Militão Augusto de Azevedo. His studio, Fotografia Americana, was located at 58 Rua da Imperatriz. In studying these photographs, we see once more the small and peaceful provincial city that was then the capital of São Paulo. Those who wish to study the old city find Militão's work unequalled as a resource. He even organized albums of photographic views comparing São Paulo in the years 1862 and 1887. Copies of these albums can still be found in the Museu Paulista, the São Paulo Public Library, and in private collections. In comparing these photographs (which have been widely reproduced) with the São Paulo of today, one is struck by the city's breathtaking growth.[78]

The studies reconstructing the old city of São Paulo, carried out by Benedito Calixto and J. Wasth Rodrigues, would not have been possible without the photographs of Militão. Thanks to him, and to others who came later, Benedito Duarte, director of the Iconographical Section of the Divisão de Documentação Social e Estatística de São Paulo, was able to organize a photographic archive complete with scholarly, explanatory texts that are extremely useful to researchers. This work should serve as a model for other, much-needed future projects on all the major cities of Brazil.

In the São Paulo Public Library, there is an album entitled *Vistas da Estrada de Ferro de S. Paulo em 1865* with splendid images by a photographer as yet unidentified.

The lithographer Jules Martin, promoter of the audacious project to construct the Viaduto do Chá, served as the depository in São Paulo for the photographs of Marc Ferrez. Some of Ferrez's works were lithographed and published in 1881 in *Ilustração Paulista*, a review owned by Martin. He worked in his establishment, Imperial Litografia a Vapor (then the finest in the province), from 1863 to 1887, when he turned the business over to his sons. Martin organized a large exhibition of photographs, announced in the *Província de S. Paulo* of September 28, 1880. The exhibition included photographic views by Marc Ferrez depicting São Paulo and Santos, the falls of Piracicaba, Itu and Sorocaba, the Ipanema foundry mill, the Cubatão mountains, etc. The São João de Ipanema foundry was also photographed by Leuthold and Dursky, in 1879. Prints of their work are in the collections of the Biblioteca Nacional.

Working in São Paulo in 1873 were the photographers Carneiro and Gaspar (58 Rua da Imperatriz) and Francisco Teodoro Passig (4 Largo de São Francisco).

Carlos Hoenen, from Germany, opened his studio, Fotografia Alemã, in 1875. Hoenen had the idea of decorating interiors with enlarged photographs, painted (probably in oil) by the Viennese artist F. Piereck, whom he had contracted several months before. At least, that is what can be concluded from the following advertisement published in *A Provincia de S. Paulo* on April 30, 1878: "We would like to call the attention of art lovers to a picture made in this establishment which is destined to beautify the ceiling of the dining room of Mr. Glete's new grand hotel on Rua São Bento. This is the perfect work to decorate the luxurious reception rooms . . . of palatial buildings."

Carlos Hoenen studied his profession in Europe. In 1883, he returned to Brazil and advertised that he would employ "principally the dry plate [gelatin dry plate], instantaneous process. . . . By means of these exposures, it is possible to obtain a perfect portrait of the most fidgety child, nervous persons, etc." He taught amateurs and professional photographers from the outlying areas to work with dry plates of all sizes and, for this, his laboratory was open to those who wished to use it.

The firm of Alberto Henschel & Cia., Photographers to the Imperial House, inaugurated a branch office in São Paulo in 1882. The firm's principal studio had been established in Rio de Janeiro since 1870. Their works are of the highest quality. Those who wished to have their portraits made in oil would find, in charge of this type of work, the competent painter Ernesto Papf. Later, Papf relocated to Petrópolis.

Militão, Carneiro & Gaspar, and Alberto Henschel were the most notable photographers active in São Paulo until about 1890. After that time, Gaensly & Lindemann, who also had a studio in Bahia, established a firm at 28 Rua Quinze de Novembro. Gaensly had earned quite a reputation as a photographer in Bahia before he moved to São Paulo, leaving his associate Lindemann to manage the studio in Salvador. Gaensly's works can be seen in the book *São Paulo*, by Gustavo Koenigswald. He organized a complete and very fine collection of views of coffee plantations, showing the clearing of the land, planting, cultivation, harvest, preparation, sacking, and exportation of the product from the port at Santos. He attended the International Exhibition at St. Louis in 1904, where he won a silver medal. His views of the city of São Paulo, taken from the end of the century until 1910, are superb. The glass-plate negatives still exist, in excellent condition, preserved by the late, well-known book collector Olinto Moura, from whom I obtained prints of the complete series.

Around the end of the century, competing with Gaensly were José Vollsack (successor of Casa Henschel) at 2 Rua Direita, and one G. Renouleau, whose studio was located at number 9 on the same street. Of Vollsack, Valentim Magalhães wrote:

> Besides ice cream, São Paulo has something else that outshines the capital city of Rio de Janeiro: the photographic establishement of Mr. Vollsack, successor of the firm of Henschel & Cia. . . . The proposition is arrogant, the Capital having, as it does, very talented photographers. . . . Their works are not comparable to those of Mr. Vollsack. The finest portraits of Ramalho Ortigão were made by him; and they are truly admirable portraits, in which the eminent critic was, to put it thus, captured in an instant, with the fullness of his bearing.[79]

In Campinas, the notable Swedish photographer Henrique Rosen was owner of the Fotografia Campineira studio, founded in 1862. His works were disseminated throughout the province of São Paulo until the end of the century. Upon his return from Europe, where he studied with Bernardo Munchs (owner of an important photographic studio in Germany), Rosen published a lengthy advertisement in *A Provincia de São Paulo* on November 3, 1880. An excerpt from this text, below, states:

> We call the attention of persons of good taste to the following Specialities:
>
> 1st Portraits in life-size . . . ;
>
> 2nd Permanent portraits on porcelain (not imitation), hand-tinted or colored, transparent and of an exceptional delicacy, suitable for anniversaries, Christmas, and New Year, etc.;
>
> 3rd *Boudoir* and *Promenade* portraits, only recently introduced in Paris where they are greatly esteemed, suitable for distinguished ladies and elegant attire;
>
> 4th Portraits of children taken instantaneously, with the greatest facility, using a new chemical formula.
>
> 5th Portraits colored with pastel, in large format, reproduced from any old photograph, no matter how damaged;
>
> 6th Portraits of large family and organizational groups, regardless how numerous, having specially constructed cameras for this purpose;
>
> 7th Heliominiatures, made by an improved process;
>
> 8th Views—photographic, drawn, or painted with watercolor—of plantations, farms, gardens, etc.
>
> The prices will be within the reach of all, with a reduction of 20 percent for those distinguished families who prefer to pay in cash.

Another photographer who should be mentioned is Fernando Starke, of Piracicaba, who Dom Pedro II made Photographer to the Imperial House.

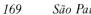

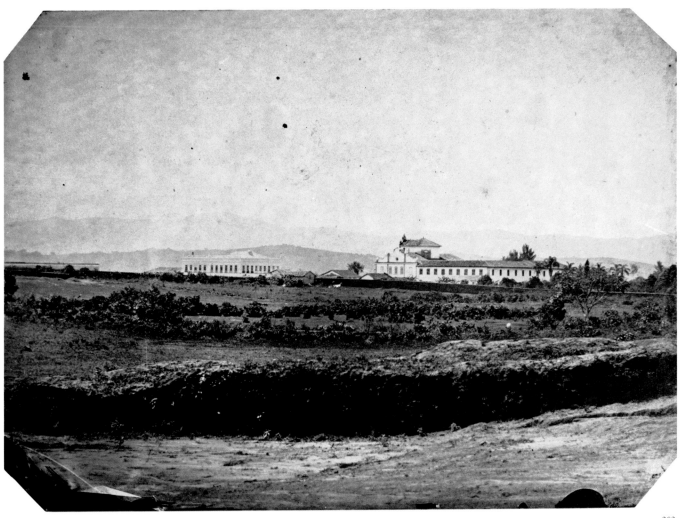

202

202. *Militão albumen 16 × 22.5 cm GF*
Campo da Luz, 1862. Also visible is the building of the
church and Convento da Luz, which, after restoration by
the Serviço do Patrimônio Histórico e Artístico Nacional,
became the Museu de Arte Sacra de São Paulo.

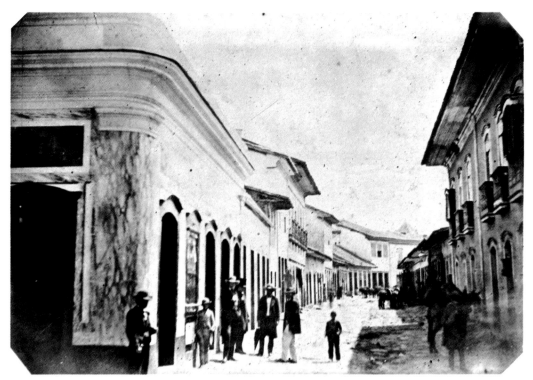

203

204

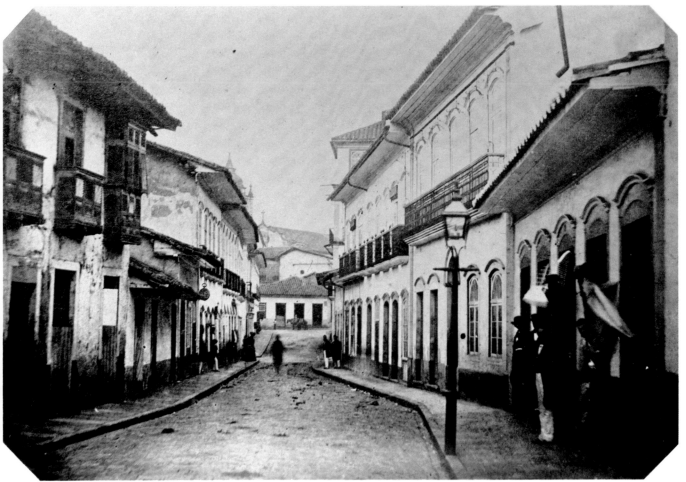

205

203. *Militão albumen 14.1 × 20.6 cm GF*
Rua da Quitanda, 1862. At the corner with the former
Rua do Comércio (now Rua Álvares Penteado), the Con-
feitaria Leão, at left.

204. *Militão albumen 15 × 20 cm GF*
Rua Direita, 1862.

205. *Militão albumen 14 × 21 cm GF*
Rua do Rosário (now Rua 15 de Novembro), 1862. This
priceless photograph shows the various types of houses in
the center of São Paulo at that time: the old residences
built in the 18th century, with their Moorish balconies,
and the mansions, or *sobrados,* of the 19th century.

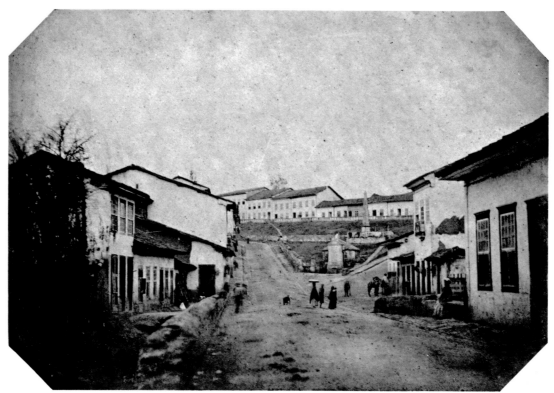

206

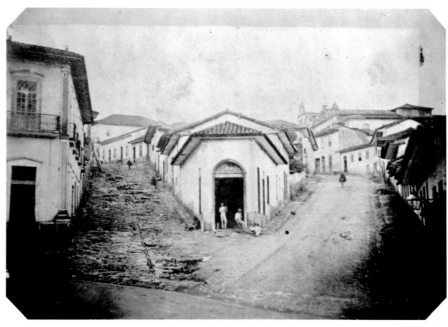

207

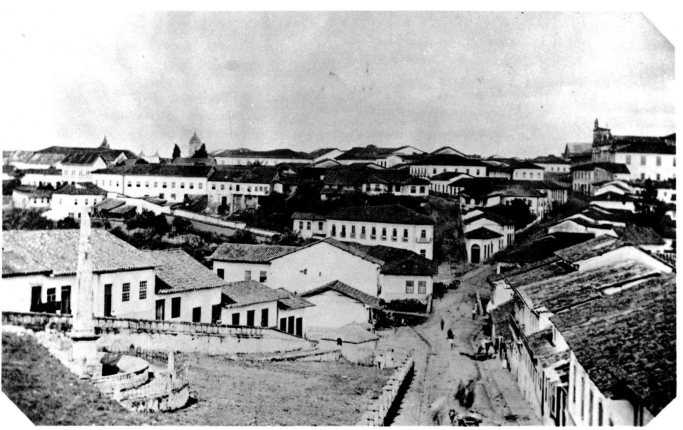

208

206. *Militão albumen 15.8 × 23.2 cm GF*
São Paulo, 1862. Paredão dos Piques, Rua Xavier de
Toledo, showing the Largo da Memória, in a photograph
taken from Vale do Anhangabaú.

207. *Militão albumen 14 × 21 cm GF*
São Paulo, 1862. The steep hillside streets Ladeira do
Ouvidor and Ladeira do São Francisco.

208. *Militão 15 × 23.5 cm GF*
The city of São Paulo seen from Piques, in 1862. In the
foreground, Rua Quirino de Andrade which opens onto
the square of the same name. Shown at left, the obelisk
of Piques and the Ladeira da Memória. Farther on, the
bridge over the Rio Tamanduateí, and the Ladeiras of
Ouvidor and São Franciso, the latter leading to the
church of the same name. The steep street at the left side
of the photo is the Ladeira do Falcão.

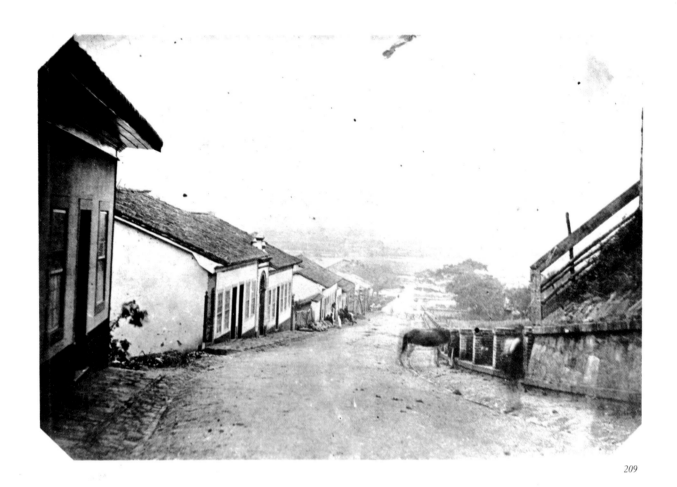

209

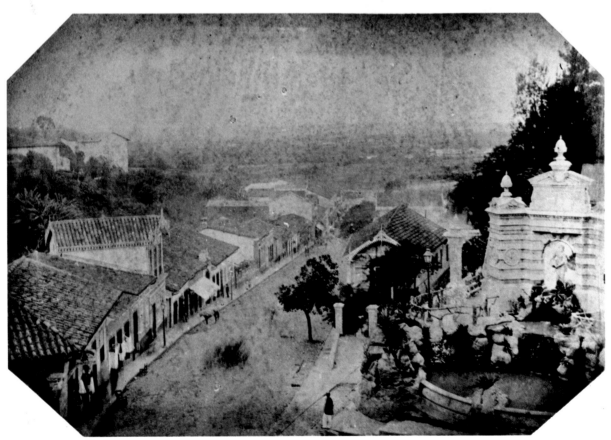

210

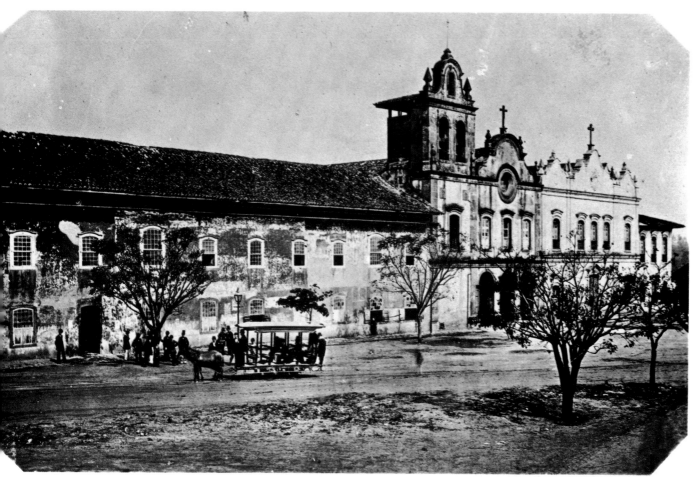

211

209. *Militão albumen 14.3 × 20.9 cm GF*
São Paulo, 1862. Ladeira do Palácio (later Rua João Al-
fredo), which leads to the banks of the Tamanduateí
River, locale of preference for the city's washerwomen.

210. *Militão albumen 15 × 22 cm IHGB*
São Paulo, 1887. Rua João Alfredo, formerly Ladeira do
Palácio.

211. *Militão albumen 14 × 22 cm GF*
São Paulo, 1862. Igreja de São Francisco and Igreja da
Venerável Ordem Terceira da Penitência de São Fran-
cisco, on the Largo de São Francisco. The Faculdade de
Direito de São Paulo [Law School] was housed in the old
convent, where it still operates today.

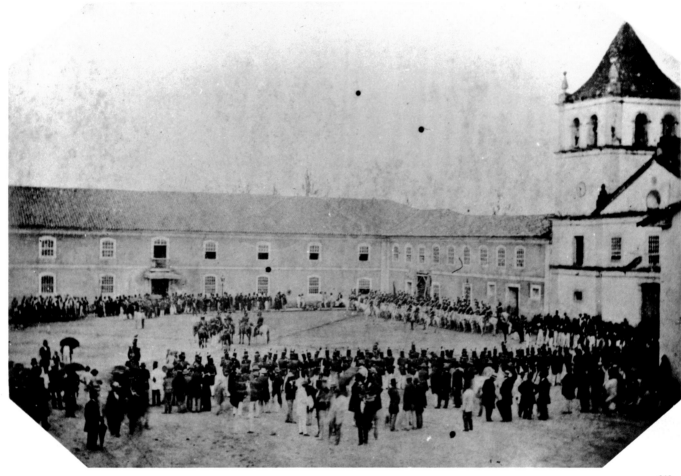

212

212. *Militão albumen 14 × 21 cm IHGB*
The Jesuit church and school, in São Paulo, 1862. There,
the city was founded, in 1554. After many modifications
to the structure, this architectural ensemble was de-
stroyed. In 1980, the church was rebuilt.

213. *Militão albumen 14.3 × 21.5 cm GF*
São Paulo, 1862. Rua da Cruz Preta, showing, in the
background, the tower of the Igreja da Misericórdia.
Note the houses with platbands, probably from the 18th
century. Conselheiro Silveira da Mota lived in the large,
two-story building.

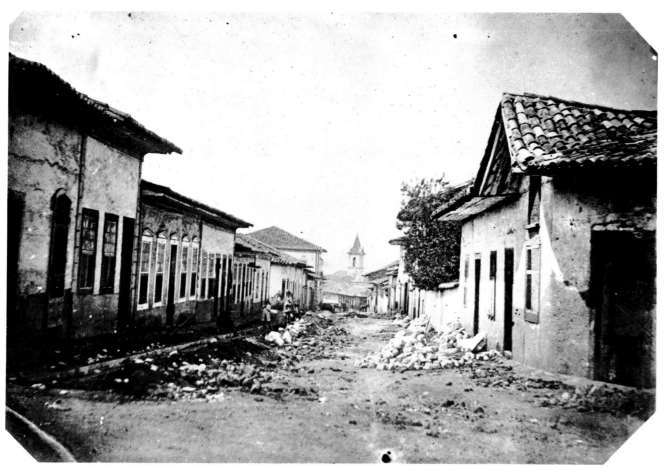

213

214

214. *Anonymous albumen 19 × 22.5 cm GF*
The S. Paulo Railway's viaduct over Grota Funda, in the
Serra do Cubatão, during its construction in 1867 by the
English enterpreneur Robert Sharp & Sons. All the iron
structure was brought from Europe in pieces and hauled
up the mountain through virgin forest.

215. *Marc Ferrez mc 16.5 × 22 cm GF*
The railroad bridge over Grota Funda in the Serra do
Cubatão, completed and in use, c. 1890.

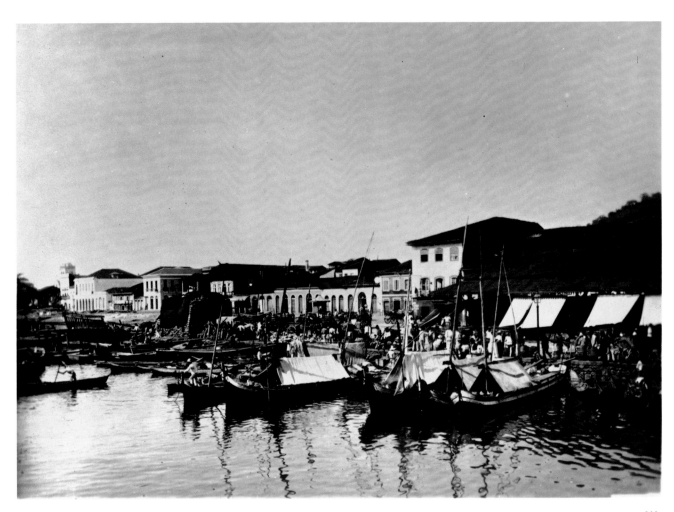

216

216. *Marc Ferrez mc 13 × 18 cm GF*
The market at the port of Santos, c. 1880. Sacks of coffee
piled at the quay's edge, awaiting shipment.

217. *Marc Ferrez mc 16.5 × 22 cm GF*
The port of Santos, c. 1880. Seen along the shoreline, at
center, the convent and Igreja de Santo Antônio.

218. *Marc Ferrez albumen 15 × 22.2 cm GF*
The port of Santos, c. 1885, when yellow fever decimated
entire crews while their ships crowded the harbor to be
reoutfitted.

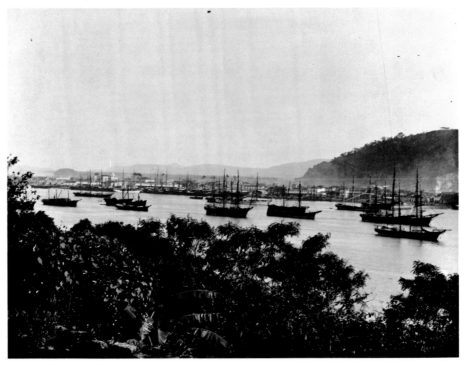

217

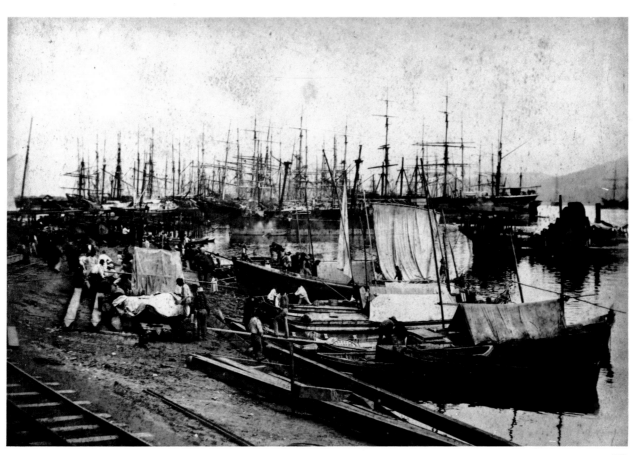

218

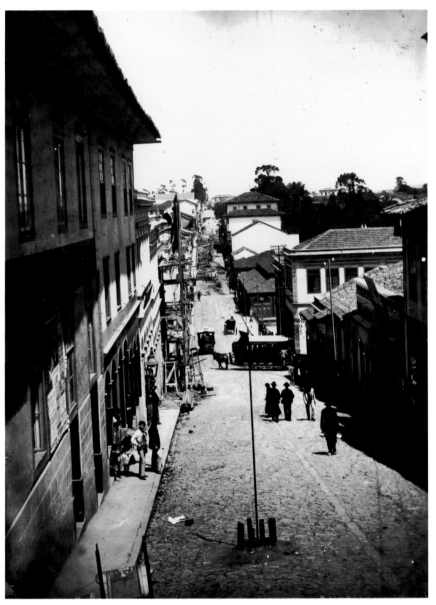

219

220

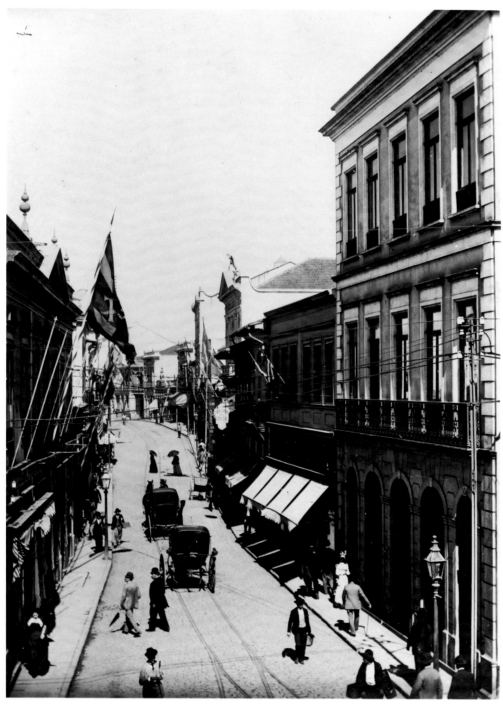

221

219. *Marc Ferrez albumen 22 × 16.5 cm GF*
São Paulo, c. 1890. Photograph taken from the corner of
Rua São Bento with Rua São Jão, looking toward the
Largo do Paissandu. The large building at left is the old
Hotel Itália e Brasil, built in 1814 and demolished in 1915
to make way for the Edifício Martinelli. The burro-
drawn tram is headed for Rua São José (now Rua Líbero
Badaró).

220. *Marc Ferrez albumen 16.5 × 22 cm GF*
São Paulo, c. 1892. Vale do Anhangabaú and the Viaduto
do Chá, shortly after its inauguration. The viaduct was
constucted as a result of the efforts of the Frenchman
Jules Martin, who conceived the idea. It was 240 meters
long and 14 wide. At first, the user paid a toll of 3 vin-
téns, that is 60 réis. The name *do Chá* comes from the
fact that the first plantings of tea in São Paulo were made
at this site.

221. *Marc Ferrez mc 22 × 16.5 cm GF*
São Paulo, c. 1892. Rua 15 de Novembro, formerly Rua
dos Bancos.

222

222. *Marc Ferrez albumen 16.5 × 22 cm GF*
The São Paulo Observatory of General Couto de
Magalhaães, at Ponte Grande, c. 1880.

223. *Marc Ferrez mc 16.5 × 22 cm GF*
São Paulo, c. 1870. Ponte do Carmo, connecting Ladeira
do Carmo with Brás. Looking below and beyond the
bridge, the so-called Mercado dos Caipiras can be seen.

224. *Marc Ferrez mc 16.5 × 22 cm GF*
Fábrica Ipanema, SP, c. 1870. The first ironworks built in
Brazil.

223

224

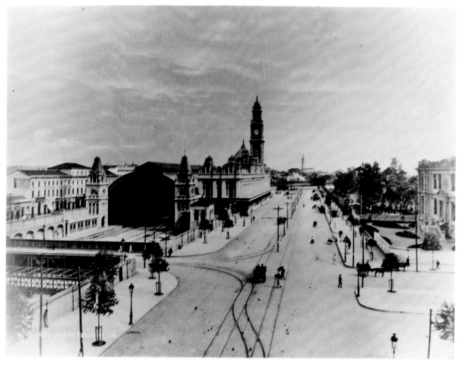

225

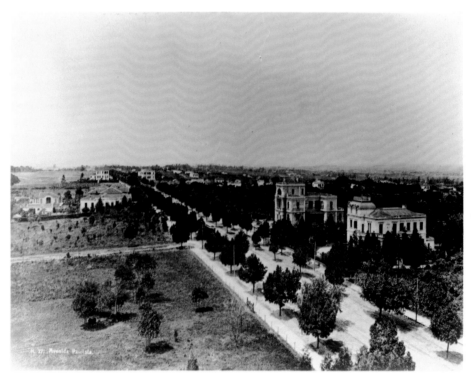

226

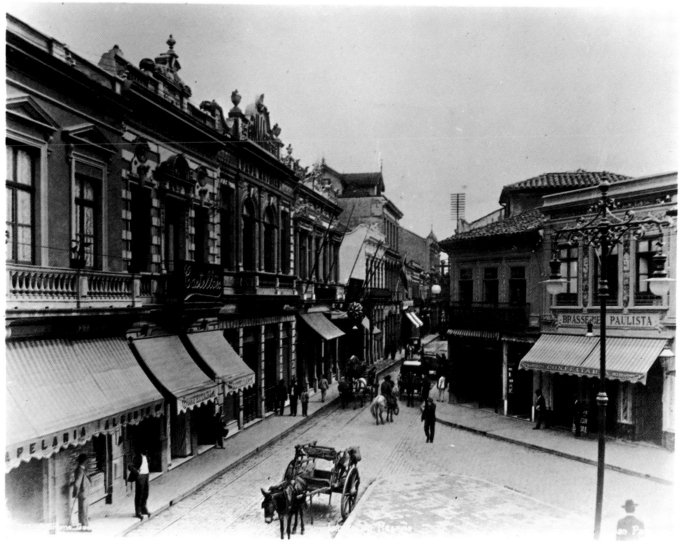

227

225. *Gaensly pni (18 × 24 cm) GF*
São Paulo, c. 1900. The S. Paulo Railway's Estação da
Luz, just as it looks today.

226. *Gaensly pni (18 × 24 cm) GF*
São Paulo, c. 1890, at the advent of Avenida Paulista,
child of the coffee barons, and the beginning of the state's
industrial development.

227. *Gaensly pni (18 × 24 cm) GF*
The Largo do Rosário, c. 1890, showing the famous con-
fectionaries, Castelões, and the Brasserie Paulista.

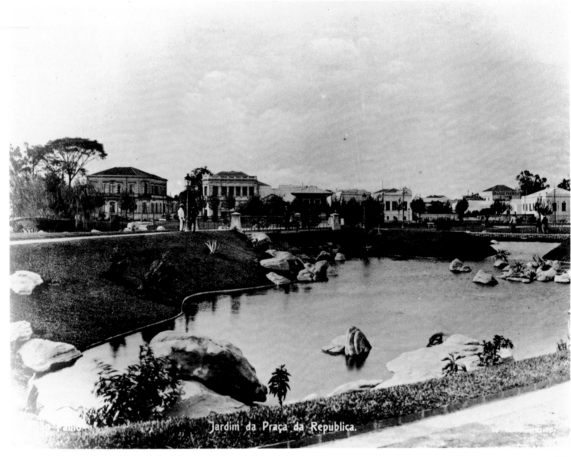

Jardim da Praça da Republica.

228

228. Gaensly pni (18 × 24 cm) GF
São Paulo, c. 1905. The park at Praça da República
shortly after its inauguration.

Paraná

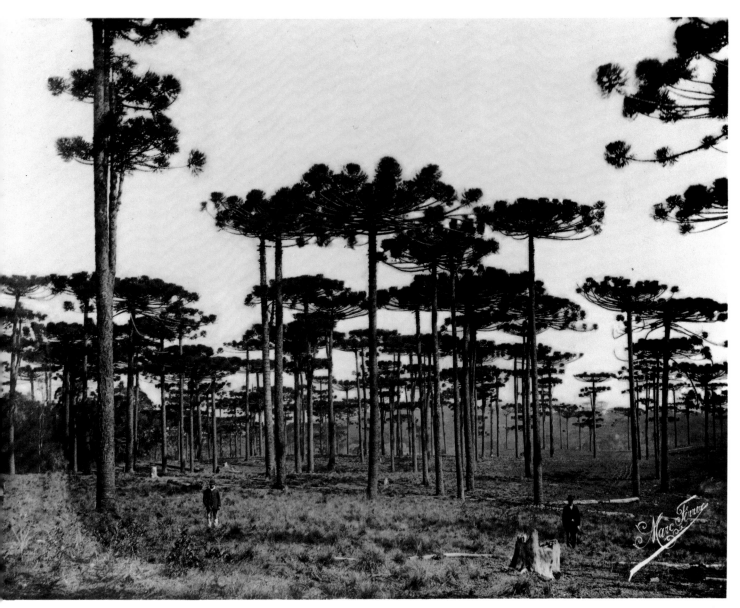

229. *Marc Ferrez mc 28.5 × 34.2 cm GF*
Brazilian pines (*Araucaria brasiliensis*), 1879.

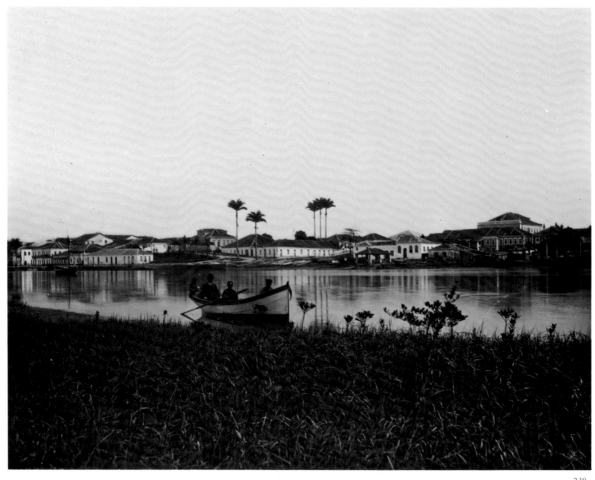

230

231

232

230. *Marc Ferrez mc 16.5 × 22 cm GF*
The city of Paranaguá, c. 1890.

231. *Marc Ferrez mc 16.5 × 22 cm GF*
Panorama of the city of Paranaguá, c. 1890.

232. *Marc Ferrez albumen 23 × 28 cm GF*
The large viaduct on the Paranaguá-Curitiba railroad,
the country's largest and most audacious railway project,
during the final phases of construction, in 1879.

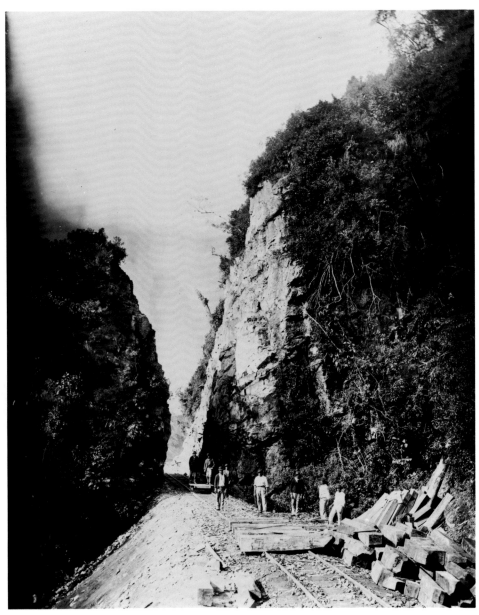

233

233. Marc Ferrez albumen 28.1 × 23 cm GF
Cut through the mountainside for the construction of the
Paranaguá-Curitiba railroad, 1879.

Santa Catarina

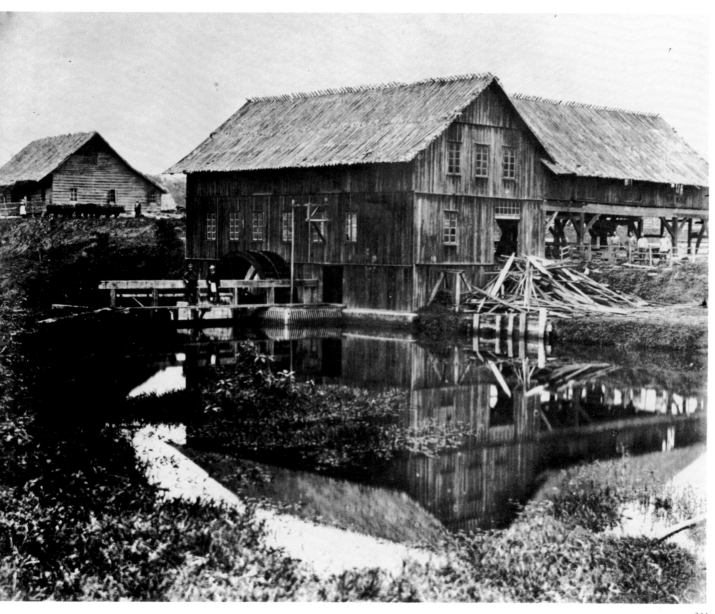

234. J. Otto Niemeyer albumen 18.4 × 23 cm BN
The sawmill of H.R.H. the Prince of Joinville at the
Colônia de Dom Francisco (now the city of Joinville),
1866.

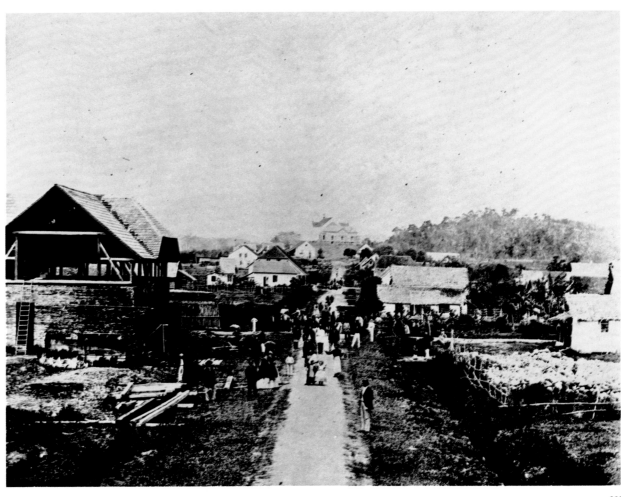

235

235. *J. Otto Niemeyer albumen 17.3 × 22.5 cm BN*
Rua do Príncipe, the main street of Colônia de Dom
Francisco, seen from the Administration building, in
1866.

236. *Marc Ferrez mc 20.5 × 28 cm GF*
The coal port of Imbituba, c. 1879.

237. *Marc Ferrez mc 16.5 × 22 cm GF*
Panorama of Florianópolis, c. 1879.

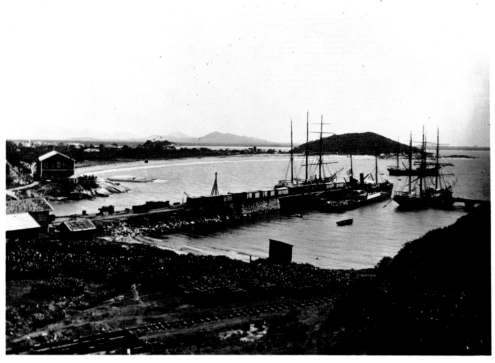

236

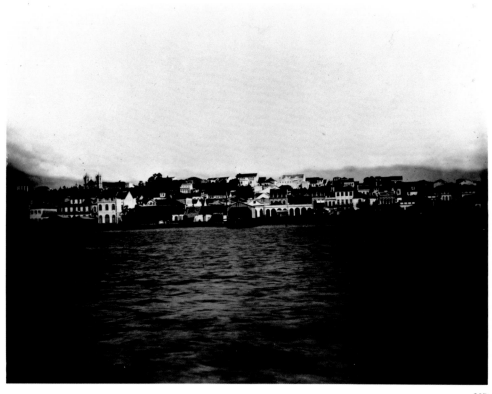

237

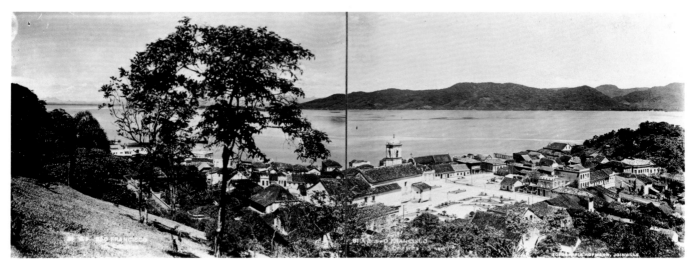

238

238. *Hoffmann gelatin silver 10.7 × 30 cm*
Panorama (two photos juxtaposed) of the city of São
Francisco, c. 1895.

Rio Grande do Sul

As early as 1868, there is documentation of the presence of three photographers in Porto Alegre: Justiniano José de Barros had a studio at 163 Rua da Ponte, where, besides taking photographs, he taught "the art with every perfection"; Bernardo Grasselli, installed at 5 Rua da Alegria, who took "portraits with or without views of the city"; and Alexandre Satamine. But the professional photographer who most dominated the *Gaucha* capital after 1860 was Luís Terragno, who had held the well-deserved title of Photographer to the Imperial House.

Terragno started out in Pelotas, later moving on to the capital of the province, Porto Alegre. His photographic panoramas and views of public and private buildings in that city are excellent in their craftsmanship and composition. Terragno participated in the Philadelphia Exhibition of 1876.

239. Marc Ferrez mc 16.5 × 22 cm GF
Dock beside the market of Porto Alegre, c. 1895.

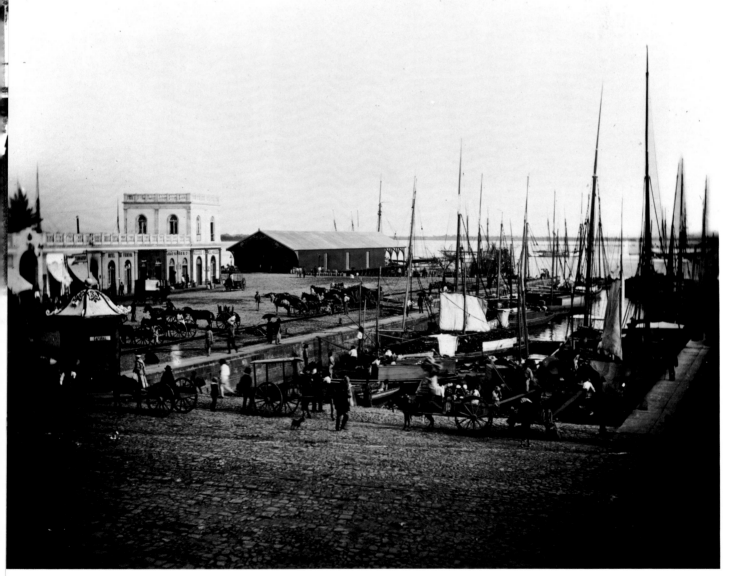

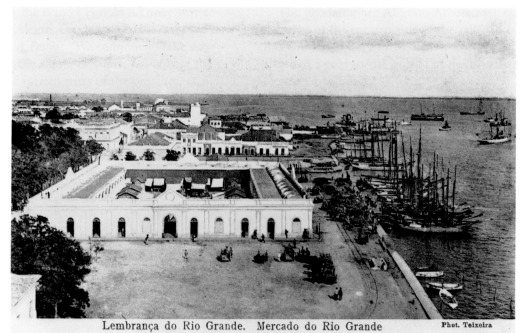

Lembrança do Rio Grande. Mercado do Rio Grande Phot. Teixeira

243

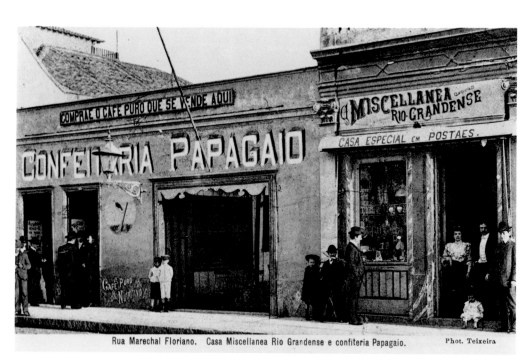

Rua Marechal Floriano. Casa Miscellanea Rio Grandense e confiteria Papagaio. Phot. Teixeira

244

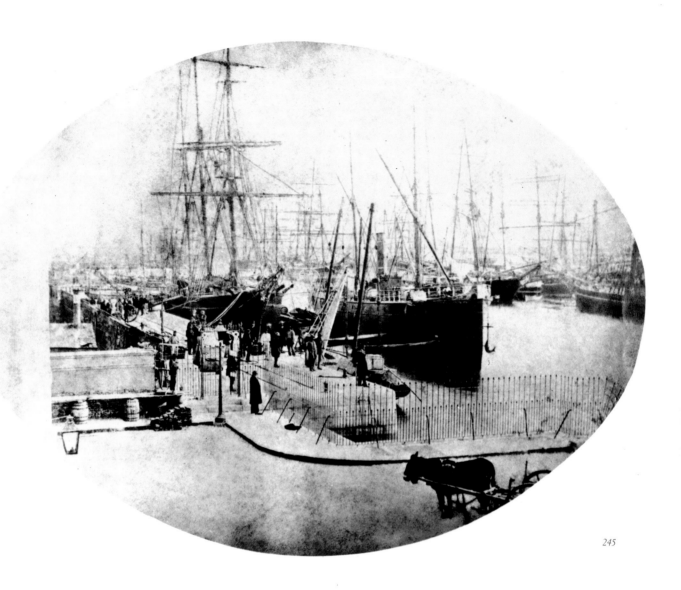

245

243. *Teixeira collotype 8.8 × 13.8 cm GF*
The Rio Grande market, c. 1900. Postcard.

244. *Teixeira collotype 8.6 × 13.8 cm GF*
Rua Marechal Floriano, in Rio Grande, c. 1900. Postcard.

245. *Anonymous albumen 26 × 35 cm IHGB*
Customshouse quays in Porto Alegre, completed in 1872
by Viscount of Rio Branco.

Marc Ferrez

Of all the artists discussed in this text (and the list of names is rather incomplete, since only the most representative have been included), none worked so diligently, or with such love for art and his country—traveling it from north to south—as Marc Ferrez.[81] No other equaled him in artistic taste or technique, nor produced such a large body of work, nor trained so many professional and amateur photographers.

Marc Ferrez was born in Rio de Janeiro on December 7, 1843, and was baptized in the Igreja do Santíssimo Sacramento on February 3, 1845. When he was seven years old, he had the misfortune to lose, on the same day, both his parents, Zeferino Ferrez and Alexandrina Caroline Chevalier Ferrez. Zeferino was a sculptor and engraver. He had come to Brazil from France as a member of the French Artistic Mission that established the Imperial Academy of Fine Arts, where he taught medal engraving—an art that he had introduced in Brazil. The death of the Ferrez couple was sudden and mysterious; the same malady was responsible for the deaths of several slaves and domestic animals at the paper factory that they owned at that time in Andaraí Pequeno (now Muda da Tijuca, in the parish of Engenho Velho).[82]

Marc was the youngest of six children; he had four sisters and one brother. At his family's decision, he was sent to France where he spent his childhood studying in Paris. There, he was cared for by family friends, the sculptor Alphée Dubois and his wife, who came to be like true parents for the young Marc. The date of his return to Brazil is uncertain, although it seems to have occurred after he had reached the age of sixteen. Back in Brazil, he went to work for Leuzinger, friend of the family and owner of the most highly regarded stationery and lithography establishment in Rio de Janeiro at the time. There, he learned the fundamentals of the business, working in the divisions of stationery supplies, binding, gilding, lithography, and so on.

Around 1860, the firm of Casa Leuzinger opened a photography division, directed by Franz Keller (1835–90), an engineer and botanist who had come to Brazil from Germany under contract.[83] Ferrez learned photography from Keller and soon became as competent as his teacher, whom he eventually replaced as the company's photographer.

246. Georges Arloing gelatin silver 10 × 10 cm GF
Marc Ferrez in old age. Vichy, France, c. 1915.

246

In 1865, at the age of twenty-one, the young photographer decided to open his own business at 96 Rua São José, under the name Marc Ferrez & Cia. He soon rivaled the Court photographers discussed in the preceeding chapters. In 1872, he dissolved that company and formed another, proudly announcing in the *Almanak Laemmert*: "Marcos Ferrez, 96 Rua de S. José (specializing in views of Brazil)."

Thus, he opted early on to follow a different path from his contemporaries, specializing in views, Brazilian landscapes and photographs of ships, which was quite difficult in the days before the invention of the "instantaneous" dry plate. Yet, he perfected a system by which, photographing from inside a small boat, he could make perfectly sharp images of the Brazilian military and merchant fleets anchored in the harbor. This feat earned him enormous prestige and advantage over his competitors, as well as the title of Photographer of the Imperial Navy. A photograph of the frigate *Pallas*, taken by Marc Ferrez, appears in the earlier-mentioned book by Raymond Lécuyer with the caption: "*Marc Ferrez*—Pallas, French frigate, photographed in the port of Rio de Janeiro in 1886. The photographer obtained this negative—an instantaneous one—by using two cameras superimposed, one of which served as a view finder. (It is in the Collections of the Société Française de Photographie)."[84]

The glass-plate negative from which this print of the *Pallas* was made is not in my own collection. However, it does contain one of the crew and another of the splended ship *France*, fully rigged, photographed outside Guanabara Bay.

By employing the technique he developed, Marc Ferrez was able to photograph all the ships in the fleet of the Imperial Navy, leaving us with a historical document of great importance today. I own a complete set of these plates, all perfectly preserved.

In 1872, Ferrez photographed the arches and bandstands erected in the streets of Rio de Janeiro on the occasion of the return of Their Imperial Majesties from their second trip to northern Brazil. A collection of these photographs can be found in the Biblioteca Nacional.[85]

In 1872, Marc Ferrez married Maria Lefebvre, who had been born in France. A few months later, at ten o'clock at night on November 18, they heard church bells sounding a fire alarm. In those days, church bells constituted the city's news media: announcing the birth and sex of children, deaths, fires, festivities, the hour, and any number of other events, as noted by Luís Edmundo in his reconstitutions of Old Rio. The building where Ferrez had his studio and residence burned in one of the most spectacular fires in the history of the city. In a few minutes, the flames devoured the fruits of many years' labor. It seems that, in order to meet his new reponsibilities as a married man, Ferrez sublet the front part of the building to a book dealer named Maciel, and that the fire started there. Owing to the amount of highly flammable material at the site, the fire took on alarming proportions. In less than an hour, it destroyed the houses at 96 and 98 Rua São José and damaged those at numbers 94 and 100 so seriously that only the furniture could be saved, and that only thanks to the help of people on the streets, since then—as always—there was no water available.[86]

Marc Ferrez was ruined. Yet, at crucial moments, he would always find someone who extended him a generous hand. Besides his wife, who encouraged him to start over, his friend Júlio Cláudio Chaigneau came to his aid. Chaigneau was the owner of a long-established business founded in 1830, successor to Vva. Le Bourgeois & Debaecker. Since 1860, Chaigneau's firm had sold "instruments and a complete line of supplies for daguerreotypy and photography."[87] From this friend, Marc Ferrez borrowed the money necessary for a trip to Europe in order to acquire specialized materials and start over again.

248

247. *Marc Ferrez mc 16.5 × 22 cm GF*
La France outside the bay of Rio de Janeiro, navigating under full sail, c. 1888, before the use of instantaneous photographs.

248. *J. F. Guimarães albumen 13.5 × 9.5 cm GF*
Marie Lefebvre Ferrez, wife of Marc Ferrez, c. 1875.

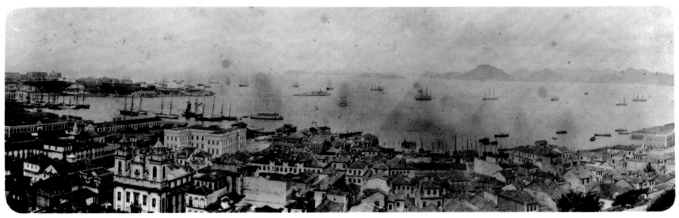

In Paris, he visited his friend Alphée Dubois, to whom he introduced his wife. On that occasion, his former guardian made two medals of the couple.[88]

Returning to Brazil, Ferrez accepted, in May 1875, an invitation to serve as photographer of the Commissão Geológica do Império do Brasil [Geologic Commisson of the Empire of Brazil]. Headed by Charles Frederick Hartt of Cornell University, this scientific expedition was the most important that had ever been organized in Brazil. Ferrez was the first to photograph the Botocudo Indians in the heart of the forest, near the village of Leopoldina in southern Bahia. While on the journey, Ferrez visited much of the northern part of Bahia and had the occasion to become friends with the scientists Hartt, Orville Ad Derby, Branner, and Richard Rathburn.[89] During this trip Ferrez contracted the liver disease that plagued him for the rest of his life.

A series of more than two hundred photos taken by Ferrez on the expedition was shown in 1877 at the commission's headquarters on Rua dos Ciganos (currently Rua da Constituição). Some of these photographs were also included in the Exhibition of Public Works of the Ministry of Agriculture in 1877.[90]

After a four-year absence, Marc Ferrez's advertisements began to appear again in the *Almanak Laemmert* in 1878. His new studio was located once again on Rua São José—no. 88, this time—where it remained until the opening in 1903 of Avenida Central (the present Avenida Rio Branco) when the building was torn down to make way for the new thoroughfare.

His reputation grew, and he became recognized for his true merit, not only as a businessman and a fine technician, hardworking and honest, but also within the artistic and scientific circles in Rio de Janeiro. Yet, Ferrez was, above all, an artist. To know his photographic work is to recognize this fact. When choosing a subject, even a purely documentary one, he would seek a new and original point-of-view. He composed his pictures with several planes, in order to give the impression of depth and atmosphere, studying the light required to achieve the total effect he desired. Since the photographic emulsions of that time were of only moderate sensitivity, it was absolutely necessary to study the lighting before making a photograph, in order to determine which would be best: a clear or cloudy day; the sun hitting the subject at an oblique angle or straight overhead. In Rio de Janeiro, the problem of making photographic views was complicated by the haze, the result of the high proportion of humidity in the air that prevails throughout most of the year.

Before the technological advances that brought it within the reach of amateurs at the turn of the century, photography was a difficult art, requiring patience and skill. In Ferrez's time, the artist had to prepare his wet plates with the collodion solution. Handling plates was a delicate affair, since the collodion layer had to be spread evenly across the surface. He also had to sensitize the printing paper. Preparing, in the heat of summer, the 30 × 40 cm glass plates that Marc Ferrez used in abundance required great skill and dexterity that could only be acquired with experience. It is easy to imagine the

249. Marc Ferrez silver gelatin 10 × 32.5 cm GF
Panoramic view taken from Morro do Castelo, looking toward the harbor, of the city of Rio de Janeiro from the market to the prison. The market, palace, and Igreja de São José can be distinguished among the buildings.

250. Marc Ferrez albumen 10.5 × 16.5 cm GF
Photographic equipment for making panoramic views, invented and built by M. Brandon, modified and improved by Marc Ferrez in 1881.

250

difficulties that would arise in working outside the studio laboratory using these plates which were meant to be used under normal, studio conditions. Yet, they were the only type of negative in use at that time and, in spite of their drawbacks, produced excellent images that were sharp and well defined.

My collection contains many glass-plate negatives (the process was in use until 1890) taken in the backlands of Minas Gerais and Bahia, in the Organ Mountains, in the heart of the forests, and in the arid regions of northeastern Brazil. To make these pictures, the photographer had to bring a darkroom tent to these remote areas, a minimum of ten to twelve flasks of chemicals and developing trays, as well as the tripod, the heavy camera, large lens, and even heavier boxes of glass plates. Even after the advent of dry plates (starting in 1880), to work with plates from 50 × 60 cm to one meter wide called for uncommon skill. Taking all this into account, the body of work produced by the tireless Marc Ferrez is truly astonishing.

Ferrez was also interested in physics and chemistry, seeking to understand everything that might, eventually, have even a remote application for photography. He always kept up with and studied the latest innovations. He spent everything he earned by sending off for all the latest photographic inventions and improvements that appeared on the European market. How often a supposedly useful invention proved to be worthless! Yet, Ferrez never concerned himself with the financial aspect of photography. He was constantly performing experiments, attempting to ally his art with other sciences, such as astronomy, medicine, and engineering. Photographs of

stars and eclipses taken through telescopes, the invisible world seen through the microscope, the earliest trials with X rays all were within his field of activity. Luís Cruls and Henrique Morize, both directors of the National Observatory, spent hours doing research in the photographer's laboratory. Working with Morize, Ferrez undertook a number of projects. He made the first photographic plates using the crude X-ray devices of the time. For Dr. Alvaro Ramos, the eminent surgeon, Ferrez made an X-ray photograph of the Siamese twins Maria de Lourdes and Maria Francisca, as well as photographs of many other unusual medical cases.

Yet, Ferrez's true speciality was panoramic views. Fascinated by the beauty of his natural environment, he wanted to make negatives, ever larger, that faithfully reproduced with sharp detail, accurate perpective, and no distortion, the broad vistas that he so frequently saw on his excursions. He had built, in Paris, the large panoramic camera designed by Brandon. In my collections are two prints of this extraordinary camera and a written description, transcribed below:

The great panoramic camera of Brandon, perfected by the artist owner of this establishment, was constructed expressly for making views of Rio de Janeiro that would be as impressive and beautiful as the splendid landscapes to be seen in these luxuriant and delightful natural surroundings.

Permit me here a brief description of this apparatus whose perfection and extraordinary size is left for all to judge from the panorama on exhibit.

This device is capable of making panoramic views with an angle of view ranging from a minimum of 120° to a maximum of 190°. It is totally automatic and functions by means of a clock mechanism. Its complete rotation can be effected in 3 minutes, as well as in 20 minutes, depending on the light and the objects to be reproduced. It weighs 110 kilograms and uses glass plates 1.10 m × 0.40 m, of 8 kilos each, making panoramic images 110 centimeters wide.

This apparatus (which the artist who owns and perfected it spent three years studying and improving) is unquestionably the best in the world, since no one has yet made photographic views that equal those it produces.

The panoramic view exhibited in Philadelphia (1876), though printed on a single sheet of paper, was made with 4 exposures 80 cm wide. While being an excellent product of the photographic art, this work—which attracted so much attention from professionals and amateurs (as it later did in Paris in 1878)—was, nevertheless, defective in that it did not present objects in their true planes, nor maintain precise mathematical perspective, even though the aberrations it contained were very slight. Such defects are not to be found with the camera that the artist now owns, and it is impossible for them to appear in the exposures made with it since it captures the images before it simultaneously and consecutively by areas from 2½ to 3 centimeters wide.[91]

The lens was a very bright one, made in England by the Dalmeyer company.

To my knowledge, this was one of the most ex-

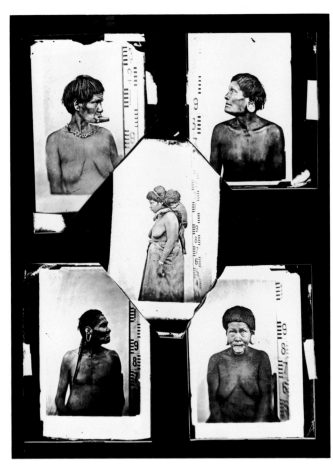

251

251. Marc Ferrez albumen 23 × 17 cm GF
Botocudo Indians from southern Bahia. Marc Ferrez was the first to photograph the Indians of the region, in 1874, during the geologic expedition led by Frederic Hartt.

252. Marc Ferrez gelatin silver 18.6 × 25 cm GF
The photographer Ferrez and his assistant on assignment. In some situations, the handcar replaced the burro for transportation.

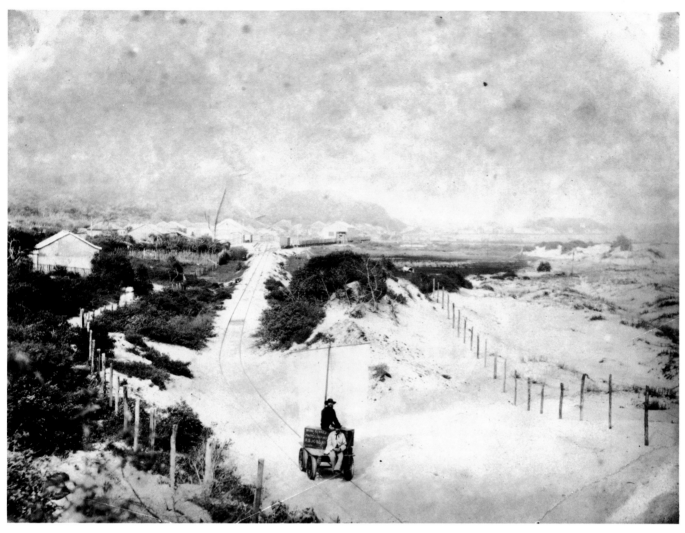

traordinary cameras ever invented. There was another, somewhat larger, but it would have been useless in Brazil because of its excessive weight. I am referring to the camera described by Helmut and Alison Gernsheim: "The largest camera made during the nineteenth century was constructed in 1860 for John Kibble, a Glasgow amateur. It was so big that it had to be mounted on wheels and drawn by a horse. The glass plates measured 44 × 36 inches and each one weighed about 44 lbs."[92]

Consider the risk involved in taking photographs from the top of Sugar Loaf before the aerial tramway existed, when it was necessary to make a difficult ascent with heavy equipment, or the effort necessary to obtain a panorama 50 × 40 cm or 55 × 35 cm in the Organ Mountains in Teresópolis, which could only be reached on the back of a burro. And this was only the beginning, in comparison to

the difficulties to be met on the Hartt Geologic Expedition of 1875–76.

One has to bear in mind that almost nothing that might facilitate the photographer's task was industrially produced at that time. Even the glue used to adhere the prints to card mounts or albums had to be made by the photographer or his assistants.

Albumen paper, invented by Blanquart-Evrard in May of 1850, was widely used throughout the world for making positive prints until nearly the end of the century. It was prepared by the photographers. The process consisted of applying a coating of egg white (albumen) to the printing paper, which was later sensitized with a solution of silver nitrate. After the paper had been placed in contact with the negative and exposed in sunlight, the photographic print was treated with gold chloride, which gave a characteristic color and greater image permanence.

Once the production of albumen paper had been industrialized, the German city of Dresden became a major center of its manufacture, with several factories in operation. Helmut and Alison Gernsheim have written that the consumption of eggs for this purpose—only at the Albumin-Papier Fabrik in Dresden, the largest producer of albumen paper in Europe—was 60,000 per day, nearly 18 million annually.[93] This level of consumption indicates a large number of photographers active in the 1870s; the albumen paper produced in Dresden was exported to a number of European and American countries.

From 1876 on, Ferrez competed in several of the national exhibitions and all of the international exhibitions in which Brazil participated. By doing so, he used the medium of communication at his disposal to contribute to the dissemination of information about the customs, appearance of the natural landscape and the cities, the production of coffee and sugar, public works, and industry of Brazil.

Among the awards that he received were gold medals for his work exhibited in Philadelphia (1876), in Paris (1878), and in Rio de Janeiro (1879) at the General Exhibition of the Imperial Academy of Fine Arts (including one for "his photographs made by the process known as Carbon"). He also won the Grand Prize at the Brazilian Exhibition in 1881. The following year, he received the Merit Award and silver medal at the Continental Exhibition in Buenos Aires and participated in the Second National Exhibition [in Brazil] which was visited, as was customary, by Dom Pedro II. Throughout his life, the Emperor displayed a profound interest in photography. According to a report on the Emperor's visit to the exhibition (*Jornal do Commercio*, June 6, 1882), he lingered to examine the photographs, the glass plates, and Ferrez's imposing camera. Ferrez won bronze medals at the Amsterdam Exhibition and the General Exhibition of the Imperial Academy of Fine Arts in 1883. Finally, on March 7, 1885, at the age of forty-one, he was made a Knight of the Order of the Rose. The certificate of award is signed by Dom Pedro II and proclaims: "We wish to give to Marc Ferrez a public testimonial of My Imperial Consideration in recognition of the artistic merit that he has demonstrated in the last General Exhibition of the Imperial Academy of Fine Arts: I hereby name him Knight of the Order of the Rose." That same year, Ferrez found time to submit works to the Universal Exhibition in Antwerp. There, he won a bronze medal, as he did at the International Exhibition in Paris in 1889. The list of competitions in which he participated is extensive, but two deserve mention here. He showed his work in Rio at the Centenary Exhibition of the Discovery of Brazil (1900) and in St. Louis (1904), where he and Insley Pacheco achieved great success, receiving gold medals—the only photographers to be awarded this distinction.

The photographer's first son, Júlio Marc Ferrez, was born on April 14, 1881 (the first child, a daughter, had died); the second, Luciano José André, on February 9, 1884.

Around 1881, Ferrez introduced several innovative processes to the Brazilian market, among them the first dry plates made in Paris by Lumière and bromide printing papers.

Ferrez's constant passion for travel led him to traverse the greater part of Brazil, sometimes on official missions, sometimes on private assignments, and other times in search of subjects for photographic views. From these travels came the variety of subjects found in his large body of work.

In 1881, he published an advertising brochure where he wrote:

> This establishment possesses more than 1,500 negatives in various sizes for making stereographs, album cards, tourist cards, and small panoramas in sizes such as 24 × 30, 30 × 39, 25 × 51, 50 × 60, 110 × 40 cm. Its portfolio contains a great variety of views of Rio de Janeiro and the surrounding area, Petrópolis, Nova Friburgo, Teresópolis, Pernambuco, Bahia, São Paulo, Campinas, and Santos. All negatives are obtained directly (*d'après nature*), and are neither copies, nor enlargements.

A dozen views 24 × 30 cm cost 30 to 48 *mil-réis*; 30 × 39 cm or 50 × 25 cm, 120 *mil-réis*. A view 50 × 60 cm went for 20 *mil-réis*, and one measuring 102 × 49 cm cost 40 *mil-réis*. As many as 245 different chemical products were available in Ferrez's store, according to a catalog in my collection. The advertisement and illustrations in this catalog are indicative of the scope of Marc Ferrez's activities during more than half a century of uninterrupted labor.

Throughout the long period from 1860 to 1910, Ferrez photographed many of the principal cities of Brazil, documenting the construction of railroads, recording the appearance of monuments, bridges, dress, plantations, Indian tribes, mining operations, the interiors of palaces and churches, the paintings of Brazilian artists, waterworks, forests, waterfalls, rivers, ports, industrial installations, mountains, the entire fleet of the Imperial Navy, and so on. Many of the glass-plate negatives were damaged by use, broken, lost, or stolen. But those that the family still preserves are numerous enough to provide a rich visual document of the Brazil of that time.

This material is a link between the earlier, precious old prints of Debret, Rugendas, Chamberlain, Steinmann, Prince Maxmillian, Maria Graham, William Gore Ousley, Desmons, P. Bertichem, Pustkow, Hagedorn, Adolphe d'Hastrel, Ender, Burchell (and the many others artists who depicted Brazil in graphic media before the advent of photography) and the works of modern photographers.

Viewers today are awed by the luminosity, the accuracy of perspective, gradation of the various planes—with sharp detail from the foreground to infinity—and impeccable craftsmanship of Marc Ferrez's negatives. They are perfect. Stored for over a hundred years, they have held up well against the ravages of time.

The advent of the trolley in 1868 would change the placid and almost insular habits of the Brazilian family. There is no doubt that phototgraphy also contributed, in a more subtle manner, to this change. Without exception, virtually every family from the middle class up had portraits made. Young ladies and matrons, thus, had one more reason for leaving the house. From then on until the end of the century, there was a constant exchange of photographs between the numerous relatives, godparents, and friends.

It was no longer necessary to spend a fortune with painters, whose services were within the means of only the wealthiest patrons. It was enough to go to one of the several photographers in the city to obtain, for the price of a few *mil-réis*, a good portrait made by the latest and most fashionable process. It might be a daguerreotype or ambrotype—toned or hand-tinted—or an albumen, gelatin, chloride, gelatin bromide, platinum, cyanotype, or carbon print. These might be made on paper, marble, porcelain, fabric, or oilcloth and then hand-colored or vitrified by fire like the painted ceramics of Sèvre and Lim-

253

253. *Marc Ferrez mc 16.5 × 22 cm GF*
Júlio and Luciano, children of Marc Ferrez.

oges. Dimensions ranges from life-size to extremely small.

The result of all this is apparent in the delightful portraits that filled so many family albums, those parlor perennials that only began to disappear from living rooms around 1920. There we see Mother seated in a chair, wearing her hat that looked more like a flower garden; Father with his frockcoat and gold-knobbed walking stick, watch chain across his chest, leaning against the ever-present column; the little girls behind the chair situated next to the no-less-conspicuous table with a vase of flowers or two books on top; or the lady with her flowing skirts, standing beneath a bower of roses or in front of a romantic, painted backdrop featuring a tropical landscape.

Some photographers had these backdrops made in Europe, commissioning them from well-known painters. One who did this was the Hungarian photographer J. Vollsack, successor to Henschel, who advertised on a colored handbill in the *Diario Mercantil* on December 1, 1887: "Desirous that his establishment, which is undergoing a complete renovation, equal the finest of its type in Europe, Mr. Vollsack, following his artistic instincts and without concern for economy, has commissioned for his magnificent studio the painting of several backdrops to be made in Monfalcone, Italy by the celebrated painter M. Moro."

In these photographs, our grandparents—then children—come before us riding tricycles or rocking horses, surrounded by an abundance of toys. It was all very rigid and formal, since it was imperative that the sitter not move, but remain attentive, with his eyes fixed on the lens from which would appear, eventually, the "little green bird."

Landscape photography was far less lucrative than portrait photography, since the clientele was more limited. The former attracted mostly travelers or foreigners who resided in Brazil and wished to send pictures of the land to their relatives and fellow citizens back home. So much was this the case that the majority of these views bear explanatory captions in languages other than Portuguese: almost always in French and, sometimes, in English. These views for the tourist market were made by Leuzinger and Marc Ferrez in Rio, Gaensly and Mulock in Bahia, Riedel in Minas, and by others.

Marc Ferrez spent a great deal of time in the laborious task of printing multiple copies of his negatives. Because of this, he realized the potential and importance, soon after it came into use, of the now-

254

254. *Marc Ferrez mc 22 × 16.5 cm GF*
First photo of work in the interior of a gold mine in Minas Gerais, c. 1880. Unidentified mine.

255. *Marc Ferrez platinotype 15.9 × 21.5 cm GF*
A pretty view, taken in Rio de Janeiro's Jardim Botânico, of the much-admired bamboo grove. Of those in Marc Ferrez's shop, this photo was one of the most widely sold to travelers eager for souvenirs of Brazil.

common photomechanical process known as collotype. Being neither experienced in the use of inks, nor having the machinery and space necessary for the adoption of that system, he solicited the Lombaerts firm, publisher of books and a fashion review, to carry out his project. The partners were not successful. Both were pioneers in a specialty that, even today, requires certain environmental conditions. The high temperatures in Rio caused the failure of the experiment, an audacious attempt in the years 1890 to 1892 to import a new technology into a tropical climate.[94]

Ferrez's firm was among the earliest, if not the very first, to manufacture the picture postcards that were so much in vogue from 1900 to 1920. Yet, one of the most important branches of his business was that of copying plans for the construction of the city's buildings. To do this, he employed the unique and practical "ferroprussiate," or blueprint, process in which the designs of façades, sections, and plans were made on a transparent screen and reproduced with white lines (heliographic system). The paper was imported in large rolls of various widths and sensitized in Brazil, as it was needed. The work was done at night, following the after-dinner rest, and went on until ten or eleven o'clock. Seeking to improve this process, Ferrez frequently imported mechanical devices, paper, and chemicals in an attempt to obtain the much-desired reproduction of plans with black lines on white paper. Yet, despite his efforts, none of the various processes he tried ever lived up to the extravagent claims of the inventors or vendors, always leaving the outcome unpredictable.

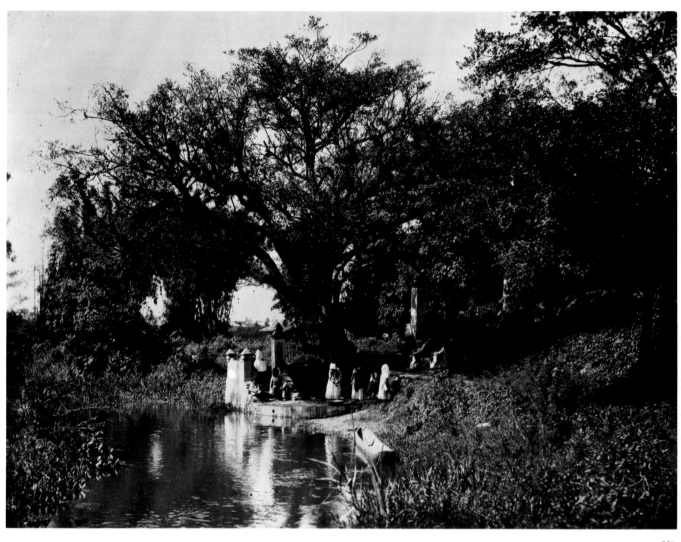

256

256. *Marc Ferrez mc 16.5 × 22.5 cm GF*
Ilha dos Amores, São Paulo, c. 1885.

257. *Marc Ferrez albumen 15 × 22 cm GF*
Shipment of coffee at the port of Santos before the construction of the quays, c. 1880. It looks like a stage set.

The lives of those who worked in the shop, though difficult compared to today, were normal for the times. It was an almost familial way of life, recalling that of artists and their apprentices during the medieval period. In brief, craftsmen, a small nucleus of people who knew each other well, worked together in harmony at a specialized task. Besides, this life-style was common and was characteristic of many other types of businesses and small industries. After all, diversions were few; there were no movies, beach outings, or soccer. Occasionally, one went to the theater, family gatherings with music, card games, or, perhaps, the most circumspect dancing. It was an age of frequent religious celebrations, courtships from afar, and flirtations at the corner, if not on the trolley car. And then there was the *entrudo*, the carnival celebration of the time, where

257

merrymakers carried their spray containers filled
with water and other liquids, not always so pure
and perfumed.

Ferrez was indefatigable in everything he under-
took. He was very severe with his assistants. If a cli-
ent ordered ten prints from a negative, all ten had
to be printed identically. If not, he insisted that the
job be repeated until it was perfect. At times, he
even became a bit brusque with his customers,
sometimes lacking patience with the amateur pho-
tographers who streamed into his shop in ever-
greater numbers. They were young people seeking
to learn the master's secrets. If they showed apti-
tude, he was overjoyed; but when a disciple con-
tinued to repeat the same errors, even after having
been corrected repeatedly, the master was disap-
pointed, and he told them straight-out what he

thought of their work. Roquette-Pinto, in his very
interesting and erudite *Ensaios Brasileiros* (p. 111),
wrote:

> Marc Ferrez was a master of his art; his name re-
> mains linked to any number of scientific initiatives.
> At the end of his life, he was an able counseler to
> amateur photographers, scarce at the beginning of
> the century. As a boy in short pants, I often visited
> his store on Rua S. José, in front of Galeria
> Cruzeiro, to buy supplies, and principally, the "sen-
> sitized paper" that he prepared himself in large
> sheets.

Photography teacher of Imperial Princess Dona
Isabel the Redeemer, Marc Ferrez was always sur-
rounded by artists, scientists, and travelers—friends

258

258. Marc Ferrez silver gelatin 10 × 17 cm GF
Street vendors.

259. Marc Ferrez silver gelatin 23 × 29 cm GF
The Cinema Pathé in 1907. It was the second movie theater to open on the Avenida Central (now Avenida Rio Branco), no.s 147 and 149. Rio de Janeiro.

260. Marc Ferrez mc 23 × 29 cm GF
Lobby of the Cinema Pathé after it was relocated to Avendia Central (now Avenida Rio Branco) no. 116, beside the Galeria dos Comerciários. Rio de Janeiro.

who came seeking his advice and knowledge. Among these were Barbosa Rodrigues, to whom the Botanical Gardens in Rio de Janeiro owe so much; Glaziou, building and landscape architect who designed Brazil's largest parks (Campo de Sant'Ana and Quinta da Boa Vista); painters, such as Fachinetti, Thomaz Driendl, Breno Treidler, Langerock, Antônio Parreiras, Vítor Meireles, Pedro Américo, and Angelo Agostini (creator of the *Revista Ilustrada*), Bethencourt da Silva (founder of the School of Arts and Crafts), Belmiro de Almeida, the Bernardelli brothers, the sculptor Berna; Paulo Ferrand, engineer, writer, and professor at the School of Mines in Ouro Preto; Jules Martin, lithographer from São Paulo; L. Berini, engineer and financier; General Tasso Fragoso, then a lieutenant and a collaborator in the creation of the Republic of 1889; Júlio Melli, author of a numismatic work unparalleled in Brazil; the engineers Teixeira Soares, Paulo de Frontin, Pereira Passos; the Baron of Rio Branco; and many other notable personalities.

259

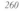
260

In 1895, the Lumière brothers introduced motion pictures. Marc Ferrez sensed right away the importance of the amazing invention which was capable of *animating* photography, rendering it even more *documentary* of the life that he so tirelessly recorded in all its aspects. After 1900, he became very interested in chronophotography. It was no longer static images but *movement*—the very characteristic of life—that could be captured on film. Ferrez was not concerned with the unlimited theatrical possibilities of the invention, as a device for the materialization of characters from novels or other literary creations, or with its future commercialization. What impressed him, rather, was the unparalleled potential of this new medium for the documention of the universe, bringing knowledge of the peoples of the world, their activities, habits, and customs to "armchair travelers" anywhere: "the world tour without leaving home." He had been an enthusiast of luminous projections since the earliest attempts to adapt the famous magic lantern for use with photographs,

replacing the glass slides painted in ink or translucent colors with others using positive photographic images. The subjects shown were portraits, panoramas, and even microorganisms, made visible by means of microphotography, quite a difficult procedure at the time. Etherized light was used in the projections, which were held in theatres, conference rooms, and even public streets.

It is not surprising that Marc Ferrez took great interest in the first steps of the nascent art of cinematography taken by his friends, the Lumière brothers. Ferrez had the opportunity to operate the first movie cameras that were imported to Rio.

In 1905, his son Júlio Marc Ferrez became the Brazilian representative of the Parisian firm of Pathé Frères, the largest and best maker of motion-picture cameras and films in Europe. He also started the business of sending agents from town to town showing a small collection of films—comedies, tragedies, and fantasies—thus bringing the new invention to many parts of Brazil.

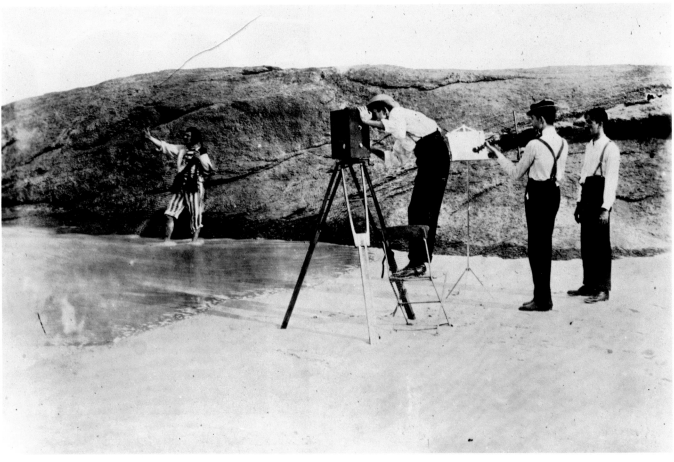

261

261. *Júlio Marc Ferrez gelatin silver 11 × 17 cm GF*
Scene of the first talking film made by Júlio Marc Ferrez,
eldest son of Marc Ferrez. It featured a barcarole sung by
the baritone Cataldi and was filmed in Copacabana, next
to Mère-Louise, where the Forte de Copacabana is lo-
cated today. The musician is Costa Júnior.

262. *Marc Ferrez mc 21.8 × 27.8 cm GF*
Pão de Açúcar and Urca, in Rio de Janeiro, seen from
Prainha de Dentro (in Niterói), c. 1885.

Two very successful enterprises for showing films
commercially in large rooms especially adapted for
this type of entertainment soon appeared in Brazil:
one in São Paulo managed by Vítor de Maio, and
another in Rio, which belonged to the impresario
Paschoal Segreto. From then on, many itinerant
movie exhibitors rented theaters for the presentation
of their films, while placing luminous advertise-
ments in the magic lantern shows held outside in
the public squares.

The true era of permanent movie theaters—
established in shops or warehouses especially
adapted for this purpose—began in 1907. On Au-
gust 10, J. R. Staffa opened the Parisiense. Soon af-
ter, on September 17, Marc Ferrez (in partnership
with Arnaldo Gomes de Souza) opened the Pathé
Cinema at 147-49 Avenida Central (now Avenida
Rio Branco). There, he began to exhibit, on a regu-
lar basis, the films made by Pathé, which dominated
the market in the early years of motion pictures.

Tickets were popularly priced a 1 *mil-réis*, and the program changed twice weekly.

His interest in motion pictures did not take Marc Ferrez away from still photography. On the contrary, in 1903, he accepted the invitation of the Avenida Central Construction Commission of Rio de Janeiro to produce an album that would be a document worthy of that grandiose undertaking. His assignment was to record the entire project: first photographing the plans of the façades approved for construction and—after the work had been completed—the actual façades of the newly constructed buildings.

The result was a monumental album entitled *Avenida Central 8 de março de 1903–15 de novembro de 1906* which is, perhaps, unique in the world. It was produced partly in Rio de Janeiro, partly in Paris, and partly in Zurich, in an edition of one thousand copies.

The project, however, was plagued by misfortune. By the time the boxes containing the albums—each measuring 52.5 × 42.5 cm and weighing nearly six kilos—arrived in Rio, the commission had ceased its activities. There was no one to receive the albums or to store them. What was worse, there was no one to take responsibility for

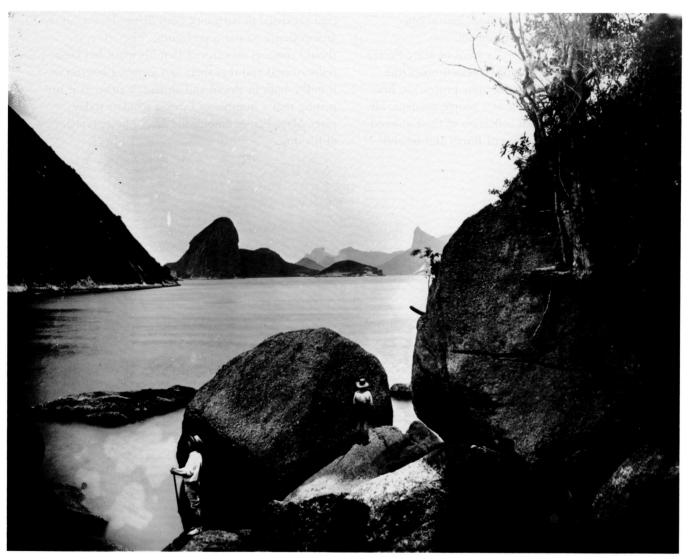

the payment of the final part of the work. Under these conditions, Ferrez had to store the boxes in the basement of his home at 23 Rua 2 de Dezembro. While he was seeking a solution to the problems created by the dissolution of the commission, a major sea storm hit Rio in 1913 that destroyed nearly all of the new Avenida Beira-Mar that ran along the seafront in Flamengo, and innundated neighboring streets, flooding the basement where the boxes were stored. Most of the albums were ruined. This disaster made the album a rarity, until 1982, when the laudable initiative of the firm of João Fortes Enghenharia and the proven competence of Editora Ex-Libris came together to produce a well-made second edition. Thus, it is possible to have access today to a work that, in the opinion of Professor Paulo F. Santos, a recognized authority, is "a living document for the study of the urban renewal of Rio de Janeiro, of which the opening of Avenida Central constituted the most important element."

The irrepressible pioneering spirit of Marc Ferrez led him to introduce Lumière's autochromes (the first commerical color photography process) to Brazil in 1912, acting this time as a simple amateur. He put together a marvelous collection of these colored glass plates, including views of Brazil and several European countries.

In 1914, he lost his beloved wife. It was a hard blow. Grief-stricken and ill, Marc Ferrez retired from business and artistic life and went to France. While he was there, he tried to be useful to the company that he had founded and left to his children. He returned to Brazil, where he died on January 12, 1923.

In every way, the work of Marc Ferrez is a landmark in the history of Brazilian photography. It is both a culmination and a point of departure. On one hand, it marks the end of the long adventure set into motion by the daguerreotype demonstrations of Chaplain Louis Compte in Rio de Janeiro. On the other hand, his daring innovations herald the existence of paths that would be blazed somewhat later. His work is a bridge between Brazilian photography's past and present. His work is the reflection of the man in whom the artist and technician coexisted in harmony, both driven by the same ardent desire to attain perfection. Therefore, it should come as no surprise that his work has been rediscovered and that there is a growing interest in it today, both in Brazil and abroad. Neither is it surprising that a number of foreign scholars today place Marc Ferrez among the great photographers of his time.

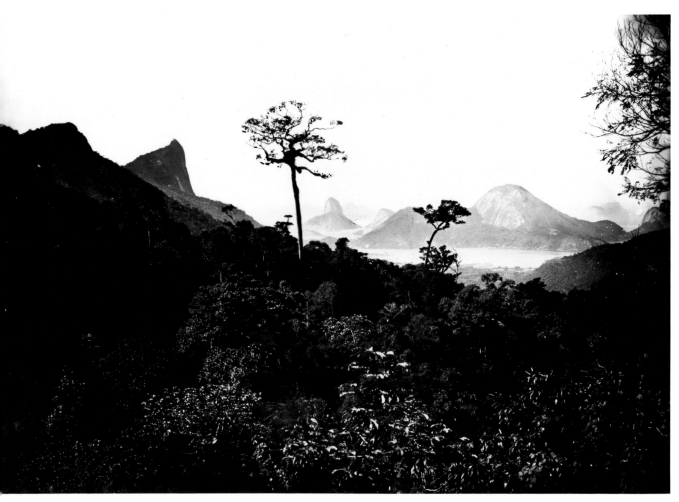

263

263. *Marc Ferrez mc 15.5 × 22 cm GF*
Vista Chinesa, showing, from left to right, Corcovado,
Pão de Açúcar, Morro dos Cabritos, and Lagoa Rodrigo
de Freitas. Rio de Janeiro.

Notes

1. On the occasion of its opening, the Hotel Pharoux announced: "To be found in this inn: richly appointed accommodations, sleeping and dining areas for upwards of eighty persons. Cleanliness and prompt service recommend this establishment to the public, as well as its size and location with a view of the entrance to the Bay. A bathing facility is available for the guests of the house. On the same premises: ice creams, served at the customary hours." *Jornal do Commercio*, Rio de Janeiro, February 12, 13, and 15, 1838. The original building was still standing on the corner of Praça 15 de Novembro and Rua Pharoux, where it served as the Hotel Real, in 1959. Later that year, it was demolished to allow the passage of Avenida Perimetral.

2. It is notable that the writer uses both the word *daguerrotype* (in Portuguese *daguerrótipo*, a misspelling that appeared in Brazilian newspapers for a period) and the word *photography*, indicating that he was informed about the early developments of the new art.

3. *Jornal do Commercio*, Rio de Janeiro, January 17, 1840. In the same newspaper, on January 20 [1840], read *Comte* [sic].

4. José Maria Fernández Saldaña, "La Fotografía en el Río de la Plata," *La Prensa*, Buenos Aires, January 26, 1936. Julio F. Riobó, *La daguerrotipia y los daguerrotipos en Buenos Aires*.

5. Of the passage of *L'Orientale* by Salvador, the only mention found in the local newspaper is this announcement entitled "New Method to Make Sculpture." It reads: "The captain of the corvette Oriental [sic], which is undertaking a training voyage around the world for the purpose of obtaining everything that could be of interest to the sciences, commerce, and industry of France, brings in his company an artist to record the most remote and least-known peoples with the aim of enriching the museums of France. This artist—who, before his departure from Paris, made busts of the entire royal family using his personal method—alerts the inhabitants of this city that he takes the opportunity afforded by his stay in this port to model those persons who desire their perfect effigy. The operation is executed in the space of two to three minutes, and whoever wishes may direct himself to Mr. Sauvage, aboard the above-mentioned corvette during its brief stay." *Correio Mercantil*, Salvador, December 13, 1839.

The person mentioned in this announcement had nothing to do with daguerreotypy, as will be shown later. It appears that, if Father Compte demonstrated the process in Salvador, the citizens of Bahia were not aware of it. Nor is it known exactly when the ship arrived there. *O Correio Mercantil*, which already had at that time a section listing the arrivals and departures of ships, did not record the day of arrival of *L'Orientale*, stating only that "the French vessel *Orientale* departed on the day of December 17." *Correio Mercantil*, Salvador, December 18, 1839. In the announcement transcribed above, a Mr. Sauvage is mentioned. However, this was Frederic Sauvage, who left the expedition soon after arriving in Rio, where he remained for several months, according to what can be deduced from newspapers and other sources. Mr. Sauvage was a sculptor who worked with the physionotrace (a mechanical drawing instrument). As soon as he arrived in January, he made the busts of Emperor Dom Pedro II and his two sisters Dona Januária and Dona Francisca, for which he received 240 *mil-réis*. See Guilherme Auler, "Mr. Sauvage," in *O Imperador e os Artistas*, pp. 32–33.

In *O Despertador*, Rio de Janeiro, January 18, 1840, Sauvage announced: "Physionotrace—such is the name of a new machine, by means of which the facial features of living persons can be registered with such exactitude and perfection that all of the contours can be found admirably represented. It is well known that the eyes always make sculptors despair. Yet, physionotrace resolves all these difficulties; nothing could be easier than keeping the eyes open [when using this method]. The advantages for the phrenological and medical sciences are obvious, and even those for ordinary people, since the perfect and exact manner with which it receives the features of the face allows the plaster to be made to precisely resemble the sitter. As the ship *L'Orientale* is preparing to leave within a few days, those who wish to see how this device works should address themselves to the Hotel d'Europa between noon and 4:00 P.M., where Mr. Sauvage will provide them full information."

In July of the same year, he said that he "resumes his work once more, between 11 and 3 o'clock," and, later, that he "gives up one of his machines," and, further, that he would depart on July 25. *Jornal do Commercio*, Rio de Janeiro, July 15, 23, and 25, 1840. (These announcements were given to the author courtesy of the historian José Antônio Soares de Souza.) In December, he returned to Rio de Janeiro and announced that "having sculpted, by means of the physionotrace, the portrait of His Majesty the Emperor, a reduction of the same has just been produced, also in low-relief, and luxuriously mounted." Guilherme Auler, op. cit., p. 32. Thus, it is clear that Mr. Sauvage was a sculptor who had nothing to do with daguerreotypy.

6. There is a controversy concerning the attribution of this daguerreotype. In *Pioneer Photographers of Brazil, 1840–1920*, Weston J. Naef stated his opinion that it was not made by Father Compte, but by Augustus Morand. My opinion is based on a text in the *Jornal do Commercio*, January 17, 1840, describing the daguerreotypes made in

Rio by Compte and kept by the Emperor with such care (being the first made in Brazil) in three *absolutely* identical cases. I consider that the description of Morand's daguerreotype given by Daniel Parish Kidder (see *Pioneer Photographers of Brazil*, p. 16) does not correspond to the image published in this book (Fig.1). To complicate the question, there is an engraving by Louis Buvelot and Auguste Moreau made on the occasion of the coronation of Dom Pedro II in 1841 (see the author's *O Paço da Cidade do Rio de Janeiro*, p. 55). In the engraving, the Neo-Classical plat bands of the Paço have begun to be constructed, while in the daguerreotype of Compte they appear entirely, concealing the eaves. To judge by this document, the daguerreotype could not have been made in 1840, as I initially maintained. Lacking the certainty to reach a definitive conclusion, it is incumbent upon me to point out these contradictions.

7. Michel Braive, "Les chasseurs d'images," in *Miroir de l'histoire*, p. 126. See also, Braive's beautiful work, *L'age de la photographie* . . . , p. 207.

8. Could this be the Joseph Natterer that went to Brazil on the Austro-Bavarian scientific mission in the escort of Archduchess Leopoldina? Helmut and Alison Gernsheim seem to have thought so when they wrote in *A Concise History of Photography*, p. 77: "Early in March [1841] the brothers Joseph and Johann Natterer of Vienna were reported to have taken portraits experimentally with the Voigtländer camera on plates prepared according to Kratochwila's method, which they found increased the sensitivity five times. . . . Chemical acceleration in conjunction with the Voigtländer camera reduced the exposure to a fraction of a second out of doors in bright weather, enabling the Natterer brothers to take instantaneous street views with people and traffic."

9. The French Mission was a group of some forty artists and artisans brought from France to Brazil in 1816 by Emperor Dom João VI to found the Imperial Academy of Fine Arts. Although most of the members of the mission eventually returned to France, their influence on Brazilian arts was profound and enduring. The name of the French Mission is closely linked with the Neo-Classical style in Brazilian nineteenth-century art and architecture. Among the artists who came with the French Mission were Marc and Zeferino Ferrez, respectively the uncle and father of the Brazilian photographer Marc Ferrez (—Trans.).

10. *Jornal do Commercio*, January 21, 1840.

11. Julio F. Riobó, op. cit., pp. 12 and 16.

12. *Jornal do Commercio*, Rio de Janeiro, June 20 and 21, 1840.

13. Ricardo Martim (pseudonym of Guilherme Auler), "Dom Pedro II e a fotografia (1)," *Tribuna de Petrópolis*, Petrópolis, April 1, 1956.

In 1840, 250 *mil-réis* was equivalent to approximately 125 U.S. dollars. A deluxe model daguerreotype outfit could be purchased in the United States at that time for 80 to 100 dollars. Considering the cost of shipping to Brazil, the price paid by the emperor seems to have been within the range of fair market price for the period (—Trans.).

14. *Travels of his Royal Highness Prince Adalbert . . . in the South of Europe and in Brazil, with a Voyage up Amazon and the Xingu*, vol. I, p. 280.

15. According to the Imperial Account Books, Dom Pedro spent the following amounts on photographs only in the period from 1848 to 1867: from Buvelot & Prat 2,999 *mil-réis*, Victor Frond 9,127 *mil-réis*, Joaquim Insley Pacheco 243 *mil-réis*, Stahl 730 *mil-réis*, Henrique Klumb 2,815 *mil-réis*, Carneiro & Gaspar 1,600 *mil-réis*, Carneiro & Smith 1,045 *mil-réis*, and Casa Leuzinger 237 *mil-réis*, totaling 18 *contos* and 796 *mil-réis*. In addition to this, he bought ten copies of the large album by Victor Frond and Charles Ribeyrolles for 2,000 *mil-réis*, six albums by Desmons for 330 *mil-réis*, and numerous lithographic portraits by Luiz Aleixo Boulanger for 1,402 *mil-réis*. This adds up to the figure, relatively high for the period, of 22 *contos* and 528 *mil-réis* (Archives of the Superintendency of Petrópolis). To understand the significance of these figures, it suffices to point out that the professors at the Imperial Academy of Fine Arts received *annually* from 300 to 800 *mil-réis*, and that in 1855 the yearly endowment of Her Majesty the Empress was 96 *contos de réis*, and that of Princess Isabel was 12 *contos de réis*. *Almanak Laemmert para 1855,* Supplement.

16. Julio F. Riobó, op. cit., pp. 14–15. *Jornal do Commercio*, Rio de Janeiro, December 23, 1842.

17. The exhibition was the third held in the country. See *Catálogo da Exposição da Academia Imperial das Bellas Artes do Rio de Janeiro*, p. 50c. *Jornal do Commercio*, Rio de Janeiro, December 23, 1842. *Notícia do Palácio da Academia Imperial das Bellas Artes do Rio de Janeiro*, p. 50.

18. Raymond Lécuyer, *L'histoire de la photographie*, p. 75. Still, Daguerre's invention also found admirers among artists and aesthetes. The painter Ingres, speaking of the magnificent portraits obtained by daguerreotype, declared: "It is to this exactitude that I would like to attain. It is admirable—but one mustn't say so." Helmut and Alison Gernsheim, op. cit., p. 64. The sharpness of detail and the texture of the daguerreotype still evoke admiration today. John Ruskin, comparing the daguerreotype of a Venetian palace with a painting of the same building by Canaletto, preferred the former. "In 1843 he wrote enthusiastically to his father: 'Photography is a noble invention, say what they will of it. Anyone who has worked, blundered and stammered as I have done [for] four days and then sees the thing he has been trying to do so long in vain, done perfectly and faultlessly in half a minute, won't abuse it afterwards.'" Ibid., p. 72.

19. *Jornal do Commercio,* December 23, 1842.

20. Daniel Parish Kidder, *Sketches of residence and*

travels in Brazil . . . and, in collaboration with James Cooley Fletcher, *Brazil and the Brazilians . . . sketches.*

21. Quoted in Beaumont Newhall, *The Daguerreotype in America*, rev. ed., New York Graphic Society, 1968, pp. 71–72.

22. *Jornal do Commercio*, Rio do Janeiro, October 23, 1842 and March 18, 1843.

23. Hercules Florence, *Viagem fluvial do Tietê ao Amazonas . . . a 1829.*

24. Boris Kossoy, *Hercules Florence . . . fotografia no Brasil*, p. 86.

25. *Jornal do Commercio,* Rio de Janeiro, February 14 and 18, 1844.

26. *Jornal do Commercio*, Rio de Janeiro, February 5 and 10, 1844.

27. *Jornal do Commercio,* Rio de Janeiro, January 4, 7, and 13, 1840.

28. *Jornal do Commercio*, Rio de Janeiro, January 15 and April 4, 1846.

29. *Jornal do Commercio*, Rio de Janeiro, March 20 and April 9, 1850.

30. This notice appeared in the pages of *Almanak Laemmert* in 1849 and 1850.

31. Dom Pedro II left to posterity an annotated list, written in his own hand, of these daguerreotypes. They were, as Guilherme Auler informs us: "1—a view of the Palace under constuction, taken from the bridge of the 'Bacia.' 2—one of the street in front of the Palace, taken from the mountain opposite [from the Cruzeiro]; beyond the temporary church, the end of Rua do Imperador [15 de Novembro] can be seen. 3—The back of the Palace. 4—Rua do Imperador. 5—Another view of Rua do Imperador. 6—Hotel Suiço—'Petrópolis's best, as regards service, while the França and Brangança have magnificent structures.' 7—Rua de Dona Francisca—'[the] big house belonged to the late Major Koeler and now to D. Alda, mother-in-law of Antonio Barbosa, brother of Paula Barbosa, we stayed in this house at the end of [18]47 and beginning of [18]48, the first time we went to Petrópolis, after establishing the settlement.' 8—'Saw-mill that belongs to me and is now leased—it is a single-story building with four windows—the Quitandinha River can be seen, unchanneled, behind—beginning of the Quarteirão da Renania [Renania Quarter, a section of the city], that extends more than one league through this valley.' It was almost in front of the present-day factory *Dom Pedro da Alcântara.* 9—'Part of the Quarteirão, taken from zig-zig mountain,—a little house with a garret that can be seen in the background is where the Russian minister usually stays—the road that can be seen is the one that leads from the villa to the Hospital.' All these daguerreotypes and the transportation of the daguerreotypists cost the royal purse the sum of 184 *mil-réis* (only in travel expenses), plus one *conto*, seven hundred and sixty *mil-réis.* These were the amounts paid for 1851 only. Before

that, there were numerous other expenses for portraits paid to these same artists in 1849 and 1850." Ricardo Martim (pseud. of Guilherme Auler), *Tribuna de Petrópolis*, Petrópolis, March 13, 20, and 27, 1955. It is truly sad to think that these precious daguerreotypes are lost, since they document the earliest days of Petrópolis. Auler advances the hypothesis that they were made for presentation to Their Highnesses D. Francisca and D. Januária [sisters of the Emperor]. Who knows? Perhaps these daguerreotypes are in Europe with the descendents of the Imperial Family.

32. *Jornal do Commercio*, Rio de Janeiro, August 19, 1852.

33. Mello Moraes Filho, *Artistas do meu tempo*, p. 62.

34. L. Buvelot and Augte. Moreau, *Rio de Janeiro pitoresco.*

35. Buvelot was, reportedly, the subject of a thesis written by the Austrialian scholar Jocellyn Gray. *O Globo*, February 8, 1963.

36. *Jornal do Commercio*, Rio de Janeiro, March 21 and April 6, 1850.

37. *Jornal do Commercio*, Rio de Janeiro, October 18, 1851 and January 7, 1855.

38. Mello Moraes Filho, op. cit., p. 72.

39. *O Mercantil*, Petrópolis, January 6 and 9, 1875.

40. Mello Moraes Filho, op. cit., pp. 46–47.

41. *Tribuna de Petrópolis*, February 19, March 4, and April 1, 1956. *Jornal do Brasil*, November 10 and 11, 1957.

42. The author of this text owns a number of originals by Klumb—views of Rio de Janeiro, Petrópolis, Juiz de Fora, the União Indústria highway, and landscapes—some of which were used to illustrate the two previously mentioned books by the photographer. The Instituto Histórico e Geográfico Brasileiro and the Museu Histórico Nacional each possess albums by Klumb. The Biblioteca Nacional cataloged some hundred very interesting stereoscopic photographs made between 1856 to 1870 and signed "R. H. Klumb of Rio de Janeiro and Petrópolis."

43. Mello Moraes Filho, op. cit., pp. 38–69.

44. Container 36, no. 6.

45. *Relatório da 2.ª Exposição Nacional de 1866*, pp. 158–70.

46. *Semana Illustrada*, Rio de Janeiro, March 3, 1866, p. 3077.

47. "Dom Pedro II e a fotografia (1)," *Tribuna de Petrópolis*, April 1, 1956.

This amount would have been equivalent to approximately 6,250 U.S. dollars at the time. Although rates of exchange naturally fluctuated, the reader may have a general idea of the dollar equivalents of the prices stated in Brazilian currancy by assuming a value of 50 cents for the *mil-réis* and 500 dollars for the *conto*. For more precise rates of exchange between the years 1821 and 1930, see Julian Smith Duncan, *Public and Private Operation of Railways in Brazil*, New York: Columbia University

Press, 1932, p. 183 (—Trans.).

48. Petrópolis, Museu Imperial. Arquivo da Família Imperial, bundle 127, d.6.300.

49. These can be found in the Biblioteca Nacional and the Museu Imperial, as well as in the collections of the Ministry of Foreign Affairs, Dr. Américo Jacobina Lacombe, and the author.

50. Louis Agassiz, *Voyage au Brésil*, Paris, Hachette, 1869.

51. Biblioteca Nacional, Seção de Iconografia.

52. *O Recreador Mineiro*, vol. 1, May 1, 1845, p. 139.

53. *O Bom Senso*, March 21 and 31, 1856.

54. *O Noticiador*, April 5, 1871.

55. Biblioteca Nacional, Seção de Iconografia, Arm. 17.1.3, and Biblioteca Brasiliana, Robert Bosch Foundation, Stuttgart.

56. "Catalogo da Exposição de Historia do Brazil . . . 1881." *Annais da Biblioteca Nacional*, vol. 9, no. 17361/64, 17357, and 17912.

57. Instituto Histórico e Geográfico Brasileiro, Container 36, no. 11.

58. Biblioteca Nacional, Arm. 28.4.2.

59. Biblioteca Nacional, Seção de Iconografia, Arm. 17.1.10.

60. *Correio Mercantil*, Salvador, June 6, 1844.

61. Biblioteca Nacional, Seção de Iconografia, Arm. 17.3.2 and Arc. 29–21 and 22. This album, commissioned by the railroad entrepreneur John Watson, was presented to Dom Pedro II.

62. Biblioteca Nacional, Seção de Iconografia, Arm. 17.1.5 to 8.

63. Biblioteca Nacional, Seção de Iconografia, no. 16.972 of the "Catálogo da Exposião de História do Brazil . . . 1881."

64. No. 16926, 16927, 1633–35 do "Catálogo da Exposição de História do Brazil . . . 1881."

65. "Relatório da comissão diretora da Exposição de Pernambuco," in *Relatório da 2.ª Exposição Nacional de 1866*, Part 2.

66. Biblioteca Nacional, Seção de Iconografia, Ar. 17.1.2.

67. *Memórias da viagem de SS. Magestades Imperiaes às Províncias . . . Pernambuco . . .*, vol. II, p. 83. See also the Diary of Pedro II of 1859 in the Museu Imperial, and *Velhas fotografias pernambucanas, 1841–1900*, by Gilberto Ferrez.

68. Instituto Histórico e Geográfico Brasileiro, Container 35.

69. José Antônio Gonsalves de Mello, *Ingleses em Pernambuco*, pp. 64–66.

70. "Relatório da commissão diretora da Exposição de Pernambuco," in *Relatório da 2.ª Exposição Nacional de 1866*, Part 2, p. 343.

71. *Memórias da viagem de SS. Magestades Imperiaes ás provincias da Bahia . . .*, vol. ii, p. 69. Mordomia da Casa Imperial [Imperial Account Books], Decree of September

18, 1860, vol. 76 of the Archive of the Superintendency, Petrópolis.

72. *Catálogo da Exposição Provincial de Pernambuco em 1872*, pp. 46–49.

73. *Correio Pernambuco*, July 15, 1868.

74. Biblioteca Nacional, Seção de Iconografia, Arm. 18.3.10.

75. *Almanak administrativo, mercantil, industrial e agrícola da Província de Pernambuco para o ano de 1881*, p. 207.

76. Beaumont Newhall, *The Daguerreotype in America*, pp. 72–73.

77. *O Ipiranga*, São Paulo, October 6, 1852.

78. See *São Paulo de outr'ora* by Paulo Oursino de Moura, *Velho São Paulo* by Affonso d'E. Taunay, and *São Paulo antigo e São Paulo moderno*.

79. *Diário Mercantil*, São Paulo, February 22, 1888.

80. The Instituto Histórico e Geográfico Brasileiro owns one of these collections: Container 35, no. 18. The railway was inaugurated on December 2, 1884.

81. Not to be confused with his namesake, uncle, and godfather, the French sculptor Marc Ferrez of the French Artistic Mission, who came to Brazil in 1816 with his brother Zeferino.

82. See "Os Irmãos Ferrez da Missão Artística Francesa," in *Revista do Instituto Histórico e Geográfico Brasileiro*, vol. 275.

83. The records of the Exposição Nacional of 1881 contain the following statement: "Sr. Marc Ferrez dedicated himself to photography since 1860." In 1881, Marc Ferrez published a brochure, extremely rare today, entitled *Exposição de paisagens photographicas productos do artista brasileiro Marc Ferrez Photographo da Marinha Imperial e da Commissão Geológica*, where he states: "This establishment, dedicated especially to making views of Brazil, was founded in 1860." Lapse of memory. Possibly, he meant to say that he had been a photographer since that time.

84. Lécuyer, *L'histoire de la photographie*, p. 130.

85. *Jornal do Commércio*, Rio de Janeiro, June 12, 1872, "Gazetilha." Biblioteca Nacional, Seção de Iconografia, portfolio of documents on the city of Rio de Janeiro, 11 photos. "Catalogo da Exposição de Historia do Brazil . . . 1881." In *Anais da Biblioteca Nacional*, vol. 11, no. 17546.

86. The "Gazetilha" of the *Jornal do Commércio* reported that event on the following day: "Yesterday at 10 o'clock at night there was a fire in the building located at 96 Rua S. José (formerly Rua do Parto), a single-story house where Mr. Maciel, a bookseller, lived in front, and Mr. Marc Ferrez, photographer, in back: the fire started in the front of the house. . . . The fire soon spread to the buildings at numbers 98, 100, [and] 94, completely destroying numbers 96 and 98, [and] greatly damaging number 100, with some harm to number 94. . . . The lack

of water became a grave problem, its supply being delayed for more than one hour. . . . Giving first aid were Lieutenant Colonel Luís Inácio, Inspector Faria, and several persons whose names could not be ascertained. . . . Present were the Minister of War, Chief of Police and his deputies, the Chief of the Fire Dept., Captain Marques Sobrinho, several station chiefs and district inspectors, and a great crowd of onlookers. . . . Responding promptly, the war arsenal brought their pump, which proved very useful, and soon after the pumps from several other military posts." See also the *Diário do Rio de Janeiro*, November 19, 1873.

87. *Almanak Laemmert*, 1860, p. 687.

88. The sculptor also made two commemorative medals that were commissioned by the Institut de France and sent to Dom Pedro II, together with a letter carried to the Emperor by Marc Ferrez: "Paris, March 14, 1874. . . . The permanent Secretary of the Academy to His Majesty the Emperor of Brazil . . . Sire, . . . While I still have the honor to preside over the Commission des Monnaies et Médailles [Commission of Coins and Medals], I am pleased to have had made, by a very competent artist, Monsieur Alphée Dubois, two medals commemorative of great moments in astronomy: 1st—the discovery of the 100th small planet. 2nd—the discovery of the process, currently in use, for the observation of solar protuberances. . . . Mr. Marc Ferrez is pleased to accept the responsibility [of bringing to you] an example of each of these medals, which I pray Your Majesty allow me to present as an hommage of Science to one of its most worthy protectors. . . . I believed myself authorized to add to the two astronomical medals, the medal that the Academy has offered to our doyen of Chemists, Monsieur Chevreul. It is by the same artist. . . . I seized this occasion to offer to Your Majesty, my gratitude for the honor that He bestows upon me, and all my wishes for his prosperity. I have the honor to be, Sire, with the deepest respect, the very devoted Servant of Your Majesty. . . . V. Dumaz." Archives of the Museu Imperial, m. 169, doc. 7746.

89. "Returning from a costal exploration of the southern part of the Province of Bahia, the Commision's assistants Rathburn and Ferrer [sic], arrived yesterday from Caravelas, bringing very important collections and a fine series of photographs, among them a great number of portraits of Botocudos." *Jornal do Commercio*, Rio de Janeiro, August 12, 1876.

90. The author has tried in vain to locate this material in a number of government offices. It is very possible that the prints that remained with the American scientists are in the archives at Cornell University.

91. See the brochure published by Marc Ferrez, mentioned in note 83.

92. Gernsheim, op. cit., p. 42.

93. Gernsheim, op. cit., p. 34.

94. The firm Lombaerts, Marc Ferrez & Cia. edited books and published *A Estação*, an "illustrated journal for the family," according to an advertisement in the *Jornal do Brazil*, Rio de Janeiro, Ano I, no. 1, April 9, 1891, p. 6.

Glossary of Photographic Terms
[Written by Pedro Vasquez.]

Albumen

Obtained directly from the white of the hen's egg and composed of various proteins and other constituents. Albumen was used extensively during the last century and the beginning of this one for making photographic papers. It served as the transparent adhesive layer in which the image-forming metallic silver was held in suspension.

Owing to its complex chemical composition, a series of reactions could occur, causing the yellowing of the albumen. This process of deterioration is greatly influenced by the relative humidity of the area in which photographs are stored.

Albumen negatives

Albumen negatives were prepared as follows: one side of a glass support was coated with a layer of albumen, which, after drying, was sensitized with a solution of silver nitrate. Different albumen negative processes were developed by Abel Niepce de Saint Victor, in 1848 (France), and John A. Whipple, in 1850 (U.S.A.). Albumen negatives presented the inconveniences of poor adhesion to the glass support and low sensitivity to light. For these reasons, they were superseded by the wet-collodion negative.

Albumen paper prints

Introduced by Louis Désiré Blanquart-Evrard (France) in 1850, it became the most widely used photographic printing paper up to 1890. Albumen printing paper was treated with a coating of albumen containing sodium chloride, then sensitized with silver nitrate. The success of albumen paper resulted from its uniformly smooth surface that rendered fine detail better than the salt papers previously used for printing.

Ambrotype

See *Collodion positives*

Cabinet card

Developed in England in 1866 as an offshoot of the *CARTE-DE-VISITE* (which pratically disappeared at this time), it had the same type of format—a posed portrait adhered to a cardboard mount—but was larger: a photograph 9.5 × 14 cm, mounted on a card 11 × 16.5 cm. The cabinet card was used frequently up to the end of the nineteenth century.

Calotype

Negative/positive process developed and patented by the Englishman William Henry Fox Talbot and, for this reason, also known as *talbotype*.

A paper negative was exposed in the camera, developed in a solution of gallic acid and silver nitrate, and then fixed. Positives were obtained through exposure to sunlight, the negative being held in contact with a sheet of salted paper inside a printing frame. The process was used from 1841 until the mid-1850s, principally for landscape and architectural photographs.

Carbon process

A process for obtaining positive prints, developed and perfected between 1855 and 1864 by several researchers working independently. The process employed pigments suspended in gelatin bichromate. Carbon black was often used, hence the name. This photographic technique produced a stable, nearly inalterable, image.

Carte-de-visite

Portrait mounted on pasteboard, patented by André Adolphe Eugène Disdéri in 1854, the *carte-de visite* attained its greatest popularity around 1860, declining in 1866, and disappearing in 1885. The format consisted of a photograph 6 × 9.5 cm glued to a card 6.5 × 10.5 cm.

Collodion

Substance used as a transparent medium (binder layer) for suspending the light-sensitive silver halides on a support of glass (for negatives) or paper (for prints). The collodion consisted of a solution of cellulose nitrate with equal parts of ether and alcohol.

Collodion positives

This name was given to wet-collodion negatives, generally of slight density, on glass supports. When mounted on a black background, these produced the effect of positive images. Introduced by Frederick Scott Archer in 1851 (England), collodion positives were mounted in cases, like the daguerreotypes that they imitated. The process was widely used between 1850 and 1860 for portraits, and existed under various forms, the best-known being the AMBROTYPE.

Collotype printing

Photomechanical printing process introduced in 1870 and still in limited use today. A metal or glass support covered with bichromated gelatin is placed in contact with a negative and exposed to light, producing a matrix for the impression of images in continuous tone.

The hardening and reticulation of gelatin upon ex-

posure to light permits the differential absorption of ink by the matrix, corresponding to the tonal gradation of the photographic image on the negative, and the subsequent impression of copies. (Generally used for illustrations in publications or on postcards.

Cyanotype

Process invented by Sir John F. W. Herschel (England) in 1842. The paper, impregnated with light-sensitive iron salts, was exposed in contact with a negative, producing a blue image. Owing to its simplicity, this process was much used by amateur photographers at the end of the last century (1880-1900). Cyanotype is also used to produce, by contact, copies of plans and designs called blue prints because of the blue color obtained through this process.

Daguerreotype

Direct positive process created by Louis Jacques Mandé Daguerre (France) and made public in 1839. The image was formed on a copper plate covered with a sheet of polished silver, and sensitized with a vapor of iodine. After exposure, the plate was developed in a vapor of mercury and fixed in a solution of sodium thiosulfate. The delicate image formed on the surface of polished silver is protected by a glass cover and typically placed in a decorative case. Owing to its polished surface, the image is seen as a positive when it reflects a dark background, and as a negative when it reflects a light background. [The daguerreotype is a unique image, since no negative is made in the process, multiple copies could not be produced from a single exposure.]

This process was used, above all, in the 1840s, especially for portraits. It was considered obsolete by the period between 1850 and 1860.

Gelatin

Commercial product manufactured from bones and other parts of animals, gelatin is a purer and more chemically stable protein material than albumen. The fact that it changes states—from a liquid to a gel, and vice-versa—with changes in temperature, permits its use in photographic emulsions. Gelatin can be applied on various supports while in a liquid state; after cooling it becomes the transparent medium (binder) that contains the light-sensitive silver halides.

Gelatin dry plate

So named in opposition to the preceding collodion wet plates that had to be exposed to light immediately after the sensitizing bath in a solution of silver nitrate. The dry plates, with their gelatin emulsion, were much easier to use since they could be bought already sensitized and exposed in the camera without any previous treatment by the photographer. They were introduced in 1871 by R. L. Maddox (England). The preparation of gelatin emulsions containing photosensitive silver halides for later application to various supports (glass, paper, flexible film), made possible the development of the photographic industry such as we know it today.

Gelatin silver print

Gelatin photographic papers were introduced commercially around 1880, and have remained in use since that time. As with the many photographic materials that employ animal gelatin as a transparent medium for the suspension of light-sensitive silver halides, the production of gelatin photographic papers was soon industrialized, since the gelatin emulsion allowed for mechanical coating of the base (paper, glass, or flexible film). Depending on the formula, presensitized photographic papers with different characteristics can be produced. The two principal types of gelatin photographic papers are: those where the image is produced by direct action of light (*printing-out paper*), and those where, following a brief exposure, the latent image is developed chemically (*development papers*). In this latter category are gelatin photographic papers containing silver bromide, which are sensitive enough to allow for enlargment of the negatives. This fact not only revolutionized laboratory practice at the end of the last century (the production of prints no longer required exposure in contact with the original negatives), but made possible the development of small-format cameras and films.

Gum bichromate process

Introduced in 1894, the process employs a paper support coated with a layer of gelatin, or gum bichromate, containing pigments in suspension. After exposure in contact with the negative, the emulsion is washed with water. Only the unexposed areas are removed, since exposure to light makes the gelatin insoluable.

Phototype

See *Collotype*.

Platinotype

Photographic process for making prints on paper using light-sensitive iron salts and precipitate platinum to form the final image. Deposited directly on the paper fibers, the image is one of rich tonal scale and extremently fine detail. It is considered one of the most permanent photographic processes.

Salted paper print

This process, based on the light-sensitivity of silver chloride, was developed by William Henry Fox Talbot (England) in his first photographic experiments, after 1834. It

was widely used between 1840 and 1850 for making photographic prints, from negatives on either paper (calotypes) or glass (collodion or albumen). The image (metallic silver) is deposited directly on the paper fibers.

Stereoscopic photography
The production of pairs of photographs that appear to be three-dimensional when viewed through a special viewer. The effect was produced by making the two photographs simultaneously using a camara with two lenses spaced at approximately the same distance as a person's eyes. The resultant photographs, taken from slightly different angles-of-view, imitated the effect of human binocular vision.

This ability to produce three-dimensional effects, long a fundamental concern of some photographers, has culminated in contemporary holography. Although rare, there are several examples known of steroeoscopic daguerreotypes, dating from the 1850s. Other positive processes such as ambotype, calotype, and albumen paper prints were used in making stereoscopic photographs.

The image on the cover of this book, made in 1875 by an anonymous photographer, is reproduced from a stereoscopic photograph on albumen paper, mounted on card stock (stereograph card).

Tintype
Introduced in 1855, tintypes used iron plates coated with black enamel as a support for a binder of wet collodion. As in other positive collodion processes, the plates exposed in the camera produced, after development, direct positive images.

Waxed paper process
A refinement to the calotype process, the waxed paper negative was introduced by the Frenchman Gustave LeGray in 1851. The paper was treated with wax—rendering it transparent—before being sensitized in a bath of silver nitrate. Positive prints made from contact with these negatives produced sharper, more clearly detailed images. Another advantage of the waxed paper negative was that it remained sensitive to light for a longer time, allowing photographers to prepare their paper negatives days before their photographic excursions.

Wet collodion process
The process was introduced in 1851 by Frederick Scott Archer. A glass plate was coated with a layer of collodion containing potassium iodide, then immersed in a bath of silver nitrate. The exposure had to be made while the plate was still wet, and the negative developed immediately afterward in an acid solution of iron sulfate, then fixed in a solution of potassium cyanide. The pioneers who worked with this process must have faced serious difficulties. Roger Fenton reported that when photographing the Crimean War in 1855, he encountered problems with the excessively high temperatures in the region, which dried his plates before he could take the photograph.

Note:
The photographs identified in the text with the term ALBUMEN are prints on albumen paper.

The photographs identified in the text with the term GELATIN SILVER are prints on gelatin silver paper.

Glossary of Portuguese Terms

This glossary of Portuguese terms that recur in the text and captions within proper names has been added to the English edition for the readers' convenience.

barra—entrance to a harbor, often demarcated by a natural or man-made barrier.

capela—chapel

cascata—cascade, waterfall; cascatinha (diminutive)

cidade—city

colégio—school, usually equivalent to high school

colônia—settlement, colony

estrada—road, highway

garganta—gorge

igreja—church

ilha—island

ladeira—steep, hillside street

lagoa—lagoon

largo—plaza

matriz—mother church

morro—hill

mosteiro—monastery

Pão de Açucar—Sugar Loaf, mountain landmark of Rio de Janeiro

paço—palace

pedra—rock, as used in proper names of landforms, they are of mountainous proportions

ponte—bridge

praça—a city square

praia—beach

quinta—residence of a large rural estate, plantation house

serra—mountain range

Bibliography

Adalbert of Prussia, Prince. Travels in the south of Europe and Brazil: with a voyage up the Amazon and its tributary the Xingu, now first explored. London: David Bogue, 1849.

Agassiz, Louis. *Voyage au Brésil.* Paris: Hachette, 1869.

Almanak Administrativo, Mercantil e Industrial . . . Laemmert. Rio de Janeiro: Laemmert & Co., 1885.

Almanak da Gazeta de Notícias. Rio de Janeiro: Typographia da Gazeta de Notícias, 1879 and 1800.

Almanak Laemmert . . . da Côrte . . . das Provincias . . . Rio de Janeiro: Laemmert & Co. (Editions for the period 1844–1900.)

Archivos da Exposição da Industria Nacional. Rio de Janeiro: Typographia Nacional, 1882.

Arquivo Imperial. Petrópolis: Museu Imperial, n.d.

Auler, Guilherme. *O imperador e os artistas.* Petrópolis: Tribuna de Petrópolis, 1955.

Bell, Alured Gray. *The beautiful Rio de Janeiro.* London: William Heinemanna, 1914. (Excellent reproductions of watercolors and photographs. Photographers unidentified.)

Bourroul, Estevam Leão. *Hercules Florence.* S. Paulo: Typographia Andrade & Mello, 1901.

Braive, Michel F. *L'age de la photographie* . . . Bruxelles: Editions de la Connaissance, [1965].

———. "Les chasseurs d'images." *Miroir de l'Histoire,* Paris (December 1965): 192.

Brazil at the Louisiana Purchase Exposition. St. Louis: Saml. F. Myerson Printing Co., 1904.

Le Brésil à L'Exposition Internationale d'Amsterdam. Lisboa: Typ. Castro Irmão, 1885.

Buvelot, L., and Moreau, Aug^te. *Rio de Janeiro pitoresco.* Rio de Janeiro: Lithographia de Heaton e Rensbug, 1845.

Catalogo da Companhia Photographica Brazileira. Rio de Janeiro: J. Gutierrez, 1892–93.

Catalogo da Exposição de Historia do Brazil realizada pela Biblioteca Nacional do Rio de Janeiro a 2 de dezembro de 1881. Rio de Janeiro: Typ. de G. Leuzinger & Filhos, 1881.

Catalogo da Exposição Nacional. Rio de Janeiro, 1861, 1866, 1873, 1875, and 1881.

Catalogo da Exposição de Obras Publicas do Ministerio da Agricultura inaugurada por Sua Magestade o Imperador em 31 de dezembro de 1875. Rio de Janeiro: Typographia Perseverança, 1875.

Catalogo Geral das Obras Expostas no Palacio da Academia Imperial das Bellas Artes. Rio de Janeiro: Typographia Nacional.

Catalogo dos Produtos Naturaes e Industriais que Figurarão na Exposição Nacional. Rio de Janeiro: 1861.

Catalogos dos Productos Naturaes e Industriaes Remetidos das Provincias . . . Exposição Nacional . . . 1861. Rio de Janeiro: Typographia Nacional, 1862.

Catalogue of the Brazilian Section, Philadelphia International Exhibition. Philadelphia: 1876.

Catalogue of the Brazilian Section at the World's Columbian Exposition. Chicago: 1893.

Cunha, Sylvio. "Velha Petrópolis." *Rio* 129 (March 1950).

Cruls, Gastão. *Aparência do Rio de Janeiro.* Rio de Janeiro: Livraria José Olympio Editora, 1949.

Daguerre. *Historique et description des procédés du daguerreotype et du diorama.* Paris: Alphonse Giroux & Cie. [1839].

Dias, Arthur. *Il Brasile attuale.* Nivelle (Belgium), Stampa Lanneau & Despret, 1907. (Contains unusual photographs, poorly printed. Photographers unidentified. Some photos by Marc Ferrez.)

Edmundo, Luís. *O Rio de Janeiro do meu tempo.* Rio de Janeiro: Imprensa Nacional, 1938. (Profusely illustrated with drawings and photographs. Unfortunately, photographers' names are given only on the title page.)

L'empire du Brésil à l'Exposition Universelle de 1867 à Paris. Rio de Janeiro: Typographie Universelle Laemmert. 1867.

Exposição Geral das Bellas Artes . . . catalogo explicativo. Rio de Janeiro: Typographia Nacional.

Exposition Universelle de Paris, 1889. Empire du Brésil. Catalogue officiel. [Paris], 1889.

Ferreira Da Rosa. *Rio de Janeiro.* Rio de Janeiro: Prefeitura Municipal, 1905. (Good photographs. Photographers unidentified.)

———. *O Rio de Janeiro em 1900.* Rio de Janeiro: Typ. Aldina, 1899. (Includes some photographs.)

———. *Rio de Janeiro: Notícia historica e descritiva da capital do Brasil.* Rio de Janeiro: Annuario do Brasil, 1924. (Includes photographs. Photographers unidentified.)

Ferrez, Gilberto. "Um passeio a Petrópolis em companhia do fotógrafo Marc Ferrez." *Anuário do Museu Imperial.* Petrópolis: Ministério da Educação e Saúde, 1948.

———. "Os irmãos Ferrez da Missão Artística Francesa." *Revista do Instituto Histórico e Geográfico Brasileiro* (Rio de Janeiro, April/June 1967): 275.

———. *Velhas fotografias pernambucanas, 1841–1900.* Recife: Departamento de Documentação, 1956.

Ferrez, J. O. *amador photographico.* Paris: Imprimerie Mournier Jeanbin & Cie., n.d.

Ferrez, Marc. *Avenida Central.* Genève e Rio de Janeiro: Marc Ferrez, 1906.

———. *Exposição de paisagens photographicas . . .* Rio de Janeiro, [1881].

———. *Máquinas e acessórios para fotografia.* Rio de Janeiro, 1905.

Florence, Hercules. *Viagem fluvial do Tietê ao Amazonas . . . ,* trans. Visconde de Taunay. São Paulo: Edições Melhoramentos, 1941.

Folhinha Laemmert. Rio de Janeiro: Laemmert, 1839–1929.

Franck, Harry A. *Working North from Patagonia.* New York, s. ed. 1921. (Includes some interesting photographs. Photographers unidentified.)

Frond, Victor. *Brazil pittoresco;* album de vistas, panoramas, paisagens, monumentos, costumes, etc., . . . acompanhados de 3 v. in-4°, sobre a história, as instituições, as cidades, as fazendas, a cultura, a colonisação, etc., do Brazil, por Charles Ribeyrolles. Paris, Lemercier, 1861.

Gernsheim, Helmut & Gernsheim, Alison. *A concise history of photography.* London, Thames & Hudson, 1965.

Guia da exposição anthropologica brazileira realizada pelo Museu Nacional do Rio de Janeiro. Rio de Janeiro, Typ. G. Leuzinger & Filhos, 1882.

Guia de Santos Cardoso. s. 1., s. ed., 1883.

Kidder, Daniel P. *Sketches of residence and travels in Brazil . . .* Philadelphia: Sorin & Ball; London, Wiley & Putnam, 1845.

Kidder, Daniel Parish, and James Cooley Fletcher. *Brazil and the Brazilians . . . sketches.* Philadelphia: Childs and Peterson, 1857.

Kossoy, Boris. *Hercules Florence . . . fotografia no Brasil.* São Paulo: Faculdade de Communicação Social Anhembi, 1977.

Lecuyer, Raymond. *L'histoire de la photographie.* Paris: L'Illustration, 1945.

Leuzinger, G. *Oficina fotografica de G. Leuzinger . . .* Rio de Janeiro: Typ. G. Leuzinger, [1866?] (Catalog with 337 photographs.)

Mello, José Antônio Gonsalves. *Ingleses em Pernambuco.* Recife: Instituto Arqueológico, Histórico e Geográfico Pernambucano, 1972.

Mello Moraes, Filho. *Artistas do meu tempo.* Rio de Janeiro: H. Garnier, 1904.

Memorias da viagem de S.S. Magestades Imperiaes às provincias da Bahia . . . Rio de Janeiro: Typ. e Livraria de B. X. Pinto de Sousa, 1861.

Newhall, Beaumont. *The Daguerreotype in America.* New York: Duell, Sloan & Pearce, 1961.

Noticia do Palacio da Academia Imperial das Bellas Artes do Rio de Janeiro. Rio de Janeiro: Typographia Nacional, n.d.

Paula Pessôa. *Guia da cidade do Rio de Janeiro.* Rio de Janeiro: E. Bevilacqua and Co., 1905. (Profusely illustrated with photographs. The author does not cite the photographers' names. Several works included

are by Marc Ferrez.)

Relatorio da Exposição Artistico-Industrial Fluminense . . . Rio de Janeiro: Imprensa Nacional, 1901.

Relatorio da Exposição Nacional. Rio de Janeiro: Typographia do Diario do Rio de Janeiro, 1861, 1866, 1869, 1873, 1875, 1881.

Resumé du Catalogue de la section Brésilienne à . . . Vienne en 1873. Vienne: n.p., 1873.

Riobó, Julio F. *La daguerrotipia y los daguerrotipos en Buenos Aires.* N.p.: 1949.

Roquette-Pinto, E. *Ensaios brasilianos.* São Paulo: 1940.

Taunay, Affonso d'E. Hercules Florense. *Jornal do Commercio,* Rio de Janeiro (January 20, 1946).

———. *Velho São Paulo.* São Paulo: Edições Melhoramentos, 1952.

Wright, Marie Robinson. *The New Brazil: its resources and attractions, historical descriptive and industrial.* 2nd. ed. rev. enl. Philadelphia: George Barrie and Son, 1908. (Illustrated with numerous photographs. Photographers not identified. Some works included are by Marc Ferrez.)

Bahia

Almanach do Diario de Noticias. 1882.

Almanach Litterario e de indicações . . . 1888, 1889.

Almanak administrativo, commercial e industrial da Provincia da Bahia para o anno de 1873, . . . compiled by Altino Rodrigues Pimenta. Typographia de Oliveira Mendes & Co., 1872.

Almanak administrativo, mercantil e industrial da Bahia . . . 1857, 1860, 1863.

Almanaque da Província da Bahia. 1881.

Almanaque do Estado da Bahia. 1898, 1899.

Catalogo da Exposição Bahiana . . . Bahia: Imprensa Economica, 1875.

Catalogo da Exposição Provincial da Bahia . . . Bahia: Typographia de J. G. Tourinho, 1872.

Peixoto, Afrânio. *Breviário da Bahia.* Rio de Janeiro: Livraria Agir Editôra, 1945.

———. *Livro de horas.* Rio de Janeiro: Livraria Agir Editôra, 1947.

Minas Gerais

Almanack administrativo, mercantil, industrial, scientifico e litterario do municipio de Ouro Preto. Ouro Preto: Typographia d'A Ordem, 1890.

Almanak administrativo civil e industrial da provincia de Minas Geraes . . . Rio de Janeiro: Typographia do Diario do Rio de Janeiro, 1870, 1875.

Pará

Almanach, administrativo, mercantil, industrial e noticioso da provincia do Pará . . . Carlos Seidl and Co., 1868, 1869, 1871, 1873, 1874, 1875.

Almanak paraense de administração, commercio, industria e estatistica . . . Typ. de Assis and Lemos, 1883.

Almanaque do Pará, comercial, industrial e administrativo. 1889.

A Exposição artística e industrial . . . do Pará. 1895.

Pernambuco

Almanach de Pernambuco. Recife: F.P. Boulitreau, 1899, 1900, 1901.

Almanak administrativo, mercantil, industrial e agricola da provincia de Pernambuco . . . Recife: Typographia Universal, 1881.

Almanak administrativo, mercantil e industrial da provincia de Pernambuco . . . [Recife]: Typ. de Geraldo Henrique de Mira and Co., 1861.

Almanak Litterario Pernambucano para o anno de 1899. Recife: Liv. e Typ. de Tondella, Cockles and Co., 1898.

Almanaque de Pernambuco. 1872.

Arquivos Prefeitura Municipal. Recife.

Catalogo da Exposição Provincial de Pernambuco em . . . Recife: Typographia Mercantil, 1875.

Catalogo dos objectos remettidos à Exposição Nacional pela commissão directora da Exposição da Provincia de Pernambuco . . . Rio de Janeiro: Typographia Perseverança, 1866.

Costa, F. A. Pereira da. *Anais Pernambucanos.* Recife: Arquivo Público Estadual, 1951.

―――. *Artes em Pernambuco.*

Folhinha de Almanak ou diario ecclesiastico e civil para as Provincias de Pernambuco, Parahyba, Rio Grande do Norte, Ceará, e Alagoas, para o anno de 1861. 1861, 1863, 1865.

Freyre, Gilberto. *Um engenheiro francês no Brasil.* Rio de Janeiro: Livraria José Olympio Editora, 1940.

―――. *Guia prático, histórico e sentimental da cidade do Recife.* Rio de Janeiro: Livraria José Olympio Editora, 1942.

Guia da Cidade do Recife. Recife: Prefeitura Municipal, 1935.

Relatório apresentado ao Governo pela commissão directora da Exposição de Pernambuco em 1866. 1866.

Relatorio da commissão directora da Exposição Provincial de Pernambuco em 1872. 1873.

Sette, Mario, *Arruar.* Rio de Janeiro: Livraria-editora da Casa do Estudante do Brasil, 1948.

Teatro Santa Isabel . . . Recife: Prefeitura Municipal do Recife, [1950].

Petrópolis

Klumb, Revert Henry. *Doze horas em diligencia; guia do viajante de Petropolis a Juiz de Fóra.* Rio de Janeiro: J. J. da Costa Pereira Braga, 1872.

[Taunay, Carlos Augusto.] *Viagem pittoresca a Petropolis* . . . Rio de Janeiro: Eduardo and Henrique Laemmert, 1862.

[Thomas Cameron]. *Os estabelecimentos uteis de Petropolis.* Petropolis: Typ. de B. P. Sudré, 1879.

Tinoco, J. *Petropolis, guia de viagem.* Rio de Janeiro: Typographia de L. Winter, 1885.

Rio Grande do Sul

Ferreira, Athos Damasceno. *Imagens sentimentais da cidade.* Porto Alegre: Edição da Livraria do Globo, [1940].

São Paulo

Almanach da provincia de São Paulo administrativo, comercial e industrial . . . São Paulo: Jorge Seckler & Comp., 1884, 1885, 1886, 1888, 1891.

Almanak administrativo, commercial e profissional do Estado de São Paulo para 1897 . . . *organisado por Canuto Thorman.* 1897.

Almanak administrativo, mercantil e industrial da provincia de S. Paulo para anno de 1857. Marques & Irmão, 1856.

Almanak da provincia de São Paulo para 1873. Antonio José Baptista de Luné e Paulo Delfino da Fonseca, 1873.

Indicador de S. Paulo administrativo, judicial, industrial, profissional e commercial para o anno de 1878. Abilio A.S. Marques, 1878.

Koenigswald, Gustavo. *São Paulo.* São Paulo: Als Manuscript Gedruckt, 1895.

Memorial Paulistano para o anno de 1863. São Paulo: JRAM, 1862.

Milano, Miguel. *Os fantasmas da São Paulo antiga.* São Paulo: Edição Saraiva, 1949.

Moura, Paulo Cursino de. *São Paulo de outr'ora.* São Paulo: Melhoramentos, [1932].

Novo almanach de São Paulo para o anno de 1883. Jorge Seckler and Co., 1882.

Sant'anna, Nuto. *São Paulo historico.* São Paulo: Departamento de Cultura, 1937.

Velhas fotografias pernambucanas 1841–1900. Recife: Departamento de Documentação e Cultura, 1956.

O velho Rio de Janeiro através das gravuras de Thomas Ender. São Paulo: Melhoramentos [1957?].

Other Works by the Author on Brazilian Photography

O álbum da Avenida Central de Marc Ferrez. São Paulo: João Fortes, 1982.

―――. *Bahia, velhas fotografias, 1858–1900.* Rio de Janeiro, Kosmos and Salvador, Banco de Bahia Investimentos, 1968.

―――. & Weston J. Naef. *Pioneer Photographers of Brazil, 1840–1920.* New York: The Center for Inter-American Relations, 1976.

―――. *O Rio Antigo do Fotógrafo Marc Ferrez.* São Paulo, Editora Ex Libris, 1985.

―――. *Velhas fotografias pernambucanas 1841–1900.* Recife. Departamento de Documentação e Cultura, 1956. Album.

Index

Photography in Brazil, 1840–1900

Designed by Milenda Nan Ok Lee
Typography in Granjon
by Keystone Typesetting, Inc.
Printed by Dai Nippon Co., Ltd.
Printed in Japan